Prehistoric Art

Prehistoric Art

T. G. E. Powell

NEW YORK AND TORONTO
OXFORD UNIVERSITY PRESS

Contents

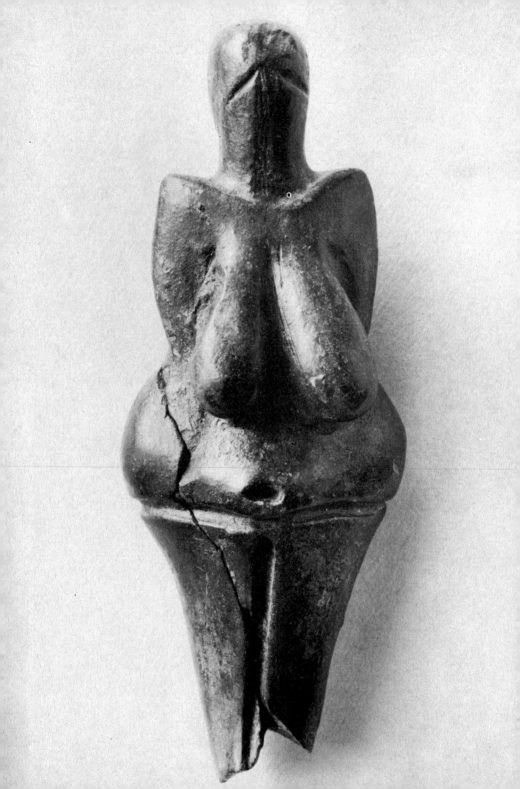

Preface

Art is a term too easily borrowed in archaeology to explain things from the far past that are not obviously utilitarian. But every scratch and mark is not art any more than need be the most elaborate, costly, or curious, objects of devotion and display. On the other hand, many straightforward appliances of daily life, mere tools and vessels, by virtue of their stark simplicity, their aptness for use, positively draw out that sensation of accord which is the recognition of art uniting the modern beholder with the maker however far apart in time and space.

No closer approach to a definition of art will be made here, and furthermore it must be accepted that strangeness to modern eyes has not by itself been a criterion for choice in these pages although strangeness could indeed be regarded as the only encompassment of so different a series of expressions in visual form.

This book is therefore a plain endeavour to introduce work from the skilled hands of men whose names are not known, nor of whom can be claimed knowledge of their personal dates and circumstances. That, strictly, is all that the words 'prehistoric' and 'art' brought together can mean. The majority of great art traditions are in fact historical whatever the range of bygone centuries, and they have been called by the names of self-conscious cities or dynasties: Babylon and Rome, Achaemenid and Han, for instance, or again by the names of peoples such as Sumerian and Greek. For the most part, too, the historically accountable art traditions embody elements that began in a truly prehistoric setting but which can be more easily accepted and understood as the forerunners of the greater achievements that followed. These clearly are not to be torn out of their contexts, but there remains, none the less, a most challenging and various range of ancient arts that can conveniently be set apart, at least in the present stage of enquiry, and marshalled under the banner of Prehistoric Art.

7

◀ 1 Female figurine of baked clay from Dolní Věstonice, Moravia

It is in Europe that this term is most applicable, and there are three reasons that should be especially kept in mind. First, that the conditions for preservation happen to have been comparatively good, secondly, that the prehistory of Europe has been more intensively studied than that of any other continent, but thirdly, and by far the most important, because the natural complexities of Europe, in topography, climate, and resources, evoked from one region to another more intense and diversified responses than those usually to be found in realms of older story and more prolonged continuity.

Even within the limits thus set, little more has been possible than to indicate backgrounds and apparent causes, and to draw attention to some methods of work. If absolute judgements are required, the reader is encouraged to observe patiently and closely, and to seek an independent understanding.

I wish to express my especial thanks to Mr Walter Neurath for his encouragement to write this book, and to Mr P. A. Clayton for his ardent pursuit of illustrations and much valuable help in other ways, and to all those friends, colleagues, and institutions, who have so willingly helped in supplying photographs; their names are recorded separately.

<div align="right">T. G. E. POWELL</div>

The Art of the Hunters

Man everywhere was first a food-gatherer depending on nature in every season for day to day needs. From such beginnings eventually arose communities who hunted large mammals, and the substantial rewards in flesh to eat, skins to wear, antler and bone for tools and weapons, made possible further advances in the organization of life, in the ability to venture into severer climatic zones, and to establish a long continuing equilibrium between such hunters and their environment. This process varied greatly in success, or even failure, from one part of the world to another as remoteness and climate played their part, but in the zone that was to become Europe, from the Urals westwards, and in all the region bordering to the south, from Persia to Palestine, there came into being active peoples, few and scattered, who were to include the first artists as indeed much later they were to initiate the beginnings of civilization. These people were of course *homo sapiens*, the human stock that had everywhere gradually pushed out and replaced less developed hominids. It is important to seize the fact that the oldest art is the work of men directly ancestral to modern humanity, and has nothing to do with extinct 'fossil' species, such as *homo neanderthalensis*, although these had attained various degrees of tool making. A point of great interest is that the oldest art appears to have arisen in a zone to which man deliberately penetrated, and remained established in the face of an often bitter climate being attracted by the special properties of such cold-loving animals as the mammoth and reindeer over and above the quarry offered in more temperate regions to the south. These spurs to activity, the challenges of peculiar natural conditions, and the quest for great animals, duly met, must surely be accountable for that stretching of the mind which found expression in the first fashioned shapes : women, mammoth, and animals both huntable and hostile. In saying first, it must be understood that it is first in terms

of modern investigation. The prelude is unknown, and probably unknowable; it need not have been very long, and perishable materials may have formed the experimental media. Wood, and skins, may well have remained as important as vehicles for display as the durable substances that have survived.

In terms of archaeology, the oldest art derives from communities whose material culture is classified as Upper or Advanced Palaeolithic. The durable remains that form the basis for the life of such peoples are flint artefacts of wide ranging purpose and typological variation; to a lesser extent bone artefacts, but all principally informative when observed in association with each other, with hearths, rarely graves, or in properly recorded stratified deposits in caves, or reliably excavated dwelling places on open sites. The climatic background was that of the last phase of the Würm glaciation with its several fluctuations, and the Würm was of course itself the last of the four major glacial periods of the geological era known as the Pleistocene. The time range of the Advanced Palaeolithic was immensely long even adopting, as is done here, the most modern reduced views based on radiocarbon measurement. A span of some twenty thousand years is involved, a reduction to about one-third of the chronological proposition generally held before the application of F. W. Libby's discovery of the measurable qualities of certain radioactive properties of organic materials. The approximate beginning of the Advanced Palaeolithic in Europe is now taken as being in the order of 30,000 years B C, and its duration down to about 9000 B C. It is clear that centuries, even millennia, one way or the other can mean nothing in actual apprehension. But the Advanced Palaeolithic was nearly twice as long as the time between its ending and ourselves. The real importance of absolute dates lies in the opportunities to mark, as between one region and another, the beginnings or duration of particular cultures or even manifestations of art. It is much more useful to know that figurines carved in mammoth ivory were made earlier in Moravia than in the south-west of France than to worry over multiples of centuries for their own sake. To this end, absolute dates, if only accurate to within a few centuries, provide a much finer grading than anything possible through

geological or climatological correlations, and the way becomes more certain for deducing the location and priority of creative societies, and the direction of their subsequent movements and influence on other peoples. This indeed leads to the central question as to whether the carved figurines of the mammoth hunters, and all that was to ensue in favoured regions, should be ascribed to the potentialities of the Advanced Palaeolithic peoples in general, or to a particular group. The direct archaeological evidence weighs in favour of one group, the Gravettian, while evidence for art in Aurignacian contexts does not seem certainly to antedate contact with Gravettian communities. Archaeological nomenclature is necessarily based on site names producing characteristic assemblages that were brought to notice during the early stages of research so that what was typified at Aurignac in Haute Garonne, and at La Gravette in the Dordogne, led to applications of these names to comparable assemblages throughout much vaster areas. Both the Aurignacian and Gravettian culture groups seem to have had common origins probably in southwestern Asia, and to have developed divergencies as their bearers moved into Europe choosing somewhat different terrain. The Aurignacians are best known from caves strung along the foothills of the great mountain ranges, while the Gravettians are first found on the open plains of Russia and Central Europe, but not avoiding caves, and coming to make use of them especially in south-western France where the Aurignacians had already established themselves.

There is not yet complete unanimity in the terminology for the Upper, or Advanced, Palaeolithic, and what is here described as Gravettian is called by some Upper Aurignacian or Perigordian. It has been the more important therefore to make clear what is envisaged for Aurignacians and Gravettians in the pattern of the Palaeolithic as it touches the subject matter of this chapter. From the Gravettian site of Pavlov in Moravia, which has produced examples of figurine art, a radiocarbon date of about 24,800 B C has been obtained, and this is some two or three thousand years earlier than any date so far available from Gravettian deposits in south-western France. Only a series of dates forming a consistent pattern could prove that Gravettians in central and eastern Europe first developed

their art, and then brought it to new territory in the west, but this does in fact seem to have been the course of events.

Coming now to the figurine art itself, the number of representations of women is something over sixty, and these are distributed in Gravettian deposits from the Ukraine to Moravia, Austria, Germany, Belgium and France, and into Italy. In the other direction, Siberia has produced at least two important sites with highly stylized figurines, and these speak for an extension beyond the Urals from the Russian loess-lands. Of contemporary animal models in the round, the number is much smaller, and they are confined to the central area of figurine art as a whole. There are some engaging little models of mammoth, bear, and ibex, from Moravian sites, and fragments of many more, made in clay, including this head of a lioness (*Ill. 2*). From the Vogelherd cave in Würtemberg come ivory figurines of horse, mammoth, and unidentified felines, but little can yet be said in way of general appreciation. For figurines, anthropomorphic or zoomorphic, the materials were various. Mammoth ivory was the most widespread, and produced the finest surviving results. Soft stone was occasionally used, and from the Moravian sites have come figurines modelled in clay mixed with powdered bone ash, and hardened by heating in hot ashes at the hearth, or perhaps in some kind of specially contrived 'kiln'. Unwittingly a ceramic substance had been brought into existence millennia in advance of the utilitarian potters craft, nor did it outlast the requirements of the mammoth hunters.

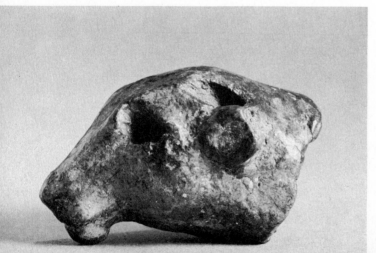

2 This lioness's head in baked clay mixture from Dolní Věstonice, Moravia, is a perceptive study of a feline. The damage behind the ear may be evidence of a ritualistic wounding or killing of the animal represented

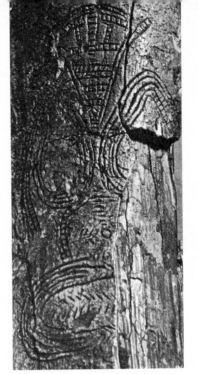

3 A highly schematized engraving on mammoth ivory of a female figure. It comes from the Gravettian camping site at Předmostí in central Moravia. A fine tool, a graver, was used to carve this figure, with its triangular head and enlarged pelvic area, in geometrical style

Although plastic anthropomorphic representations are in every way the most striking and interesting pieces on account of their implications for the range of feeling and intention of their makers, it is well to discuss first a highly schematized engraving on mammoth tusk of a female figure from the Gravettian camping site found at Předmostí in central Moravia (*Ill. 3*). It comes as a reminder that naturalistic plastic art need not exclude schematic, even geometric, representation of the same things in the one primitive society. Furthermore it raises the question, still largely to be explored, as to whether abstractions and schematic portrayal did not play as important a part, if not a prior one, in the origins of art as did naturalistic representation. There is as yet too little direct evidence, but the outcome did see a strong preference for naturalism amongst the western hunters while at the eastern end of the range schematic and geometric designs became ever more popular, and at the same time more limiting. The Předmostí engraving is best understood by comparing it with the plastic figurine from Dolní Věstonice which lies some 90 kilometres to the south (*Ill. 1*). This latter is one of the best

13

of the fire-hardened clay models, and it embodies the essential characteristics of the whole female figurine art without that extreme exaggeration that some display. Here, however, are the full pendulous breasts, the fleshy hips, and indications of pregnancy. The deep groove around the top of the legs accentuates the intention to show rolls of fat above, but the legs themselves are in reasonable proportion as are the shoulders and indications of upper arms. The head is well modelled, and the pair of deep oblique incisions almost certainly represent the line of brow and hair, rather than a crudely marked mouth, so that a slightly inclined posture for the head is suggested. This is a point to be returned to, but meanwhile the multilinear schematism of the Předmostí figure can be seen to accord in the shape of the breasts, and the accentuation of the lower torso. The drawing of a thin arm on the undamaged side is a further link, but the separation of the legs contrasts with those of the figurines which are drawn together although separately rendered, and this is, of course, likely to have been dependent on practical considerations of carving and modelling. The head of the Předmostí engraving is of great interest in that it departs so much from the convexity of the body lines, and introduces an elegant fan-shaped motif surmounting the ovate breasts. Do the converging side lines intimate forward inclination of the head, and do the horizontal hatched lines convey the hair style of the Willendorf figurine? Could the total fan effect represent some kind of head-dress? It must suffice to pose these questions in meditating the object itself.

It has long been emphasized in commentaries on the figurine art that the face plays no positive part; it is featureless, or in the case of Willendorf apparently covered by the hair arrangement (*Ill. 6*). It is certain that Gravettian artists were capable of portraying the human face, that their vision of women could take account of their facial characteristics generally if not individually, but in the case of the fecundity figurines the emphasis must needs be different. It is impossible to recapture the whole mind of the mammoth hunters, and it may not have been wholly clear or consistent, but some attempts at partial explanation can be of value. One approach suggests that the face being unessential to the achievement of luxuriance

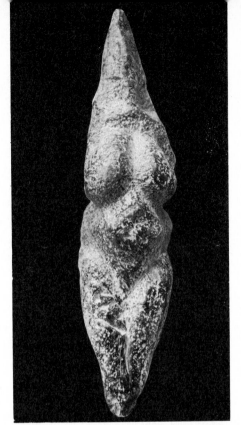

4 The Savignano female figurine may owe its unusual shape to a wooden prototype, basically a stick pared at both ends. Nevertheless the essential elements of maternity and adiposity are indicated with skill

and propagation found no place in the magical purpose of the figurine. It is possible, too, that the tradition of fecundity figurines, or such amulets, so antedates the surviving examples that the face had never been rendered for lack of skill or for undeveloped perception, and so its absence endured as an archaism in the hands of the later artists. Another view suggests that being faceless, the figurines represented an ideal lodged in the past: the great mothers of the community potent now only in their undefinable subterranean contribution to present well-being.

The figurine from Savignano, Modena, is the finest of the group from the north Italian plain (*Ill. 4*). It is made of serpentine, and is 22 cm. high. The elements of maternity and adiposity are brought out with remarkable skill in the organization of mass and contour. Arms are just indicated resting on the breasts. The head presents an unusual form in its high conical shape, and the clear vertical 'nasal'

15

ridge, as well as the horizontal moulding across the neck, should especially be noted. This is by no means the mere running out of the upper end of the 'biological entity' although the stone carver's intention remains obscure to present-day eyes. The over-all shape of the Savignano figurine should not be passed by. Viewed from front or back, the pointed termination of the legs complements the head, and the result is a spindle shape that might derive from a stick pared at either end to a point. The possibility of wooden prototypes has been alluded to, but here full advantage has been taken of the less restricting properties of the stone. The ivory figurine from Lespugue, Haute Garonne (*Ill. 5*), was damaged on excavation, but has been skilfully restored. There is more evident stylization in this piece as the masses have been clustered round the centre point, the breasts positively lying on the protruding belly while the upper part of the body rises clear and shapely to be surmounted by a beautiful downward-looking head. An atmosphere of resignation, if not sorrow and subjection, pervades this figurine. It seems, too, to combine old and new capabilities in its maker, and perhaps a more complex attitude of mind amongst his people. The Willendorf figurine, from Lower Austria (*Ill. 6*), was the first to be described as a Palaeolithic 'venus', and it conveys an altogether more direct message of purpose and contentment. The material is carboniferous limestone, and the sculpture is complete; the legs being intentionally finished off at the calves. This figurine is generally recognized as the masterpiece amongst known examples in the rendering of folds and contours of prosperous flesh, and a firm balance is struck between symbolic overstatement and the possibilities of real life. The hair style has already been noted, and there are a number of points on which much might be said. In brief, it should be noted that the deep pelvic line is carried round, and is an advance on the attempt in the Dolní Věstonice figurine. Willendorf also displays most clearly the arms and hands resting on the breasts, and these, together with the well marked nipples, make clear the milk-giving attitude of the majority of these figurines. This point leads back to the characteristic pose of the head; for where but downwards does a mother look when nursing her child? There was thus no point in seeking to portray the

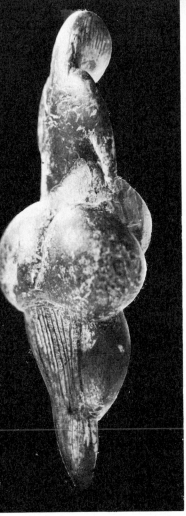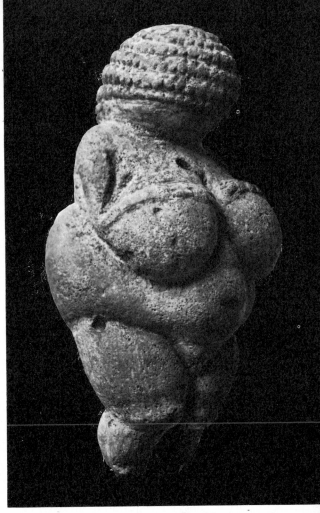

5, 6 The female ivory figurine from Lespugue (*left*) with its downcast head has an air of resignation and sorrow entirely lacking in the limestone 'venus' of Willendorf (*right*). Here there is a greater feeling of purpose and contentment, well represented in the balance struck between symbolic overstatement and the possibilities of real life

face which was hidden, and probably often obscured by tresses of hair. If a further word need be said on the 'facelessness' of the fecundity figurines, it must be a technical one to the effect that the inclusion of detail at such a small scale would have been contrary to the mode of fashioning the whole.

17

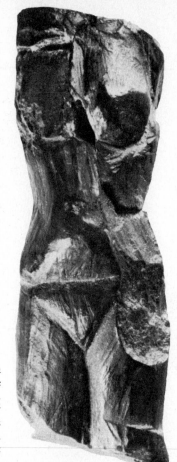

7 This miniature female torso, only 5 cm. in height, carved in haematite, comes from the camp site of Ostrava-Petřkovice in Moravia. It is in distinct contrast to the generally accepted 'venus' type of figurine and shows that the Gravettian artist was very capable in the approach to and handling of a different vision of the human form

That the Gravettian artist had other visions of the human form is witnessed in a very few pieces that are remarkable for their contrast to the figurines described. First there is the miniature female torso carved from a lump of haematite, and found at Ostrava-Petřkovice, another camping site in Moravia (*Ill. 7*). This restrained and adept work requires no additional words of recommendation, but it naturally raises many questions as to its purpose, or perhaps as to the possibility that it had no role in the community, but was an individual expression of insight and craftsmanship. In the same way, what can be said of the finely carved miniature ivory heads? There is one from Dolní Věstonice (*Ill. 8*), and another from Brassempouy,

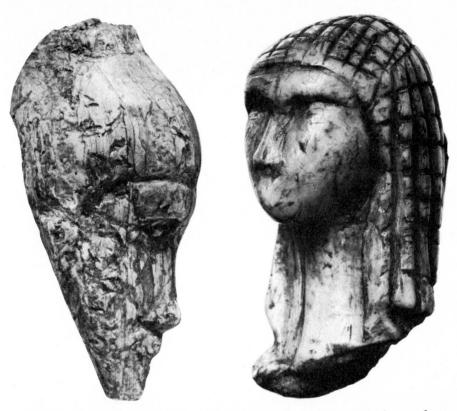

8, 9 The ivory heads from Dolní Věstonice (*left*) and Brassempouy (*right*) both come from deposits that yielded fecundity figurines, on which no facial features might be expected, yet both show carefully worked facial elements. It is not known if they formed part of complete figurines or if they were perhaps intended for use as charms or amulets

Les Landes (*Ill. 9*). Both are from deposits yielding fecundity figurines of whom no faces need be expected, but both these two pieces show carefully treated facial elements, and Brassempouy certainly looks forward, not downward. The original angle of the Dolní Věstonice head is in some doubt, nor can it certainly be ascribed to either sex though generally accepted as feminine. As to whether either head was carved as a thing in itself, or formed part of a larger composition cannot be determined on the evidence, but that they did not surmount fecundity figurines of the kind already described seems almost certain. These two heads differ a good deal, and share no pronounced technical formalities. The eyes, nose, and 19

chin, are quite differently treated in each, as is also the upper part of the head. The Dolní Věstonice head, even allowing for its battered condition, is the more natural of the two. The curved forehead, well drawn shapely eyes, long nose with rounded nostrils, and the indication of lips, are especially noteworthy. The narrowness of the chin may in part be due to the original shape of the ivory piece. Whether the upper head in its plain smoothness represents a mass of hair, or a cap or other head-dress, is not quite clear. Turning to the head from Brassempouy, there is no ambiguity about the subject in hand. The awareness of the neck, poise of head, and youthful line of the cheek, are as unexpected as they are successful. The fall of the elaborately braided hair gives further dignity, but the sharpness of the chin, and narrow, slit-like eyes, as well as the rather angular ending of the nose speak for less command of, perhaps less interest in, this kind of detail than possessed by the maker of the Moravian head. Whether or not these two little heads, and the haematite torso, were intended for use as amulets or charms, they have some claim to be accepted as utterances of personal experience.

The promise of this kind of Gravettian achievement seems to have evaporated, and for the human form expression became directed, seemingly exclusively, to formalized cult objectives. Here come in those rare carvings on blocks of limestone portraying humans and animals that have been found in rock shelters in south-western France, and which, in so far as the depiction of women are concerned, bear some relationship to the fecundity figurines. Most important is the sculpture found at Laussel, Dordogne, where a series of carved blocks had stood as a kind of frieze. It is impossible at present to say if such sculpture was contemporary with the making of fecundity figurines, or if it was something that emerged by way of other media. In any case its immobility presupposes some modification in the hunting life of the community in that it had become adapted to rocky hill country in contrast to tundra and steppe, and that particular rock features and sites now offered recurrent gathering places with a permanency of association never obtained in the earlier habitat. The sculpture from Laussel here shown (*Ill. 10*) is 44 cm. high, and is worked on a convex face of the block so that the body

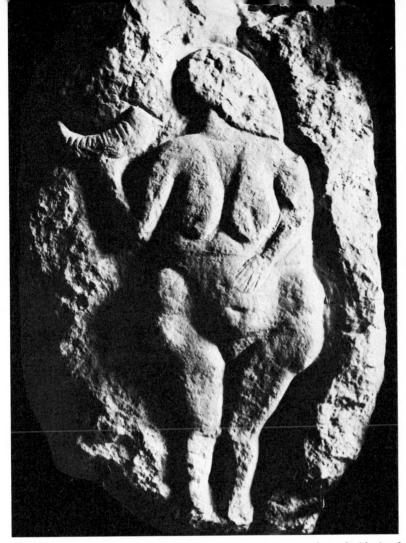

10 The female figure from Laussel is carved upon the convex face of a block of limestone so that the body swells out towards the viewer. It formed part of a frieze which included other female figures and a single male example

swells out towards the viewer, and the extremities recede. The fine finish of the sculpture contrasts with the rock surface around the deep and wide reduced area from which the figure stands forth. The general aspect immediately recalls the fecundity figurines, and there is obvious continuity or parallelism in the style and purpose.

21

There is no need to go over these features again so that attention may be given to different points. First, the legs are complete, and there is evidence for broken off feet. Then, the arms no longer press down on the breasts, but the left one, with outlined hand and fingers, rests on the abdomen, and the right hand holds up to shoulder level an object which is most likely to be a horn, probably of bison, but just possibly it is the tip of a mammoth tusk, that animal so integral to the early prosperity of the Gravettians. Whatever precise symbolism this object may have possessed, it surely betokens the great antiquity of *cornu copiae*, and the remote ancestress of Amalthea may here be glimpsed. This Laussel figure illuminates a widening of purpose, she is not engrossed in her own maternal role, fundamental as it remains, but projects her potency to external things implied by the horn. This is the first instance of relationship between a human figure and something outside, and the head is a very purposeful silhouette variant of the faceless style of the figurines. The head well balanced on the neck, and the hair arrangement, somewhat recall Lespugue rather than other examples. The more fragmentary sculptured blocks from Laussel show less well fashioned female figures, and there are some few deeply cut outlines of animals, principally horses. There is however a strongly outlined male figure, half turned and with outstretched arms perhaps in the act of spear throwing. The figure is generally taken to be nude, but no sex organs are shown, and the indication of a belt, and of a V-line at the neck make it at least possible that this was a normally clothed hunter in the pursuit of quarry. That Gravettian hunters were well clothed in skin raiment, with sewn on ornaments, has been recently demonstrated by Russian excavations at Sungir, some 130 miles east-north-east of Moscow. At Laussel, and elsewhere, traces of ochre colouring were found on some of the carved blocks. Colour was not something reserved for the dark caves; in these rock shelter sites sun and air were factors in their choice.

A word must be said at this point about the difficulties of associating the sculptured art of the rock shelters with particular cultures or periods within the Advanced Palaeolithic. The scarcity of examples make stylistic determination hazardous although at Laussel

some useful hints have been provided, but more difficult is the problem of relationship to cultural deposits, occupation debris, remaining layer upon layer at the site itself. Clearly the sculpture will not have been made by people whose rubbish engulfs or surmounts it, but before that which occupation to choose? At what height had these figures to stand above floor level, and did the people really dwell at such close quarters with their magic? The time factor is so long that these places can have been recurrently occupied, abandoned, or set apart, for appreciable periods without recognition by succeeding peoples. An intermission in occupation may in fact be as significant for the presence of the sculptors as the contrary. The application of new excavation techniques will go far to establish actual contexts, inadequately recorded in the phase of discovery, but will be unlikely to tell how long a carved block stayed in place or how soon it fell down.

The art at Laussel has been proposed as in the Gravettian tradition, and for present purposes it seems best to consider some further examples of rock shelter bas-relief art, all being of the same general disposition and content, without reference to the various claims for cultural context based on adjacent deposits. It must however be said that claims for bas-relief art as the work of people of the Solutrean culture, which interpenetrated with the Gravettian in the Franco-Cantabrian region before the emergence of the Magdalenian culture, have not been found convincing. Overlapping of cult practices and material cultures as there surely must have been, the general trend of Advanced Palaeolithic cult and its associated art moved from the amuletic pouch and the skin tent on the frozen steppe to the sunny rock shelter, and then, leaving light and life behind, into the mysterious bowels of the earth: the deep caves yet to be treated. Meanwhile, in the rock shelter at Le Cap Blanc, Dordogne, was discovered an extensive but much defaced bas-relief frieze. A procession of horses is carved just below the roof at the back of the shelter, and occupies some 14 metres in length. The rock was cut down to a depth of over 30 cm. in some places, and as at Laussel, no more was removed in width than was essential. There is thus no intended prepared field of reduced rock, nor anything approaching a formal

border. The whole effect is that of horses emerging out of the rock and disappearing into it again. These two sculptured horses (*Ill. 11*) are on the left of the frieze, and at or near the end of a series of less well preserved horses, all moving to the right. There is one larger horse, not here seen and more or less in the centre foreground, that moves to the left. It is deeply carved, and measures a little over 2 metres in length. The horses are all at slightly different levels just as they would appear if seen at a little distance in a herd. It is difficult to be certain about points of animal behaviour, but the big horse probably represents the leader of the herd acting as guardian. The striking naturalism of the scene at Le Cap Blanc both as to individual horses, and as to the grouping and sense of movement, commands the highest admiration.

The bas-relief sculpture at Le Roc de Sers, Charente, has been considered by some to be earlier than that at Le Cap Blanc as the work is cruder. This factor could as well point to less able stone workers, but there are other matters which might suggest some falling away from rather than approach to, the standards of Le Cap Blanc. The sculptured blocks at Le Roc de Sers were, with two exceptions, found in derived positions face downwards in occupation deposits obviously subsequent to the execution of the work. A tentative reorganization of some of the blocks was worked out, but no complete scheme can now be achieved. It is clear, however, that the content of the frieze was more various and less integrated than at the other two rock shelters already described. The main impression must have been that of a display of single animals, and these included horse, bison, ox, ibex, deer, one engraved bird head, possibly of bustard, and two small human figures in direct association with animals. The greater range of zoological species is of note and may indicate an ameliorating climate. A less pleasing feature, however valuable for cult, is that some of the animals were reworked to form other species or even unnatural amalgamations.

A straightforward sculptured block is that showing a pair of ibex seemingly confronted, and usually interpreted as fighting (*Ill. 12*). It is hard to judge the original quality of the work as the edges and faces show considerable deterioration, but assuming that the sculptor

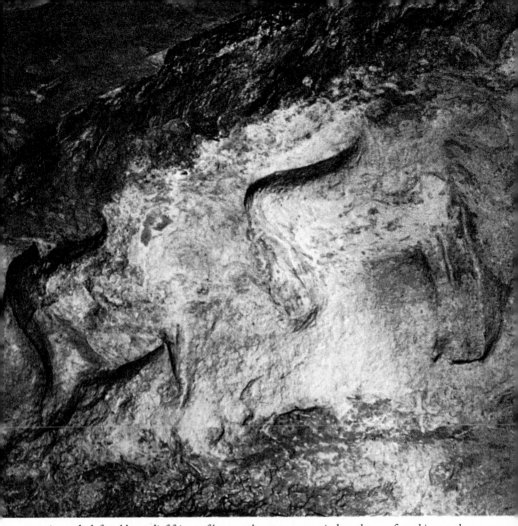

11 A much defaced bas-relief frieze of horses, about 14 metres in length, was found in a rock shelter at Le Cap Blanc. The two illustrated are on the left of the frieze which shows the horses apparently emerging from the rock and then disappearing into it again

had command of his intentions then it should be noted that the two ibex are not at the same level, and that the forelegs are so placed as to give a three-quarter view of the chests. They are not therefore directly confronted, nor are the heads correctly held to show fight. The brows and horns are not engaged, and the necks are not levelled to withstand the shock of butting. This is more likely to represent

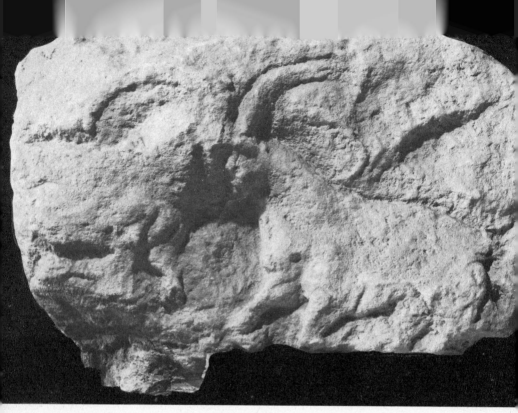

12 A pair of ibexes, facing each other but probably not meant to be fighting, are sculpted on this rather worn block of limestone from Le Roc de Sers

a scene of unsuspecting tranquillity such as would appeal to the hunter. The rake of the horns is quite different in each animal so that opposite sex may be intended. The curved outline seen above the neck of the right-hand animal is apparently an unfinished horn, not part of the completed work, but an original intention to produce backward lying horns as given to the other beast. The usual economy in cutting away stone around the animals has been observed except in the space between them where the whole area has been reduced. The importance of pregnancy in hunted animals is well exemplified by the in-foal mare (*Ill. 13*) foreshadowing a recurrent theme in the painted cave art. Of the reworked pieces, the bison body with pig's head is the most obvious (*Ill. 14*). It has been mentioned that two small human figures are included in the sculpture from Le Roc de Sers. These are not fecundity matrons, but

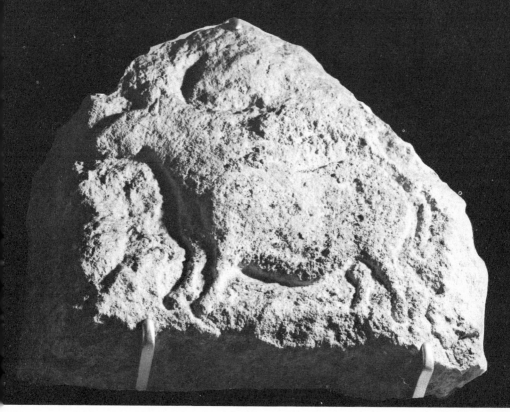

13, 14 Two more sculptured blocks of limestone from Le Roc de Sers show (*above*) an in-foal mare and (*below*) a mare and a bison which has had its head reworked into a pig's head

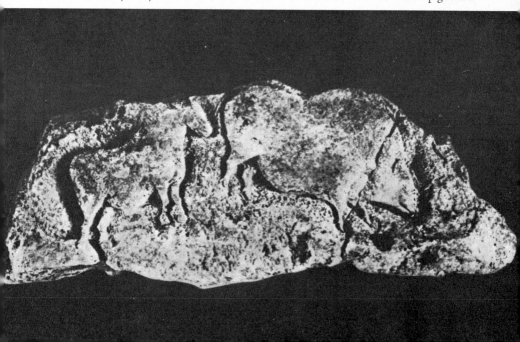

outlines of moving figures situated at either end of a single block. One figure appears to be followed by two horses, and the other, who may be bearing a shaft, is followed by a bull with head lowered, and more probably pawing the ground than actually charging. Is this another ideal hunting situation where the quarry's attention is drawn by lures so that the hunter can get close enough to make sure of his target?

From Laussel to Le Cap Blanc and to Le Roc de Sers it is possible to suggest, for proof is quite lacking, a change of emphasis in the subject matter of this hunter art that carries through to the true parietal art of the deep caves. From the primacy of the sculptured human mother, herself evolved from figurine prototypes, interest has passed to the animal world, and humanity, now often reduced to mere graffiti, only comes in as an occasional adjunct to some particular scene or situation relating to animals. Why this may have happened is a subject too complicated to pursue in a summarizing chapter of the art as such, but at least it may be observed that, once within the caves, the art gives the impression of being directed expressly to the binding of spells on the hunted. Whereas the figurine carvers' art, and some of that in the rock shelters, may be viewed as the blossoming of enlarging human expression, the perception of what most counts, with magical aspects occurring almost as second thoughts, the cave art is more limited and probably more intense in its purpose. Cave art represents one apprehendable stage, at least amongst some communities, in the development of exclusive mystery rites devoted to assurance of a food supply that was obtained by hunting. Cave art being more spectacular has tended to overshadow the kinds of art to which the pages of this chapter have so far been given, but it would in fact appear to have been less significant than these others in the general awakening in the human mind of artistic impulses.

Before entering the caves, brief reference must be made to the existence of two-dimensional linear drawings of animals engraved on smooth pebble surfaces, on pieces of flat stone, or on slips of antler and bone. These have been found in habitation deposits in the south-west of France in late Gravettian contexts, and in much

greater quantities in those of the ensuing Magdalenian Culture. There was a parallel, though as yet less well known, practice in Moravia, again associated with the late Gravettian. Many of these pieces give the impression of having been exercises in drawing, and some were perhaps explanatory of animal recognition and behaviour. It cannot be said that this mode of art led directly to engraving and colouring within caves, but it is certainly of the same general content and style, and most of it must be contemporary with true cave art. A second, and very new factor in the consideration of the origins and diffusion of cave art is that while it had been generally supposed to have been a unique development amongst the Advanced Palaeolithic hunters of the Franco-Cantabrian region, it has now been confirmed as existing in a cave in the southern Urals. In the Krapova cave, Choulgan-Tach, O. N. Bader has discovered paintings of mammoth, rhinoceros, bison, and horse, as well as abstract compositions. Only preliminary reports are so far available, but the question of the origins of cave painting must necessarily now stand out afresh. As between Franco-Cantabria, and the Urals, speculation will be directed as to whether cave art could have been borne from one to the other, whether it was a parallel invention in each, or whether both spring from some common origin not on cave walls but providing surfaces for display; perhaps even skins or tent coverings.

Attention must now be confined to the cave art of south-western France, the Pyrenees, and north-western Spain, commonly known in archaeology as the Franco-Cantabrian region. Some pieces of 'mobiliary art', cut on stone, antler and bone, will also bear witness to a source of information on the hunters' activities that has yet much to reveal. While the first recognition of Palaeolithic art in the form of engravings on stone and bone goes back to 1860, and to the work of Edouard Lartet in Ariège, it was not until 1879 that painted cave art was first recognized, and this in the famous cave at Altamira. The authenticity of Altamira was for some time contested, but Emile Rivière's excavation of the sealed entrance to the cave of La Mouthe, in 1895, and the revelations of paintings therein, carried conviction as did the demonstration by Breuil and others in 1901

of the covering by Palaeolithic deposits of paintings in the cave of Pair-non-Pair. There are now some ninety known caves with parietal art. The most important factor in establishing the authenticity of the parietal art was of course the representation of a fauna long extinct, but identical with that represented in occupation deposits and in the mobiliary art. Some of this fauna was moreover proper to a glacial or tundra environment, and of species not possibly known to nineteenth-century forgers. From the beginning of the twentieth century, the Abbé Henri Breuil took the most active and eminent part in the study of cave art, and he produced a great series of monographs and other studies on particular caves, and on general questions of style and chronology. It is no diminution of his work to say that many fundamental questions are still open today, and that current research, especially in France, naturally advancing on the groundwork of earlier labours, has been bound to call in question the validity of Breuil's scheme of art styles just as the advent of scientific skills has materially altered concepts of chronology. It is well to consider even briefly some of the difficulties in attempting to establish a sequence of styles in cave art. First, there is the doubtfulness of relationship with occupation deposits as was noted with the rock shelters. A standard of height above ground-level cannot be shown to exist; some were executed on rock immediately above natural cave floor-level, others so high on walls and roof that some kind of working platform must have been contrived. Then, as to the technique of execution, there is no as yet apparent separation of methods, and these may include in various combinations engraved lines, painted outlines, dots and in-fill painting in one or more colours with various effects, as well as the use of flat or rounded surfaces, and the incorporation of special features to enhance the subject such as rock cracks and stalagmite. In addition to single paintings and engravings on clear rock surfaces, many paintings and engravings are superimposed. On account of weathering, the interpenetration of colours, and the difficulty of deciding the order of intersection of engraved lines, the sequence of work can seldom be ascertained with certainty. Nor of course can the lapse of time between one design and those overlying be deter-

mined just by sight. The multiple involvement of techniques and manner is such that present opinion tends to regard the recognition of styles, as normally expected in historical arts, to be misleading, and it is suspected that in the majority of cases superimpositions were the deliberate work of artists who had already sketched out, or even completed the theme of the underlying subject. The recent and proceeding researches of Annette Laming and André Leroi-Gourhan also show that important results are to be obtained through the study, amongst other things, of the distribution and relationship of animal and abstract subjects within individual caves, and the repetition of combinations from one cave to another. The elucidation of cave art is thus seen to depend to a great degree on a fuller understanding of ritual needs, whatever the precise complexion of intent, and this must be something yet to be beaten out quite apart from visual evaluations, or enjoyment, of the art encountered as such. One thing is at least certain, that Franco-Cantabrian cave art is a single phenomenon, however long or short in terms of millennia, and in the following pages it is thought best to appreciate a sample of this art, drawn from some two dozen caves, without further attempting hypothetical classification. A beginning, not necessarily chronological, is made with a painted scene in the great cave of Pech Merle, Lot (*Ill. 15*). This introduces two horses moving in opposite directions, and with overlapping hindquarters. They are not strictly back to back as often described, nor do they stand at the same level; both points that recall Le Cap Blanc (*cf. Ill. 11*). The outline of the bodies is executed in a broad black line giving full effect to the characteristic curves of neck, back and rump. The heads, and shoulders, are filled in black, and the heads are portrayed in a truly schematic way that conveys the essential impression received on looking at a small horse from a distance with its head partly turned the other way. The 'transparency' of the nearer horse, so that a hind leg of the other can be seen, is an example of a practice frequently to be met. This is not superimposition in the ordinary way, but allowance for knowledge of the whole animal in compositions where one may obscure another. The low set of the tails of these horses, and the amount of hair indicated, may speak for a western

31

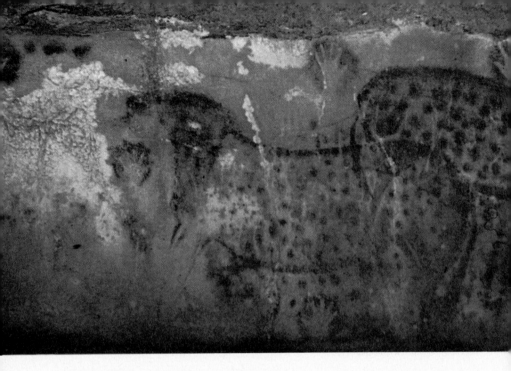

15 The two horses illustrated, from Pech Merle, are often referred to as being back to back, but in fact they are moving in opposite directions and on different levels. The dots in black and red are believed to have some magical significance as also are the hands

horse type that ranged northward from moderately temperate wood-land environment. On the other hand, the nearer horse's mane appears to be short and stiff yet the black paint comes down to cover the shoulders, as if intending to show at the same time long flowing hair. It seems possible that this is an instance of an artist accustomed to the shortmaned steppe horse, of easterly dispersion, accommodating his practice to the representation of a less familiar variant. One which would undoubtedly have been better quarry in terms of meat supply. The black dots over the bodies evidently are not meant to represent a spotted coat for they extend below each animal and around the head of that to the right. Some of these external dots are red. From their widespread occurrence in connection with animals of various kinds, dots are now believed to have had magical significance as must also the human hands that are so well exemplified here at Pech Merle, and elsewhere. The hands (*Ill. 15*) are of the

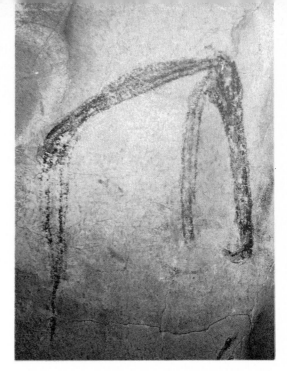

16, 17 Animal and meander drawings in colour done with red clay on the rock surface occur at the cave of La Baume Latrone. Shown here *(above right)* is a schematically outlined elephant or mammoth and *(below)* examples of abstract finger drawings

negative type, *i.e.* the hand was placed on the rock surface and the colour was applied or blown around it. Hands actually coloured are much rarer. Here, both right and left hands are represented, and appear to be complete as to fingers, except for the hand farthest to the left of the picture. Mutilated fingers, missing one or more joints, are quite common.

Interesting less for execution than for content is an area on the roof of the main hall in Pech Merle where damp clay has been used as a surface for drawings smeared on with the fingertips (*Ill. 18*). Within the maze of lines can be made out a mammoth with typical great curved tusks, and two very interesting female figures which witness tenuous links with the figurine and rock-shelter mothers. Both are side views, and the figures are bent forward showing pendulous breasts. One has no proper head, but the other has a head outline and peak of hair reminiscent of Laussel. This seems to be as far as the fecundity mothers ever got into the caves in the traditional guise of fat body and milk-laden breasts. Thereafter, if they are present in idea, it must be in the form of abstract symbols as Leroi-Gourhan has propounded. The issue is not confused by a pair of quite exceptional sculptures in the cave of La Magdeleine, Tarn, where two reclining figures of normal proportions speak for a directly sensuous evocation special to the initiates of this place. Smeared-on drawings are known from several of the major caves in the Franco-Cantabrian region, and it is possible that they are initial markings to do with the taking over of the caves as centres of cult. Somewhat similar animal and meander drawings (*Ill. 17*), but in colour done with red clay on rock surfaces, are known from the cave of La Baume Latrone, Gard, and these may include an elephant species of temperate habitat in contrast to the mammoth (*Ill. 16*).

The mammoth (*Ill. 19*) is one of several fine outline paintings in black of this great animal at Pech Merle, and shows well the artist's preoccupation with essential features of recognition in the field: the distinctive domed head and slope of the back. The trunk and tusks are merely indicated, and the feet not at all. There is a group of short, broad, red strokes over the forepart of this mammoth.

18 In the cave of Pech Merle an area of damp clay on the roof of the main hall was used as a surface for smeared finger drawings. Hidden in the maze of lines are a mammoth with its curved tusks (bottom right) and two female figures, on the left

Another of the great beasts tolerant of low temperatures was the woolly rhinoceros. It is rarely depicted in cave art though it does occur at Pech Merle, but this example comes from the cave of Les Combarelles, Dordogne, and is a good example of engraving without colour (*Ill. 20*). The rhinoceros was presumably to be reckoned as a danger, not a quarry, but as much to be controlled by the magic of the caves as any other beast. It will be remembered that it was represented in the plastic art of the Gravettians in Moravia.

Of the animals represented in cave art that betoken an improving climate, but an attachment to open plains rather than encroaching forest, the bison was of great significance to Advanced Palaeolithic hunters. Numerically its representation comes second only to the horse although this may be fortuitous. Not to forget the mobiliary art already mentioned, a bison from the Magdelenian deposits at

35

19–21 Three different techniques of illustrating animals are shown here. The mammoth (*left*), from Pech Merle, is in black outline, whereas the rhinoceros head (*opposite above*), from Les Combarelles, is engraved and has a deer's head superimposed upon it. Two confronted bison (*below*) are drawn in outline and then shaded in black

Laugerie Basse, Dordogne, is first shown (*Ill. 22*). This is an example of that aspect of the hunter's art concerned with straightforward views of animals done rather to illustrate its known features than to convey a characteristic appearance in the chase. The unnatural position of the hooves should be noticed, and this point will be taken up a little later. The bison deeply engraved on the wall in the cave at La Grèze, Dordogne, is some 60 cm. long (*Ill. 23*) and thus some six times larger than the pebble drawing from Laugerie Basse. It presents much the same profile, but only one fore and hind leg is shown, and the head is lowered. A point of special interest centres on the horns. Is this bison facing ahead, so that only one horn and that a proportionally heavy one, is seen, or should the lesser horn-like outline to the right be admitted with the deduction that either a different arrangement was first sketched, or that, both horns taken together, there is here an example of 'twisted perspective' (*tordue*)? This term defines a practice in many primitive and peasant arts of showing pairs of horns, ears, even legs, in frontal view when the rest of the animal is presented laterally. Although widespread, and found too in children's art, twisted perspective is not a consistent element, and certainly not in Franco-Cantabrian cave art. The real question here is whether intentional twisted perspective was employed in cave art or whether some horn arrangements

36

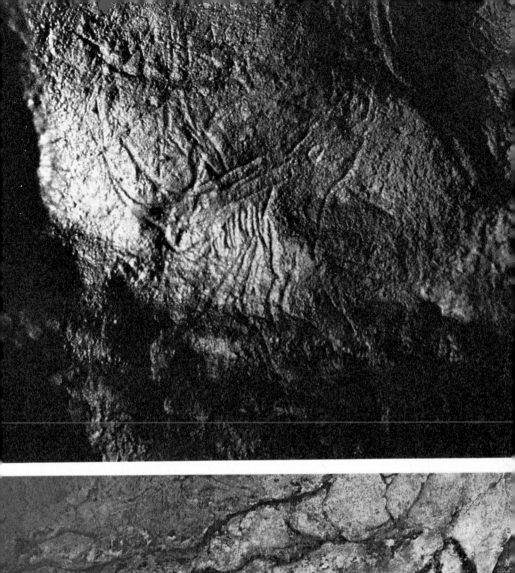
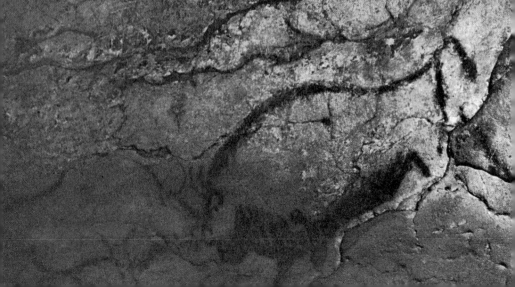

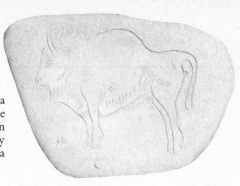

22 An engraving of a bison on a pebble from the site of Laugerie Basse. This may have been an example of an artist's preparatory sketch before the execution of a painting in one of the caves

look like it because there were difficulties of foreshortening to be overcome. It has to be remembered that wild animals open to attack by predators are much more alert than modern domestic cattle so that their heads were most normally seen moving from one quarter to another to cover the ground with each separate eye. Horns, which are rarely identical or quite symmetrical in any pair, curve both forwards and sideways so that at medium distance it is not easy to distinguish which is the nearer horn. This last factor can be tested even with a modern cattle herd. Frequently a direct impression of twisted perspective can be observed. There is no problem about the horns in the black painted bison from the cave of Le Portel, Ariège (*Ill. 21*). Here, however, may be an example of repetition work separated by no great length of time. The bison on the left is a smaller, and more lightly drawn beast than that to the right which is most effectively outlined and shaded in heavy black. A further view of this rock surface to the left would show another, even more powerfully executed, bison facing left, and these together appear to form a small frieze in which the fainter bison stands as part of the background. This small bison appears to be an in-calf cow; the sex of the other two is uncertain. Le Portel is one of the caves in which parietal art underlying stalagmite can be demonstrated. One of the finest treatments of bison is found at Lascaux, Dordogne, in a pair that reveal an artist who was both a good naturalist, and a master of his craft (*Ill. 24*). This pair of bull bison appear in three-quarter view with attention to perspective, and to the visual overlapping of their rumps so that the hindmost is genuinely obscured. The legs are correctly disposed, and the whole effect is that the two bulls are meeting some danger to the herd.

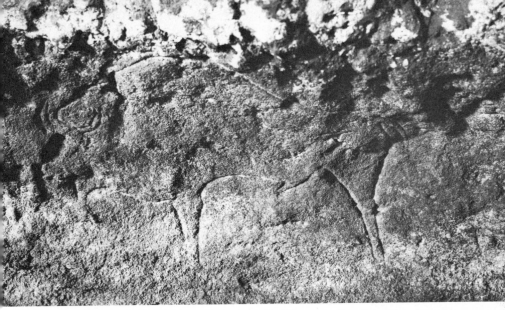

23 The bison (*above*) is deeply engraved on the wall of the cave of La Grèze. It is debatable whether or not the horns are an example of twisted perspective, or the angle shown is due to the artistic problem of foreshortening

24 Two bull bison from the cave of Lascaux—one of the finest examples showing true attention to the problems of perspective in this three-quarter view. There is an appreciation of strength and agility in this painting in the way in which the two bison stand, as if posted to meet some danger to the herd

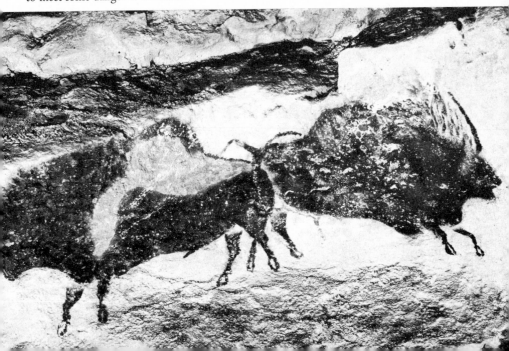

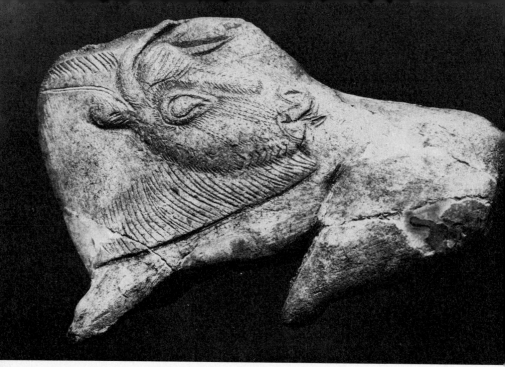

25 A study of a bison in a moment of off-guardedness is caught in this carving in reindeer antler from the cave of La Madeleine. As the animal turns its head to lick its flank, the artist has shown his expertise in completely overcoming the problem of perspective presented by the horns

This painting may be an appreciation of the strength and agility embodied in such a situation, but it is possible that in so deploying themselves to fend off predators they exposed themselves to the special ruses of man. These bison are painted overall in black with the exception of a red patch on the left hand bull. That this represents the process of early summer change of coat is probably correct. There must also be moments of off-guardedness, and one is exemplified in the bison (*Ill. 25*) carved in reindeer antler from the Magdelenian deposits at La Madeleine, Dordogne; two separate names. The beast is licking its flank. It is an altogether admirable piece of carving, and there is no trouble about the correct rendering of the horns. Another finely executed returned head is that of a reindeer engraved on a piece of reindeer antler from Lorthet, Hautes-Pyrénées (*Ill. 26*). The salmon and diamond shaped marks are thought to be full of fertility symbolism, and as the reindeer,

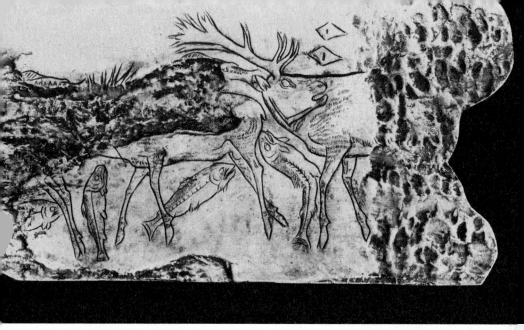

26 Another study of an animal with returned head is seen in this engraving of a reindeer on a piece of reindeer antler from Lorthet. The animal is here accompanied by salmon and diamond shaped marks, possibly fertility symbols. It has been suggested that as the reindeer's mouth is open, it may be calling to its calf

looking backward, has its mouth open it may be calling its calf. The competent drawing of beasts and fish should be noted, and especially the treatment of fur and scales. This is a photographic expansion of a carving done on a cylindrical piece of antler, always a very tough substance. The tools for this work are well known, and consist of pieces of flint so chipped as to produce sturdy but graver-like points.

As with the bison from Laugerie Basse, and other animals yet to be seen on cave walls, the Lorthet reindeer display an unrealistic position of the hooves. In brief it may be said that where hooves are depicted in detail, the animal appears to be standing on their tips, and sometimes a form of twisted perspective is involved showing the central division of the hoof. It is certain that a hunter stalking an animal is not concerned with its feet. This kind of depiction must rest therefore on other information, and in this kind of detail it 41

must come from the observation of animals lying on the ground with their feet stretched out in death. This is not to say that the drawings and paintings of all such animals are of dead ones, although some few by virtue of additional features such as raised tail and up-thrown head, do show slaughtered animals. The bison painted in strong black outline in the great cave at Niaux, Ariège, do show this tendency of the feet, but not so emphatically. A special interest of the group of which this bison is one (*Ill. 27*) is their arrangement in two roughly parallel and vertical columns which suggest some formal purpose although each animal appears as an isolated subject. This bringing together of single representations may point to the development of frieze composition, but it may also hint at the grouping of animal pictures on skins at open-air gatherings. It seems that all in this group at Niaux are cow bison. The arrows marked on some have given rise to different interpretations of ritual intent. It has been said that they imply wish-fulfilment of the hunt to be made, or that they are not functional arrows but fertility symbols. An interesting suggestion is that animals so marked had already been killed and that this was compensatory ritual towards the giving back of life.

Altamira has already been mentioned as the first cave in which Palaeolithic paintings were recognized. It is more famous for the striking quality of these paintings, and especially for those concentrated on the ceiling in a hall to the left inside the entrance. Elsewhere, in deeper galleries, there are single colour paintings, engravings and smear drawings. The ceiling displays polychrome paintings of some twenty-five animals, mostly bison. Use was made of protruding lumps of rock to form the bodies of many of the bison, and individual sizes range between four and six feet. Some engraving was employed especially for the legs and feet, but heavy black paint was used for outlines, horns, hair, and feet, and the bodies were painted over in wash varying from reds to browns. The bison are shown in two positions: standing (*Ill. 28*), or crouched, unsupported by the legs (*Ill. 29*). Taken by itself, the first bison is to be admired for the high quality of its portrayal, but its stance is no different from the general run of bison seen in full side view elsewhere in

cave art. The other bison poses some very difficult questions. The quality of painting is the same; it is the posture of the animal that is so unexpected. There are four bison in this posture on the ceiling. They are all close together and near the painting of a large calf bison which is clearly meant to be dead. The four grown bison in question show not only lowered or returned heads, and tucked in legs, but their tails are peculiarly upturned with outstanding hairs quite different from the tails of the standing bison. The dead calf's tail is also painted in this manner. These four bison have been variously described as charging, leaping, sleeping, or even calving, but such explanations would demand a complete departure from the kind of observation, and portrayal of animals, normal in cave art.

27 Painted in strong black outline this bison from Niaux is pierced by several arrows. It is not absolutely certain if this is indicative of wish-fulfilment or, alternatively, that this manner of depiction was part of a compensatory ritual towards the giving back of life

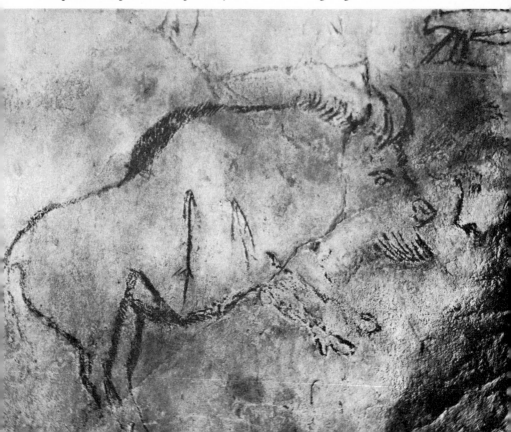

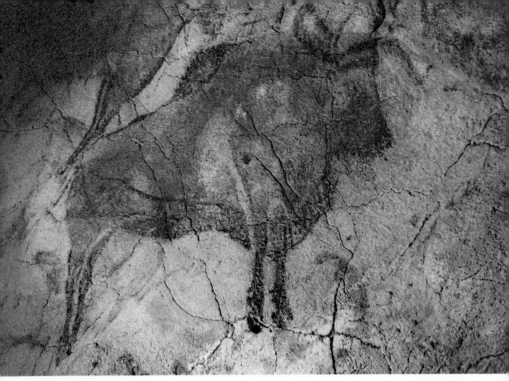

28, 29 One of the many polychrome bison painted on the ceiling of the cave of Altamira, this specimen, painted in red with a black outline, is typical in its stance of a large number of those depicted in full side view. The collapsed bison (*below*), also from Altamira, is one of four in this posture

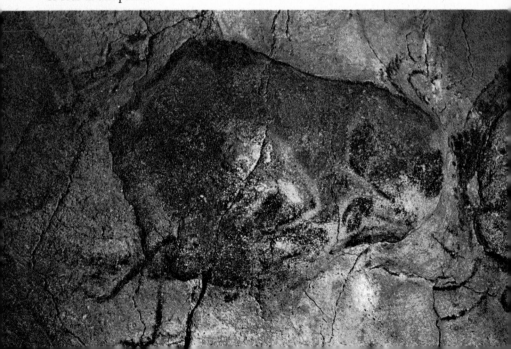

30 Another bison from Marsoulas, is represented in a completely different style, with a dotted technique for the body and only the head in line. The contracted position, together with the faint outline of the face, suggests that the bison is seen from the rear left, and not in full side view

These bison must surely be understood to be collapsed on the ground, and in distress if not dead. The position of the heads and tails is especially important, as also the amount of underbody shown. One should compare illustrations of dead bison in hunts by American Plains Indians of a century or more ago. Prior, of course, to obtaining the horse, the Plains Indians were in all essentials Stone Age hunters. Nor do bison, or any other bovids, drop their calves other than when standing or walking. If any case exists for intimation in cave art of calving bison it is to be found amongst standing cows with exceptionally high held tails. Thanks to drawings of the whole ceiling made by the Abbé Breuil, it is possible to contemplate this concentration of animals as a whole. It has until recently been generally laid down that composition did not enter the cave artists mind so that every animal was an isolated figure. This has now been challenged on various grounds, especially by the younger French scholars already mentioned, and the present writer is impressed by

45

the case for the Altamira ceiling being one grand design representing an ideal hunting scene, whether actually achieved or to be wished for. Briefly, the ceiling shows a small herd of bison of which some have been stricken, and the remainder stand facing outwards towards the danger. Coming in towards the bison are two wild-boar, a hind probably of red deer, and a young horse. These represent chance animals put up by the stealthy encirclement of the hunters, and useful in constricting the bison's movement as well no doubt in providing additional quarry. There are traces of underlying sketches which if not connected with this theme at least indicate the supposed efficacy of this ceiling. But at all events, here in the cave of Altamira is witnessed one of the grandest expressions of cave art brought to its peak in a period of optimum climatic conditions before the final cold onset forced the withdrawal of the bison herds, and led to the break-up of the hunters' way of life.

Two further illustrations of bison are shown to exemplify points of technique. First, from the cave of Castillo, Santander, a bison of which the forepart is painted, and the hind quarters formed by slight modification of the shape of the natural rock (*Ill. 31*). Castillo is important also for displays of hands, abstract designs, and for the only known example of a polychrome painted collapsed bison other than those at Altamira. The bison (*Ill. 30*) from the cave of Marsoulas, Dordogne, is painted entirely in red short strokes and dots except for the horns, face line, and small patch on the shoulder, which are in black and brown. This appears to be the outcome of a technique of simple outline in dots, to be shown later, but its relationship to the application of magical dots is unclear. The contracted appearance of this bison with mere indication of face line suggests its presentation from rear left rather than full side view.

As an interlude from the discussion of animals in cave art, three illustrations of abstract designs are here included. No attempt to explain them is necessary in terms of art if, as seems probable, their presence and form were ritually conditioned. Nevertheless they have pleasing qualities in shape and colour mainly in red and black. Here are shown examples from Altamira (*Ill. 34*), Castillo (*Ill. 35*) and La Mouthe, Dordogne (*Ill. 36*). Leroi-Gourhan's analysis seems

46

31 At Castillo, the hind quarters of this bison are formed by a slight modification of the natural rock while its forepart is painted

conclusive that no abstract design however 'tectiform' represents either a trap or a hut. Apart from direct connection with animal paintings, he has shown that some types of symbol mark the beginning and end of areas of painted rock within caves.

47

32 This horse from Font de Gaume is shown in thick black outline and slightly in front of it is the rear of another horse partly embodying the shape of a stalagmite. They appear to form a section of frieze similar to that already seen at Le Cap Blanc (*Ill. 11*)

34–36 Three abstract paintings, respectively from Altamira, Castillo and La Mouthe, show a different aspect of cave art. The colours are mainly red and black. Opinion nowadays favours the theory that they have some association with the animal paintings and that they do not represent traps or huts, as has often been suggested

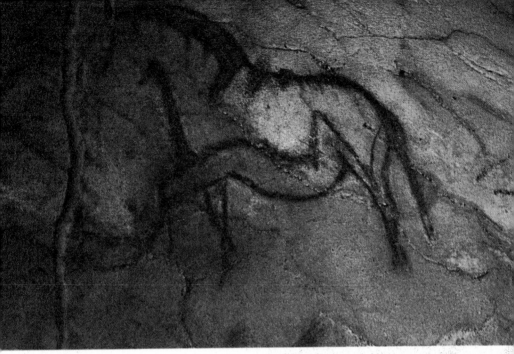

33 Generally accepted as one of the most successful animal drawings in cave art, the mare from Le Portel conveys a sense of motion even to the extent of the swing of the tail and the complex movement of the feet. It is painted in thick black outline

37 The artist of the engraving of a horse at Hornos de la Peña has caught the pose of the animal, tense and alert as it is brought up short and pricks its ears, as something engages its attention

Two species within the repertoire of cave art animals are of special interest in that they are the ancestors of domestic breeds: the horse and the ox. Some words have already been written about horses in connection with a pair at Pech Merle (*cf. Ill. 15*), and it must be emphasized that although some modifications were developing due to differences in habitat and food supply, the migrational range of horses was very great, and the interpenetration of feeding grounds especially in summer would have been considerable. For these reasons it is valueless to attempt to pronounce on each Palaeolithic illustration of a horse in terms of types more clearly developed in post-glacial times, but occasionally certain incipient characteristics seem to have been caught, and there may have been special problems for the artist if he saw different herds at different seasons. It is already clear that he drew on knowledge mentally stored, and

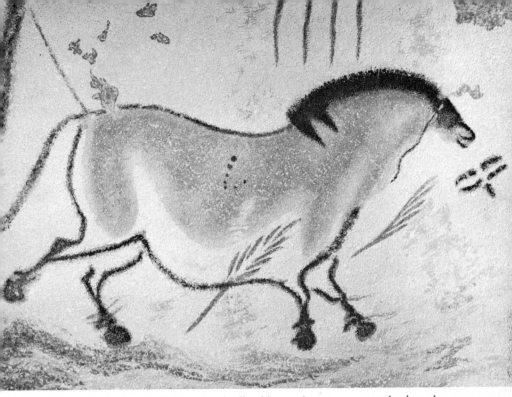

38 Often referred to as the 'Chinese' or 'Yellow' horse, this young mustard coloured mare at Lascaux is carefully executed with knowledge gained from the observation of horses and their changing coats at different times of the year

not only on vision of individual scenes. The horse (*Ill. 37*) from Hornos de la Peña, Santander, is a good example of engraving on rock, and of one characteristic horse stance: having been brought up short with ears pricked, looking at something that has engaged its attention, a moment ideal for the hunter's aim. The painting in thick black outline, in the cave of Font de Gaume, Dordogne, shows a whole horse, and just in front of it the hindquarters of another partly embodying the shape of the stalagmite (*Ill. 32*). There is no evidence to believe that this is a stallion following a mare. Both are probably mares, and form a fragment of frieze-like arrangement already familiar. The mare (*Ill. 33*) from the cave of Le Portel, Ariège, is acclaimed as one of the most successful animal drawings in cave art. Black paint is employed, and it is uncertain if the work was meant to be further completed, but the freedom of

51

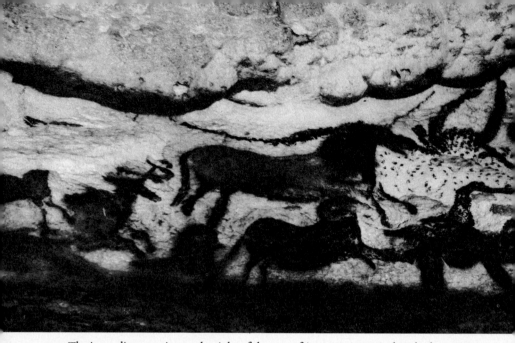

39 The immediate reaction to the sight of the great frieze at Lascaux is that the horses seem rather strange, short-legged and tubby. Yet all are carefully drawn with differentiations between them and they are not stereotyped. The biological groups of foals, yearlings and

line and sense of movement convey all the essential contours and action, even to the swing of the tail, as they would have been absorbed by the artist in the field. The use of a few crossing strokes for the lower legs sufficiently indicate the complex movement of the feet. Other points might be appreciated, but this is a well-proportioned horse, and contrasts in this respect with the horses painted in the famous cave at Lascaux, Dordogne. These latter (*Ill. 39*) are remarkable for their generally tubby appearance. The shortness of the legs, and occasional extreme length of the back, indicate a certain stylism, but the heads, taking the horses in the cave as a whole, vary a good deal and are carefully executed suggesting real knowledge not the repetition of a formal concept. One of the great interests of the horse paintings at Lascaux is that biological groups were envisaged; foals, yearlings, and older horses together with appropriate head forms and colour of coat. In this illustration, a horse family gallops across a rock surface already occupied by two great horned cattle (aurochs, or *Bos primigenius*)

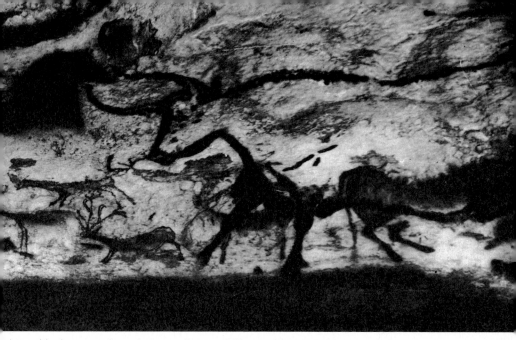

older horses are brought out in the use of the appropriate head forms and coats. The scene is rather mixed, two aurochs have intruded upon a group of frightened deer and the family of horses gallop across the rock-face

who had intruded on a group of slender red deer. The horses are painted with black outline and points, with red to brown bodies, the cattle are outlined in heavy black against the light limestone surface likely to have been an appropriate colour, and the deer are in light brown with thin black or red outline. A particularly engaging equine at Lascaux is the young mustard coloured mare, sometimes misleadingly called 'the Chinese horse' (*Ill. 38*).

The aurochs, remarkable for its great size and horn span, was the original wild ox of Eurasia, its natural habitat was open woodland, and it is still a matter of opinion if variants existed before the end of the Quaternary period. Problems of relative scale add to the difficulties of deciding the evidence at Lascaux though it is possible, as with the horses, that a smaller variant adapted to more open country did exist. On the whole variations in painting based on age and sex account best, as Laming has stated, for the differences in colour and horn shape seen at Lascaux, and no doubt elsewhere. It will be understood that in addition to seasonal migration, actual

changes in climate enlarged or restricted the movement of all the food animals pursued by Advanced Palaeolithic hunters. From as far north as modern Belgium comes the engraved sandstone block (*Ill. 40*) from Magdelenian deposits in the cave of Trou de Chaleux, Namur. It is a fine study especially of the head, and profile of the back, and the fore-hooves seem properly related to the act of walking. The outline of a stag is to be seen in the left background; a conjunction just noted in a frieze at Lascaux perhaps intending a normal ecological relationship. An outline drawing in red of a very alert aurochs comes from Pech Merle, Lot. This is a leading example of alleged 'twisted perspective', but the artist surely intended to show mainly the back of the head so that the horns are correctly viewed from behind, and only a little of the line of the face is included (*Ill. 43*).

Deer which have continued to be an object of pursuit not yet to the point of extinction are numerous in cave art, and the species is mainly red deer (*Cervus elaphus*) when amongst other temperate fauna. Simple black outline deer are exemplified in the cave of Chimeneas, Santander, (*Ill. 41*), and there is a red outline deer at Covalanas, Santander, painted in the dotted technique (*Ill. 45*) as

40 A sandstone block from Trou de Chaleux in Belgium is engraved with an aurochs, or wild ox. It is a very fine study, particularly of the forepart, and the perspective of the horns and raised right foreleg is well understood

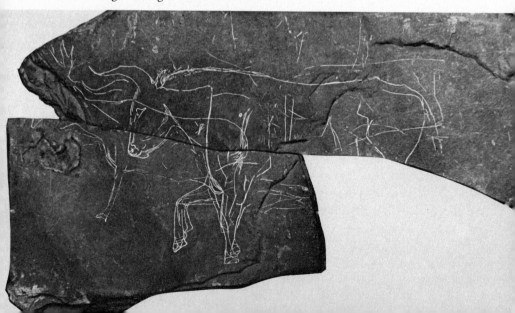

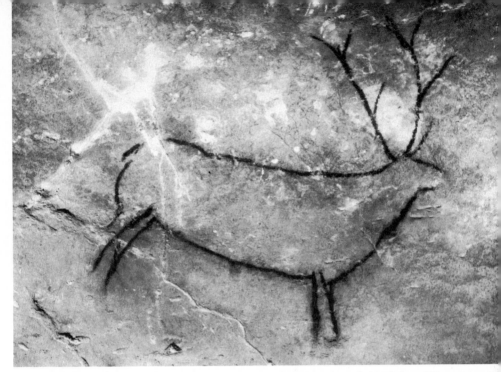

41 A deer in black outline at Chimeneas shows a great economy and simplicity of line

are most of the other deer and horses in that cave. The antlers are not well preserved, and the head seems unduly long, but it is outstretched and lowered as if grazing. The rear part of the back runs along a natural edge of rock which turns down to form the rump and tail. The opportunity to take advantage of rock or stalagmite, suggesting animal shapes, was a widespread feature in conjunction with paint. One of the finest studies of deer is of course the hind, already mentioned, in the ceiling composition at Altamira where its outline is engraved and painted in black, and the body in-filled in shades of pale brown to red (*Ill. 44*). In the great cave of Font de Gaume, Dordogne, is a painting of two reindeer best known from restored illustrations by the Abbé Breuil, but now sadly faded (*Ill. 42*). These reindeer were engraved and black painted in outline, and in-filled in shades of red in a fine polychrome style. The characteristic line of the back and sweep of the antlers of the standing animal, and parts of the red body of the sitting female to whose head the other reaches 55

42, 43 The two rein-
deer in the cave of
Font de Gaume
(*above*) are now sadly
faded but retain some
of their fine poly-
chrome style. Parti-
cularly pleasing is the
manner in which the
head of the standing
deer reaches down to
the sitting female.
Ill. 43 (right), an
aurochs at Pech
Merle, is a leading
example of so-called
'twisted perspective',
but in all probability
merely shows the
back of the head of
the animal so that the
horns are viewed cor-
rectly as seen from
behind

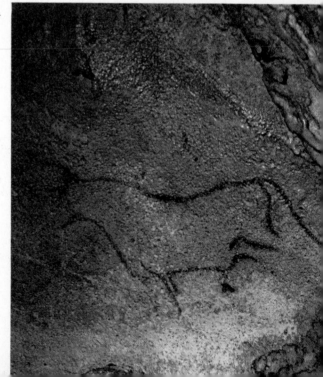

44–46 One of the finest studies of a deer is that from the ceiling at Altamira. Its outline has been engraved and painted in black and its body in-filled in shades of pale brown to red. The deer from Covalanas (*centre below*) is painted in a red dotted technique (*cf. Ill. 30*) and part of its back and hindquarters are formed by the natural shape of the rock. *Ill. 46* is an interesting example of proof of the relative age of the cave paintings. It shows an ibex at Cougnac, outlined in red, that is sealed beneath a sheet of shimmering stalagmite

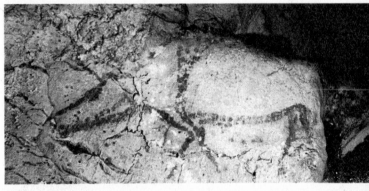

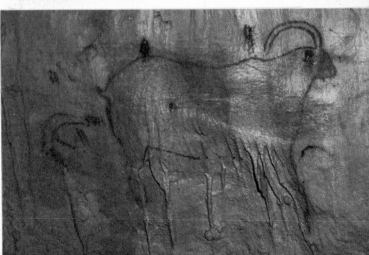

down, can still be traced. This photograph conveys well the texture of rock and partly seen animal which is an integral part of the atmosphere of the caves, and all these paintings can only have been viewed by their creators by the uncertain and flickering light of small fat-burning lamps of a sort found abandoned on the cave floors. Finally, amongst edible quadrupeds, should be mentioned the graceful ibex (*Capra ibex*) of which there are many engravings and paintings. This one (*Ill. 46*) is outlined in red and is now seen beneath a glittering sheet of clear stalagmite in the cave at Cougnac, Dordogne. Fish are rare in cave art, painted or engraved. Perhaps the finest example is the salmon carved on the roof of the small cave known as La Grotte du Poisson, Gorge d'Enfer, Dordogne, and which may be related more closely to the style of the rock-shelters than of the deep caves (*Ill. 47*). The fish is about three feet long, and the digestive tract is outlined in a way not unknown amongst primitive artists of more recent times. The cut frame is due to a modern attempt to remove the carving for unworthy commercial ends.

47 Fish are rare in cave art (*cf. Ill. 26*). The example shown here is of a salmon or trout engraved on the roof of the small cave known as La Grotte du Poisson

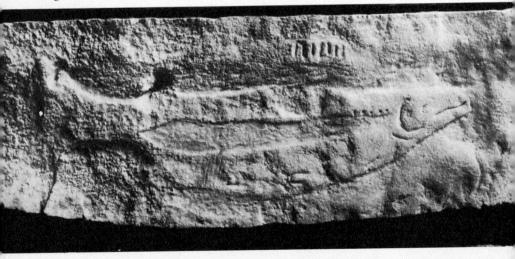

48 An extinct type of feline, generally referred to as a 'cave-lion' from the cave of Les Combarelles ▶

49 A fine engraving of a bear from Les Combarelles has captured its characteristic shambling walk and must be based on recurrent close observation

The natural predators, and perhaps contenders for cave space, are represented in Franco-Cantabrian cave and mobiliary art. This also was an early item in Moravia (*cf. Ill. 2*), and in the west such representations always show marks of one kind or another suggesting death and destruction for these creatures. They are not the less better drawn or carved so as to capture here too their whole reality. The large feline (*Ill. 48*) from Les Combarelles, Dordogne, is an extinct type, but may best be described as a 'cave-lion'. A finely engraved brown bear (*Ill. 49*) comes from the same cave, and its characteristic walk is most successfully observed. Note again the defacing strokes. A carving in reindeer antler from deposits in the cave at Isturitz, Basses Pyrénées, is of another cave-lion in a defiant attitude but under the powerful magic of well-drilled holes and weapons incised on the flanks (*Ill. 52*). There are no cave pictures of wolf or

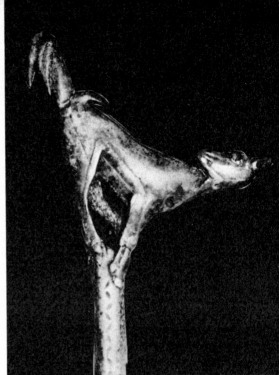

50–51 A group of *batons* from Le Placard (*left*) show typical examples of the type with ornamented heads that include a fox, a bird and an ibex. The antler spear-thrower (*right*) from Mas d'Azil is carved with a young ibex and has a bird terminal, towards which the ibex turns its head. Leaves are engraved upon the shaft

52 The cave-lion carved in reindeer antler, from Isturitz (*below*), to judge from the holes drilled through its body and the arrows incised on its flanks, is obviously under magical influence

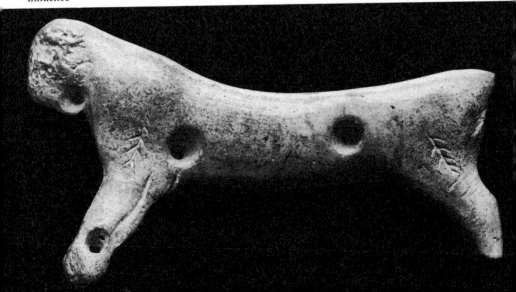

fox, but there is a finely carved head and fore-paws of a fox (*Ill. 50*) on a reindeer antler carved *baton* from deposits in the cave of Le Placard, Charente. This *baton* must stand here for a whole series of finely carved objects of this kind, the true use of which is unknown, but which display animal and plant representations of quality. A related form of carving is found on antler spear-throwers, or pro-pulsors approximately a foot in length, which were strictly utilitarian. The shaft is surmounted by a carefully carved animal, occasionally a bird, against which the butt of the missile would have rested in the act of throwing. A number of these spear-throwers have as their head a carving of a young ibex, perhaps chosen for its skittishness, but, curiously, the head looks back to a pair of birds perching on its own dung (*Ill. 51*). It can be seen that by arranging for a pro-jection beyond the animals hindquarters and the introduction of the birds, a necessary hook effect was provided for the function of spear-throwing. The resultant theme must have been an outcome of that suggestibility which quickly saw the advantage of natural rock shapes in the caves from which to elaborate painted creatures. This spear-thrower comes from deposits in the cave at Mas d'Azil, Ariège, and the leaves outlined on the shaft should not be ignored.

Before concluding this sample of Franco-Cantabrian art, the most discussed phenomenon at Lascaux must be mentioned. This is known as the Dead Man composition and is found on the wall at the bottom of a deep shaft, difficult of access, within the cave (*Ill. 53*). As compared with the general run of cave art, the drawing of the bison is inferior, and the man, and bird on a pole, are quite excep-tional, but that these three items must be taken together as conveying one message is beyond doubt, and valuable evidence in the case for claiming powers of composition in cave art as opposed to the view that the artists were mentally limited to the depiction of single animals. The only certain thing about this scene is that the bison is badly wounded, but whether it still stands, or whether the man is fallen, remains open to argument. Perhaps the bird on its pole, symbol or decoy, best gives a clue. It is generally assumed that this represents a real man, but he is drawn in such a rigid and angular fashion that he is unlike any of the human depictions in cave art

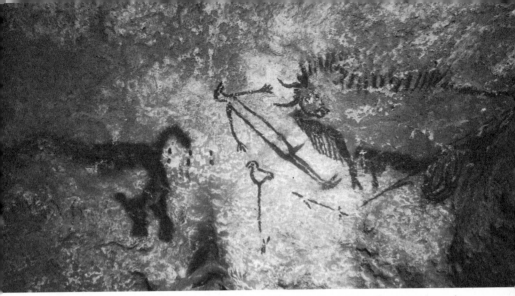

53 The curious composition in the Shaft of the Dead Man at Lascaux has caused much speculation as to its interpretation. Whichever of several interpretations is accepted, the essential point remains, that here is valuable evidence of composition in cave art, opposing the view that the artists were only capable of depicting single animals

however skimpy and indeterminate they may be. They have formed no part in this survey of art for they appertain more to graffiti. There are two principal hypothetical interpretations. One that this scene commemorates the killing of a man by a bison after it had received a deadly wound, the other that this is a ritual enactment, approaching the shamanism of circumpolar peoples of more recent times, to bring about the death of a bison. This seems to be the strongest of the two explanations, but it is also possible to suggest that we see here an enactment of hunting method in which the quarry has its attention drawn to decoys so that it can be assailed at close quarters by spear. It can be seen that the effective spear in this case was delivered from fine quarter, nor can any length of range have been involved. The desirability of strengthening through magic this aspect of the hunt would have been equally cogent. A specially selected patch of brown wall clay was used for the bison's body which is outlined in black. The man and bird are also in black outline, but all contrast in technique with the well-painted rhinoceros in thick black outline seen on the wall close by to the left, facing away from the scene, apparently quite unconnected with it. 63

54–56 Examples of Sicilian cave art have been found since 1950 which may represent a tradition brought from the Franco-Cantabrian zone, possibly by people retreating before adverse climatic conditions. Three examples of this art are illustrated. The engraved deer looking backwards, from the cave of Cala dei Genovesi, Levanzo, is most ably drawn. *Ill. 55*, from the same site, is a red-painted reclining figure with a fan-shaped head. In the Grotta dell'Adaura near Palermo (*Ill. 56*) amongst a number of rather poorly executed engravings is a large single composition of well-drawn humans who appear to be engaged in some ritual activity

The problem of relationship between Franco-Cantabrian cave art and that very recently discovered in a cave in the southern Urals was brought up earlier in this chapter. A small group discovered since 1950 belongs to Sicily. In the cave of Cala dei Genovesi, on the small island of Levanzo, have been found engravings of horse, ox, and deer of which this young animal, looking backwards, is the most ably drawn (*Ill. 54*). There are also rather schematic engravings and paintings of human figures but one red painted reclining figure (*Ill. 55*) certainly recalls the exceptional women, one with a fan-shaped head, carved in the cave of La Magdeleine, Tarn. Remember, too, the fan-shaped head of the ivory carving from Předmostí (*Ill. 3*). In the Grotta dell'Adaura on Monte Pellegrino, near Palermo, have been found engravings of rather poorly executed animals: deer, ox, horse, or ass, but there is a large single composition of well drawn humans who appear to be engaged in some

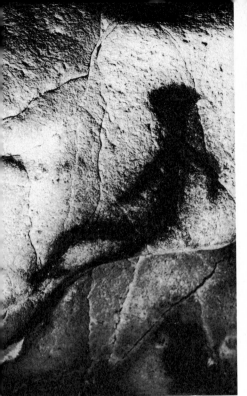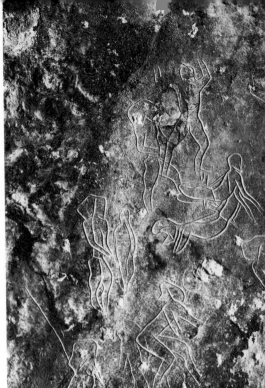

ritual activity (*Ill. 56*). The stooping figures, although not certainly women, somewhat recall the smear drawing pair of very different proportions at Pech Merle (*Ill. 18*). The Sicilian art may represent a tradition brought from the Franco-Cantabrian zone by communities retreating from the final onset of adverse climatic conditions, or it may have been an off-shoot at an earlier period from that, or some unknown, centre. Rock painting, again more in shelters than in deep caves, became a relatively widespread activity in post-glacial times although it is not at all certain that any continuity existed between these later, and less beautiful, paintings and those of the Franco-Cantabrian group. Much of the painted shelter art of Levantine Spain is certainly to be admired, in its way, especially in its magnificent setting above ravines, and it is full of ethnological interest as to scenes with archers, and dancers. The colours used are black, and a wide range of reds. Three examples are

65

57–59 Most of the Mesolithic rock paintings found in Spain are difficult to see; they were painted in red ochres and black in shallow rock shelters and have consequently suffered from weathering and also from vandalism. The examples illustrated are: (*opposite above*) a hunter shooting a leaping ibex, from Remigia; (*opposite below*) an archer carrying his bow and arrows with another figure standing one on either side, from Santolea. *Ill. 59* (*right*) shows a line of deer, presumably being driven by beaters, towards four archers who have already scored several hits amongst the animals

included here. A hunting episode of deer driven towards a line of four archers (*Ill. 59*) at Los Caballos, Valltorta, Castellon, a dramatic shooting of a leaping ibex (*Ill. 57*) at Remigia, Gasulla, in the same province, and an archer supported by two figures (*Ill. 58*) at Santolea, Teruel.

67

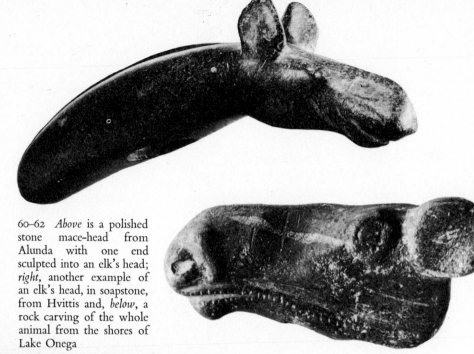

60–62 *Above* is a polished stone mace-head from Alunda with one end sculpted into an elk's head; *right*, another example of an elk's head, in soapstone, from Hvittis and, *below*, a rock carving of the whole animal from the shores of Lake Onega

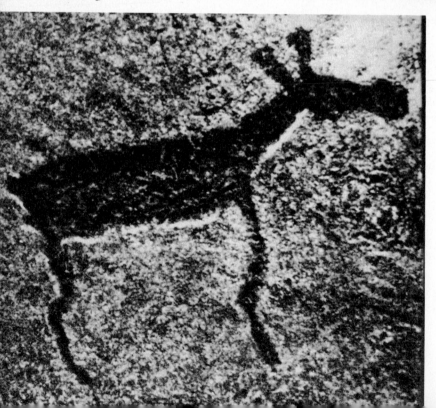

63 These animals, a brown bear from Resen and a silhouette elk head from Egemarke, together with the two shapely beads, are all made of amber. Amber was found on the shores of the Baltic and it was traded widely in prehistoric times. The examples illustrated are fine miniature carvings which show well the skill of artists of the Maglemose Culture in working this difficult substance

A minor art group that might be regarded as more in the tradition of Advanced Palaeolithic mobiliary art is that of the hunter peoples of early post-glacial times in the region of the Baltic and North Seas whose archaeological remains are known as the Maglemose Culture. The art consists chiefly of abstract patterns on objects, and fragments, of antler and bone, but there are occasional sketches of deer, and carvings in the round of which those in amber are the most effective. Apart from the shapely beads in *Ill. 63*, the brown bear from Resen, Jutland, and the silhouette elk head from Egemarke, West Zealand, are also in amber. The Maglemose art is interesting for certain techniques; in particular for ornament in lines of very regular drillings (*bohrornament*) probably made with a small bow-drill, and for patterns done by surface pricking. Engraved ornament in rows or panels of very simple linear motifs are the most common, and are exemplified on the amber bear and elk head.

Of the possible choice of the art of hunter communities still practised in post-glacial, or *neo-thermal*, times, this chapter will end with a short salute to workers in stone and wood, sometimes in amber, who maintained themselves during the third and early second millennia B C in the coniferous forest zone of north-eastern Europe, the Urals, and Siberia. A region beyond the range of possible agriculture where loosely inter-related communities continued the age-old pursuits of hunting, fishing, and fowling. The smooth stark finish of the stone and wood objects is evocative of the great still lakes, forests, and tundra beyond. The elk was the principal great animal in the food economy, and the characteristics of its head are well brought out in the polished stone 'mace-head' from Alunda, Uppland (*Ill. 60*) the most famous piece in this group, in the soapstone carving from Hvittis in Finland (*Ill. 61*), in carved wood from the peat bog site at Gorbunovo in the central Urals (*Ill. 65*), and in the rock carving of the whole animal, one of many, from the shores of Lake Onega (*Ill. 62*). From Gorbunovo also comes the wooden ladle with waterfowl handle (*Ill. 64*), one of several from this and related sites. The perforated stone axe-head from St Andreae in Karelia (*Ill. 66*) has its butt carved as a bear's head, fearsome and menacing. The sitting bear, also stone

64, 65 Two examples of naturalistic wood carving from Gorbunovo in the central Urals are this ladle with a duck-headed handle and the head of an elk

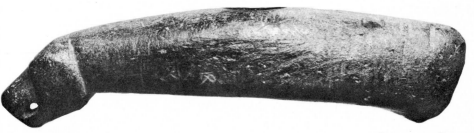

66 The butt of this polished stone axe from St Andreae is cleverly carved into a snarling bear's head

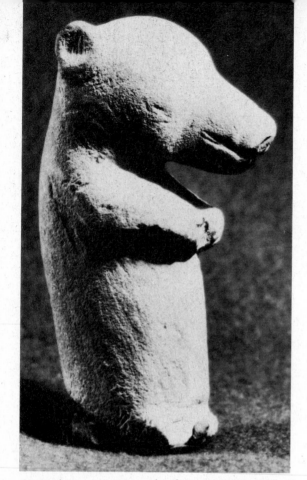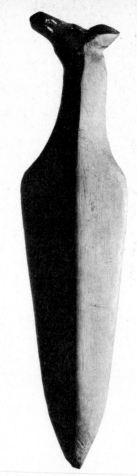

67, 68 An attractive example of stone carving in the round is the little seated bear (*left*) from recent excavations at Samus, Siberia. The slate dagger with an elk-head pommel (*right*) comes from Delbo, Sweden

carved, is the product of close observation, and its purpose was probably amuletic or magical as were the other pieces in line with the traditions of Palaeolithic art. This bear comes from recent excavations by Russian archaeologists at Samus in Siberia (*Ill. 67*). The perforated axe type, apart from the carved butt, and the dagger made of slate with elk head pommel from Delbo, Hälsingland, Sweden (*Ill. 68*), witness in their shapes to contact with peoples living farther to the south already long advanced in the skills of cereal cultivation, and stock raising, and the working of bronze.

The Art of the Cultivators

The emergence of the potter's craft must be a leading theme in the prehistory of art, and while carving in stone and bone could at best only refine on already ancient hunter's techniques, the production of pottery vessels was a unique achievement made possible by markedly different conditions of life and outlook. Until recently it had been supposed that pottery making, viewed as a technological advance, had come rapidly into use along with those fundamental changes in subsistence economy: the cultivation of cereals and the domestication of some animals. This change to a food-producing, or Neolithic, economy is now known to have been much more drawn out than earlier evidence seemed to indicate, and it is clear that many neolithic communities moved far in social and economic complexity, as at Jericho, while innocent of this particular skill. On the other hand, cave-dwellers in northern Iran, who had also begun to domesticate goat or sheep, were smearing basketry with clay, and this may have been one of the introductory steps leading to intentionally fashioned hand-made clay vessels, fire hardened, and later kiln baked. The opportunities for chance observation and experiment around the domestic hearth were always present just as they had been for the modellers of baked clay figurines in Moravia (see p. 12), but clearly these opportunities continued to be permissive, not compulsive. The eventual adoption of pottery making throughout vast areas of the world speaks of course for a growing recognition of its utility, but in the equally vast range of styles it speaks for a creative outlet unconsciously expressive of all those oscillations of change and stagnation, prosperity and catastrophe, that have been the experience of cultural traditions and the peoples who sustained them.

The formative region which saw the beginnings of neolithic ways of life was that of high valleys and uplands lying to the north

73

of the deserts and stretching in a band from south of the Caspian to the Mediterranean coast of Cilicia, and southwards through Syria into Palestine. If the first steps by hunters to improve their food supply was by the capture of young animals, and by protection of high yielding cereal grasses, such processes seem to have begun in this zone in the ninth millennium BC. In the course of the seventh millennium, the first true settled farming communities were coming into existence, and by the middle of the following thousand years such people were widespread, and had crossed into Greece and probably Thrace. The initial development of ceramic art is believed to have taken place towards the north-eastern end of the earliest neolithic zone, in Iran and adjacent parts of Anatolia, and the practice of painting pottery vessels had begun before 5000 BC in Cilicia. The ware was a fine hard-fired fabric with a cream slip and motifs painted in red. The competence of all this pottery as to fabric and firing, shape and decoration, reflects the general well-being of the neolithic polity as it found success in its world of optimum ecological opportunity, and at that stage which led to expansion on the one hand to the urban civilizations and beginnings of written history in the 'Ancient Near East', and on the other to further adventures in colonization towards the European heartland of great temperate forests and rivers, or by sea routes westward to rocky coastlands throughout the Mediterranean.

In seeking out the best of the surviving work of these further neolithic, and entirely prehistoric, explorers, the pre-eminence of the Orient for many centuries to come must be borne in mind. This was the source of their own innovating way of life, and from that quarter percolated, by trade and later emigration, newer ideas in cult, ornament, and practical skills. It would be archaeology rather than art to expound the whole pattern of neolithic Europe in so far as it has yet been discerned, but before passing to particular objects there are two short points to be added. It must not be forgotten that there had continued to exist indigenous peoples of the hunter sort with whom the neolithic colonists might intermix or establish various kinds of reciprocal relations. This could prove an important influence, but equally there is the question of adoption of

69 An elegant footed cup decorated with white on red paint from the earliest permanent settlement at Karanovo in Bulgaria. The ceramic accomplishment displayed in this vessel has its antecedents in the fine wares of Anatolia

one or more elements of the new economy and its skills by native groups. It is not always possible to follow the operation of these factors in the emergence of distinctly European cultures, no less than in analysing particular artefacts, but the tendency to diversification, most clearly exemplified in a proliferation of pottery styles, had already become a European characteristic towards the close of the fourth millennium BC.

A tradition of high ceramic accomplishment was brought into south-eastern Europe by neolithic colonists from Anatolia as is shown by this elegant footed cup from the earliest permanent settlement at Karanovo, near Stara Zagora, on the northern side of the Maritza valley in Bulgaria (*Ill. 69*). The fine red slipped ware with white painted design brings the early pottery at Karanovo within a widespread family of wares known in Greece as Sesklo, along the Middle Danube, especially around Belgrade, as Starčevo, and beyond, in Transylvania and Moldavia, as Criş. The variety of

contemporary shapes at Karanovo is greater than anything achieved north of the Balkans, but potters in this tradition persevered in turning out painted styles for best use, although the white paint tended to turn to yellow or black owing to cruder kilns with slower burning woods. The painted designs were mainly geometric, though spirals occur, and often the negative pattern, formed by the uncovered red surfaces appear to be dominant. Where the Anatolian precept of cream fabric with red paint could not be followed then the white paint had to form the field with linear red designs showing through. Many shapes and motifs suggest copying from woven reeds and basketry, but wooden vessels must also have been important as exemplars, as in the present instance. By contrast, the farming peoples who were clearing forest along the loess lands following the Danube upstream into Bohemia and Bavaria, principally used simple hemispherical bowls, still well constructed and fired, but decorated by incision while the fabric was still damp and before firing. The three vessels from the Jungfernhöhle, in the district of Bamberg, Upper Franconia (*Ill. 70*), are not amongst the earliest from the region, but are typical of their kind. An arcading motif with single deeply cut outline is seen, while spirals and geometric meanders are more typical of earlier phases and potters in closer touch with southern traditions. It used to be thought that pottery vessels with rounded bases were essentially primitive, but the oldest Danubian pots have flat bases as all those of Starčevo and regions south. Rounded or pointed bases are devolutionary traits in Europe having perhaps to do with the need to stand on rough or soft surfaces unlike the hard smooth clay floors in ancestral villages in drier, sunnier, lands.

A neolithic ware within the Danubian group, but much more decorative, is that known as Bükk from the mountains of that name in northern Hungary around which, and in adjacent parts of Slovakia, it is concentrated. As in all stylistic groups, there are rough and heavy forms for storage and cooking, and fine ones for drinking and cult purposes. The finer Bükk wares consist of globular bowls and open dishes, and they stand on small flat bases sometimes slightly dished (*Ill. 72*). The decoration was incised before firing,

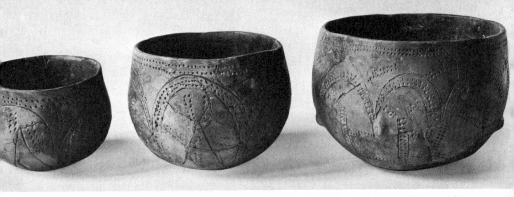

70 Three hemispherical pots from the Jungfernhöhle in Upper Franconia, with their simple incised decoration, are typical of Danubian pottery. They are not of the earliest type which have flat bases and are found in regions farther south

and sometimes in-filled afterwards with white or red paste or 'encrustation'. The plain smooth surfaces, black to dark brown, were highly burnished. *Ill. 72* shows the underside of a wide dish from Aggtelek, particularly interesting for its running spiral motif bounded by four deep incisions. A globular bowl from Borsod displays a characteristic Bükk motif of multilinear pointed arches. Traces of white inlay can be seen but the bold polished expanses of the intentional negative pattern make the greater visual impact (*Ill. 71*). Another excellently preserved bowl comes from a great find of Bükk material in the Domica cave in Slovakia excavated some ten years ago (*Ill. 73*). In this the encrustation in white of the scored panels is well illustrated, and the contrast with the burnished dark surfaces show up in their almost original vigour. The antecedents of the pointed arch motif are unknown and deserve fuller study, but it was copied occasionally by simpler Danubian potters; even some who had established themselves as far west as Dutch Limburg. The makers of Bükk pottery were interested in the exploitation of obsidian, and perhaps other products of their mountains so that their influence was likely to extend widely just as these additional resources enabled them to maintain potting standards lost elsewhere. There is now reason to think that some of the finer Bükk pottery dates to the mid-fifth millennium BC, thanks to a radiocarbon measurement available from a Hungarian site, but generally this culture has been regarded as falling later than the best Danubian wares located to the west.

77

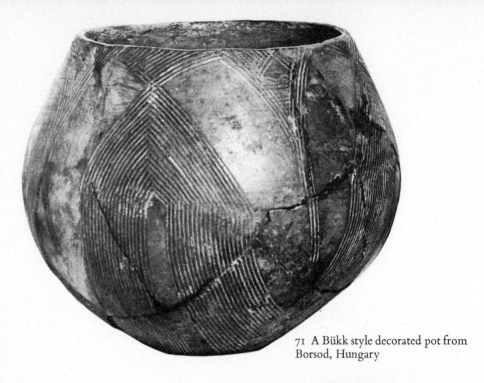

71 A Bükk style decorated pot from Borsod, Hungary

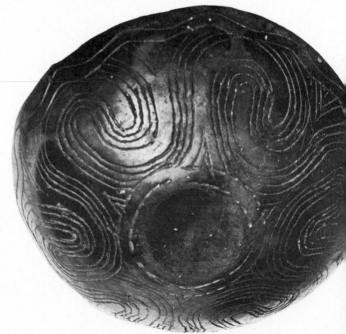

72 Bükk pottery is a neolithic ware within the Danubian group and its decoration is far more striking than the normal Danubian. The underside of this dish from Aggtelek well illustrates this with its running spiral motif bounded by four deep incisions

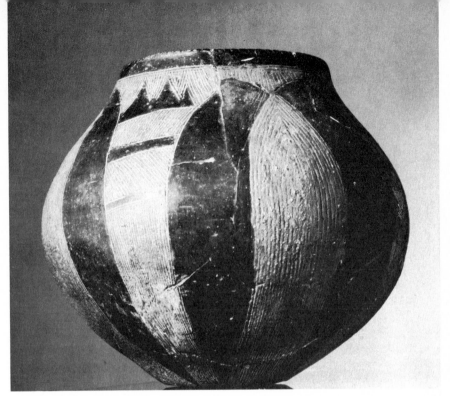

73 One of the features of Bükk pottery is its love of encrustation, its details heightened by burnishing. This fine example of the technique comes from the Domica cave in Slovakia

Towards the end of the fourth millennium BC there developed a remarkable painted pottery style in Moldavia and adjacent parts of the Ukraine known by the names of two pioneer excavations: at Cucuteni, a little to the west of the river Pruth, near Iaşi, and Tripolye, close to the Dnieper, near Kiev. The people concerned were mainly cereal cultivators, but kept domestic animals including cattle. They lived in substantial timber-frame houses in villages sited on terraces or small spurs above streams, but not directly overlooking the main waterways. Occasionally they bartered for copper and gold. Conditions in this environment must have been altogether more congenial for the practice of neolithic arts than in the moist forests behind the Carpathian Ring to the west. The result was a wider application of sun-dried and baked clay construction for shrines, ovens, floors, and gable ends, and a flowering of the potters' craft in range of shapes and elaboration of boldly painted designs. 79

The technique of painting almost certainly derives from the fore-going Criş perhaps influenced by subsequent Balkan practice. The motifs are developments of Criş, but probably owe much to Danub-ian spiral and meander decorated ware which had come through the Carpathians eastwards. Other, even quite northern, forest zone, influences may have contributed to the culture as a whole, for painted wares form only one element in the total pottery range of these villagers, and the coarse fabrics with incised decoration elucidate sources obscured by the expertise of the workers in paint. Thanks principally to the studies of Vladimir Dumitrescu in Roumania, and Tatanya Passek in Russia, the stylistic sequences are now well under-stood, and rest on excavation results, not only on art-historical museum appreciations. Beginning with bichrome painting in white and red, the curvilinear ornament was outlined by deep line in-

74, 75 Two painted pottery vessels from Truşeşti in Moldavia of the Cucuteni A style. The amphora (*left*) is typical of this style, in shape and decoration of swelling spirals, whereas the pedestal bowl (*right*) has affinities in shape with eastern Hungary

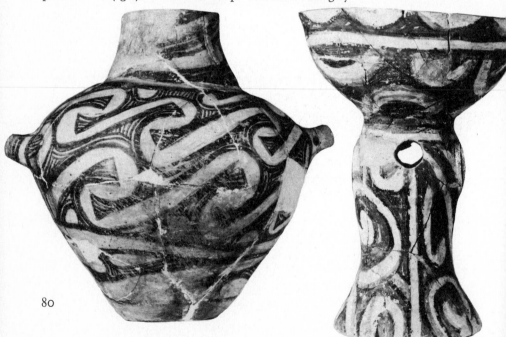

cisions. Then black paint took the place of the incised border lines, and a high point was reached in trichrome painting with white, shades of red, and black. The examples shown in these pages belong to the trichrome, phase A, of Cucuteni style, and come from important modern excavations at Truşeşti, Suceava (*Ills. 74, 77, 78*), and Traian, Bacău (*Ill. 76*), both in Moldavia. The high shouldered amphora with pronounced neck and a pair of handles at the girth (*Ill. 74*), demonstrates the full nature of bold free spirals and bands running over a swelling surface. The black lines emphasize the whiteness of the spirals, and there is red stroke work on a white field in between. The standing dish with swelling pedestal (*Ill. 75*) is interesting for the links this rather specialized shape possesses with other cultures not least that of copper workers in eastern Hungary who, however, were content with very plain undecorated wares.

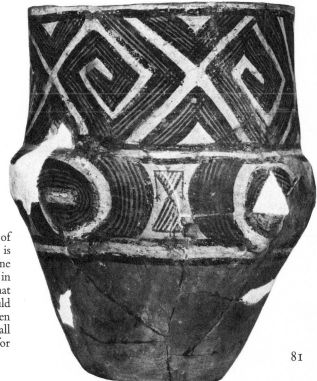

76 A rare representation of a stylized human figure is shown on the shoulder zone of this pot from Traian in Moldavia. It is strange that such representations should be so rare on pottery when the fondness of virtually all eastern neolithic peoples for figurines is so marked

81

Here red forms the field, and white with black lines form hook spirals, loops, and lunate motifs below the rim. This is almost certainly a vessel for cult purposes. The three bowls in *Ill. 77* belong to the same Cucuteni phase, but mark a tendency away from spirals and also to darker reds. The designs continue to be elaborate and most skilfully organized over the whole surface. An amphora, with short neck and small handles (*Ill. 78*), shows another successful display of trichrome painting. The ample spirals and loops reflect a confident outlook, and the intervening black strokes against a red field should be observed.

The vessel from Traian in *Ill. 76* possesses a rather straight, high, neck, rounded shoulder, and simple foot. The latter is plain showing a fabric surface of reddish-brown, but the neck is covered with a continuous band of regular geometric meanders, or key-pattern, done in red with black border lines and inner parallel strokes against a white field. The shoulder zone is of special interest as it

77 Three pottery vessels, typical of the Cucuteni A style with its elaborate running decorations, from Truşeşti

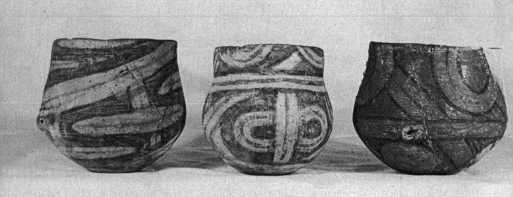

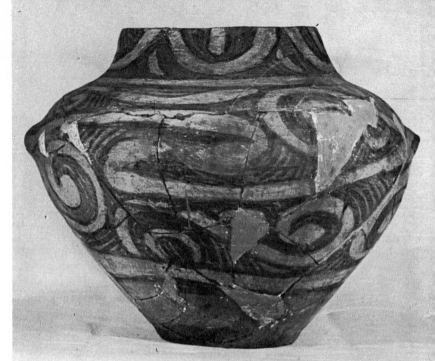

78 A successful display of t r i c h r o m e painting, this amphora from Truşeşti in Cucuteni A style, is decorated with ample spirals and loops

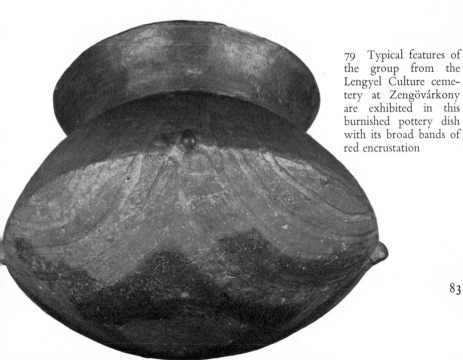

79 Typical features of the group from the Lengyel Culture cemetery at Zengövárkony are exhibited in this burnished pottery dish with its broad bands of red encrustation

83

consists of three large horizontal S-spirals, executed in the same manner as the key-pattern, but interrupted at one point where a small panel of white paint is occupied by a rigidly stylized human figure done in thin red lines. Two perforated suspension lugs, of a total complement of four, may be discerned below either flanking spiral and incorporated in the lower band of white paint. Traian has produced three other comparable figures from fragments of painted pots, but this motif is unknown in other Cucuteni contexts although three less geometrical portrayals in the Tripolye province, and one or two incised figures, in the simplest line manner, from the Middle Danubian province, are known. In all cases, the downstretched arms with open hands, seem to be important, and this point will be referred to again. It is remarkable that such human representations should be so rare on pottery in view of the fondness of all the eastern neolithic peoples for female figurines, but the Cucuteni/ Tripolye people never lavished the time and skill on their figurines that they obviously did on their painted pottery.

By the time of the flowering of painted pottery east of the Carpathians, the zone westwards had seen many changes in material culture generally, and in pottery styles in particular. Important new ideas and practices flowed north from the Balkans, some at least borne by immigrants and metal prospectors. The leading characteristic in pottery was plain burnished ware well exemplified in the tell-settlement at Vinča near Belgrade, and in the settlement and cemeteries at Lengyel, in Tolna county, close to the western bank of the Danube as it runs south through the Hungarian Plain. The Lengyel element was to be particularly influential in the formation of ceramic styles far afield in west-central and northern Europe, but within western Hungary, and in adjacent parts of Moravia and Austria, the Lengyel people practised a curious form of colour decoration for their best quality wares. This involved the application of colour after the pot had been fired so that it very easily flaked off. The ware is always of a very high quality, and burnishing was mainly sought after, but there can hardly have been any technical deficiency that prevented pre-fired painting. It may have been thought worth while to colour such vessels as were required

for use on one occasion only. This technique of post-fired colouring may best be referred to as *encrustation* to avoid confusion with true painted decoration although the two are not always properly distinguished. It should be added that the technique of encrustation was used in Asia Minor though not widely. The example in *Ill. 79* from the Lengyel Culture cemetery at Zengővárkony, Baranya county, exhibits a burnished vessel with broad bands of red encrustation delineated by broad incised channels, another typical feature of this group. In Moravia and western Slovakia, related encrusted styles are known with most elaborate schemes in red, yellow, and white, and there are some very fine pottery spoons and dippers with attractive ornament in this manner. The shape of the dippers with hook handles reveal wooden prototypes of a sort known widely to the present day.

Simple plain wares with thicker fabric and fewer shapes are typical of the neolithic cultures of the western periphery. Quantitatively they are less well known, partly from more adverse conditions of preservation, but also from the likelihood that pottery stood at a comparatively low production level amongst communities not well established in permanent villages, nor with good clay and firing facilities. The Michelsberg Culture of west-central Europe stands half-way in this matter of ceramic equipment, and tall 'tulip-shaped' vessels with rounded, almost pointed, bases, and flat plates, are amongst the more distinctive and original forms. Both types are seen in *Ill. 82* from Untergrombach in Württemberg. Note the small bosses encircling the tulip-beaker and the pinched edging of the plate. These latter are generally thought to be baking-plates, but they are somewhat akin to kneading plates made of skin stretched on withies as used until recently in the Shetlands. They can of course have had some quite different purpose. Of neolithic pottery craftsmanship as it finally reached the western seas about 3000 BC, one vessel must stand representative here. This is a wide bowl in red ware with white flecks, due to igneous rock grits, from the settlement at Hembury, in Devon (*Ill. 80*). In its regional context it would be described as a fine ware. There is no ornament, but the pot possesses a pair of well-made horizontally perforated lugs with

85

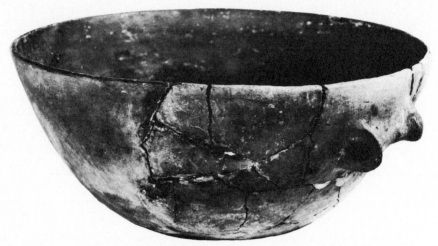

80, 81 Two examples of British neolithic pottery. The bowl (*above*) from Hembury, Devon, may be termed fine ware as found in its regional context. The bowl from Hedsor, Buckinghamshire (*below*), is a very fine complete example typical of the later Mortlake type ware. It is noticeably heavier and coarser in its ware and decoration

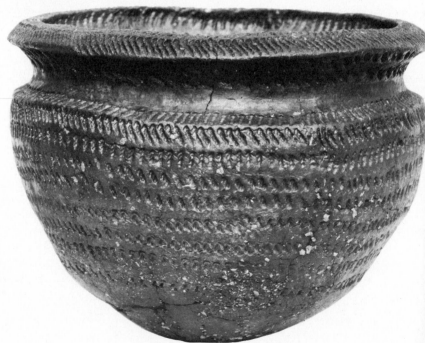

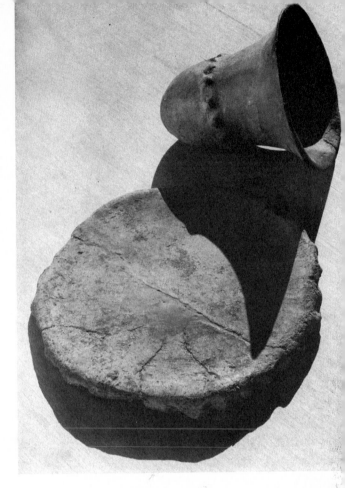

82 Tall 'tulip-shaped' beakers and flat plates are amongst the most typical forms of pottery of the Michelsberg Culture. It takes its name from a hill-top site, with rampart and ditch enclosures; the examples illustrated here came from the type site at Untergrombach in Württemberg

expanded, 'trumpet', ends. The base is rounded, but not pronouncedly so. The immediate origin of this ware lies in northern France, but its ancestry beyond that is still quite uncertain. Western Mediterranean neolithic traditions are generally thought to have played a part, and more recently views have been in circulation about Lengyel influences having reached thus far. In Britain, later neolithic pottery became much coarser and heavier in fabric, and some of it is remarkable for a profusion of deep ornament executed by impressions and stabs in rows and herringbone arrangements. It is all very crude, but with a certain attractiveness, and the pot from the Thames at Hedsor in Buckinghamshire (*Ill. 81*) is one of the best intact examples.

The introduction of pottery to northern Europe was altogether an affair of the expanding economy of the neolithic peoples of the Middle Danubian province, their principal lines being through Moravia and Bohemia, and the great waterways of the Elbe and Oder. After beginning with very simple shapes in plain wares, there developed a strong and lively ceramic art as expressive of the capabilities of these northern peoples as was to be the remarkable bronze industry they created at a later period. The three vessels and a stone implement (*Ill. 83*) from a grave at Tovstrup, near Ringkøping in western Jutland, illustrate the high degree of competence that was reached in the third phase of this first neolithic culture in the north. The vessel on the left is a form of amphora remarkable for its tall neck which has been left plain and smooth so that it contrasts with the carefully arranged stroke marked ribs on the swelling body. The pair of small lugs at the base of the neck give an added sense of balance. The centre vessel with wide mouth above an out-curving plain neck, and short deeply scored body is known as a funnel-beaker, and is the most characteristic pot form of the culture in question so that the latter is now usually referred to as the Funnel Beaker Culture. The bottle on the right, generally described as a collared-flask, declares through its shape and decoration its ancestry in leather containers held on a framework of wicker. In some cases vertical mouldings represent such ribs as they would have appeared pressing against the stretched leather covering, but in the present example, vertical lines with short cross-strokes suggest stitching. The protruding flange around the neck represents an interwoven ring which would have finished off the top of the wicker frame, the leather being then pulled over it. The ribbed and scored decoration on the other two vessels in this illustration may also owe something to wickerwork prototypes. Long-necked vessels such as here illustrated were of course made in two pieces, the neck as a cylinder which was worked on to the top of the body while the clay was still damp. The stone club-head is an elegant piece of patient grinding. The wedge-shaped tongue would have fitted into a hole at the end of a wooden handle, but the hemispherical knob is not a normal stone-worker's shape, it is known to copy the butt of a copper

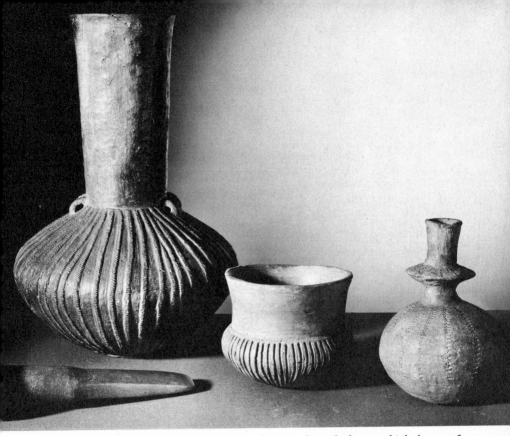

83 The pottery of the Funnel Beaker Cultures of the north reached a very high degree of competence, much of it being copied from basket or wickerwork and leather prototypes, as the bottle on the right. Great skill was also shown in stoneworking and polishing. The stone club-head to the left copies the butt of a copper shaft-hole axe of contemporary date

shaft-hole axe type being already made in eastern Hungary at this period.

Ill. 84 shows some further examples of Danish neolithic pottery of later date. The most interesting piece is the large vessel with broad handles. This comes from a megalithic tomb of Passage Grave classification, at Hagebrogård in Jutland. The sharpness of outline is further accentuated by the deep angular impressions used to form the panels of chevroning. It is a leading example of the Grand Style of Middle Neolithic pottery in Denmark. In the foreground is a pottery spoon or dipper with socket for a thin wooden handle. This is known to have been for ritual use, and has been found in

89

several instances with high footed dishes clearly related at some remove in time to those already mentioned in Moldavia and Hungary.

Apprehension of shape, function, and manufacture, goes some way towards bringing together the modern viewer and the pre-historic potter. All these vessels could be useful and pleasing today in simple surroundings, but the link is altogether weaker when it comes to an evaluation of fired-clay figurines. It might be thought that these would have given opportunity for a much more extended range of expression, but on the whole rigid factors of traditional cult would seem to have kept the modellers within close limitations. Figurines, even statuettes up to about 30 cm. in height, are typical in much stereotyped variety, of the neolithic cultures of south-eastern Europe with rare examples in the peripheral zones. The use of figurines in various substances was at home in Anatolia and the Ancient Near East, and spread thence to the islands of the Aegean, Greece, and the Balkans. It is unknown if there had possibly con-tinued a tradition in this from the time of the Gravettian hunters (see p. 11). This seems less impossible than had been supposed, but would depend on a continuity being demonstrated between the developed Gravettian stylized forms known in Russia, and the earliest recognized figurines in the primary neolithic zone described at the beginning of this chapter. Nor is it at all certain if the whole cult usage is represented in clay models that have been fired as pottery. Figurines in wood, or even unbaked clay, might have pre-ponderated, but have failed to survive. On available evidence there is no overall typology or progression of styles, spatial or chrono-logical, but regional types and fashions can be distinguished. Here it is best to consider some of the more interesting pieces for their own sake rather than to attempt a general survey of objects that rarely command visual admiration.

Important excavations by Professor D. Berciu at Cernavoda in the Dobrudja, have brought to light, in a grave of the neolithic Hamangia Culture, a pair of figurines of exceptional achievement (*Ill. 85*). The date should lie in the latter half of the fourth millen-nium BC. The two pieces, a man and a woman, might better be

84 A group of Middle Neolithic Danish pottery ▶

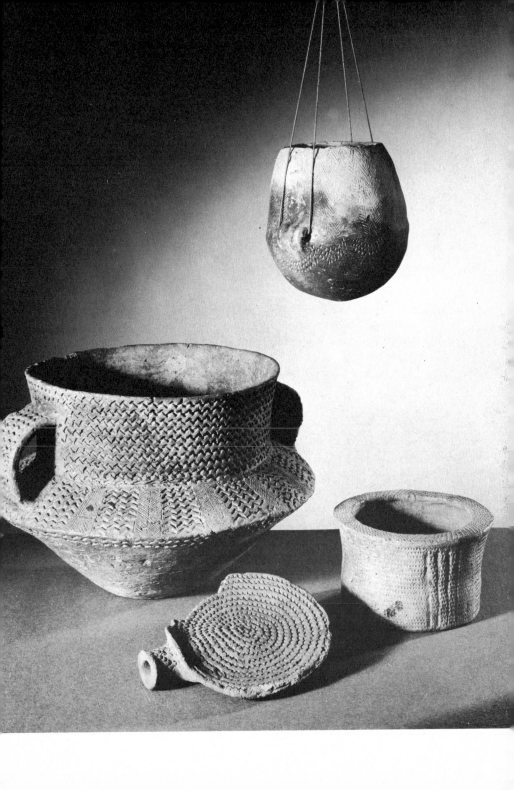

described as statuettes; they are over 11 cm. high. They were modelled in a light brown clay which was then coated with a black-brown slip, and highly burnished. The man sits on a low four-legged stool, both being made all in one piece. His back is curved in both directions, and has a deep groove marking the spine. The neck is columnar but also grooved up the back. It is exaggerated in length and thickness, and the relatively small flattened head gives the impression of having been pushed down onto it. The whole attitude of the body is quite unique, and the hands supporting the lower face push up the folds of the cheeks. The general impression is that of a man of flesh, massive but not obese, nor are sex organs shown so that the implications are not for connection with a fertility cult. The emphasis is on the sitting, pensive, attitude, and on the accentuated deep-cut eyes, the broad nose with marked nostrils, and the small tight mouth. If this statuette should have represented the dead man, it seems likely that he had been some kind of magician or seer, now for ever held in communication with the Beyond.

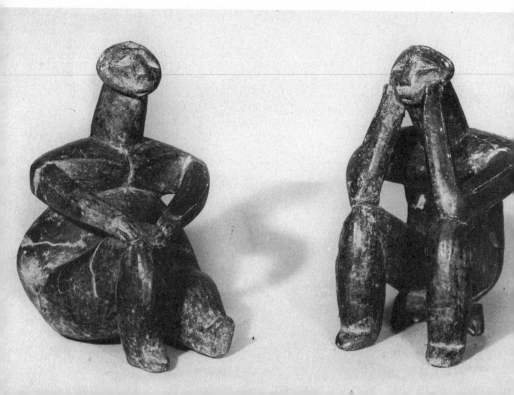

Natural disturbance of the ground made it impossible to tell if the grave had been a double one, and if therefore there was a likelihood that the man's wife could be represented by the female statuette. She is executed in the same technique, but was a simpler undertaking. The back is curved in the vertical line but is otherwise flat, and without indication of spine. The flattened areas across the shoulders and chest, and along the arms, should be noted; a treatment present but less obvious in the man. Both show the same kind of stumpy feet. The obesity of the lower part of the female body recalls the fecundity motif, but pregnancy does not seem to be suggested, and it has been put forward that a predominantly cereal diet would have been a factor in producing the kind of steatopygy illustrated by many neolithic figurines. The Cernavoda woman must be content to sit on the ground with hands clasping an up-drawn knee. Did she also deliver oracles? The general aspect of both heads, flattened as they are, is of upward-looking with almost horizontal jaw line. The antecedents for this, as much else, are to be

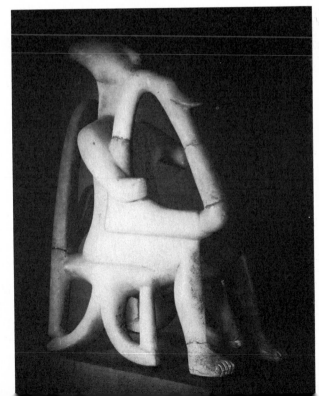

85, 86 An exceptional pair of pottery figurines, excavated by Professor D. Berciu at Cernavoda in the Dobrudja, are illustrated opposite. They may be dated to somewhere in the latter half of the fourth millennium BC. The man sits on a low four-legged stool whilst the female figurine sits upon the ground clasping an up-drawn knee. Both figures have their heads tilted, looking upwards with almost horizontal jaw line, and possibly represent seers or magicians. The same tilt of the head and similar stumpy legs are also seen in the marble sculpture of a harpist from Keros (right), although there is, of course, no chronological sequence implied between these objects. For similar expressions of the up-tilted head see Ills. 89, 90

found in Anatolia and the Aegean, and the marble sculpture of a harpist from Keros, in the Cyclades (*Ill. 86*), shows the same upward gaze, and massive neck. Although much more refined in portrayal of the limbs, the Keros figure offers other points of similarity in the widespread legs, and short feet. It shows too that an occupation, or skill, directed for magical or cult ends, was held a suitable subject for representation, and this certainly reflects a higher aim than that implied in the ordinary run of figurines. Stools such as possessed by the Cernavoda man will be met again farther into Europe, but chairs like that from Keros are known in small models, perhaps toys, from the third phase of settlement at Karanovo. It will be understood that there is no essential chronological sequence as between these particular examples, but that they all witness to participation in a common southerly art tradition.

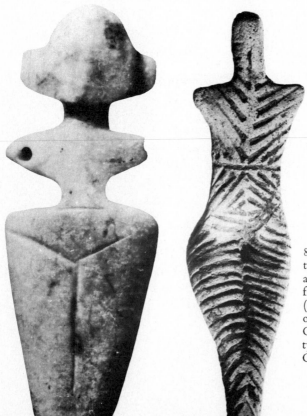

94

87, 88 Somewhat more typical of neolithic figures are the marble example from Karanovo, Bulgaria (*extreme left*), and a pottery one (*left*) from Phase A at Cucuteni, Moldavia, the type site of the Cucuteni Culture

To dispose of neolithic figurines of more usual aspect, a marble piece from the fourth phase, as defined by Professor V. Mikov, at Karanovo (*Ill. 87*), and a pottery specimen from Moldavia of Cucuteni A phase (*Ill. 88*), are next presented. The perfunctory shape of these is clearly more an indication of their numerous manufacture and common use than of limitations of skill. The Karanovo piece illustrates a widespread flat form with angular outline and prominent head that also spread in variant forms to the western Mediterranean and beyond. The Cucuteni figurine is only one of several types in that culture. The two pieces are not so unconnected as might first appear, many other specimens show variations tending to one or the other, but there are marble figurines from Jassa-tepe in Bulgaria with deeply grooved horizontal lines on the hips and legs which are fairly rounded. The deep markings on the Cucuteni figure, executed in a stab-and-drag technique when the clay was soft, may more immediately copy painted strokes on other figurines.

That the quality of figurines and statuettes depended more on strength of tradition and zeal than on proximity to the old centres is evidenced by productions at the hands of people of the Moravian facies of the Lengyel Culture, already mentioned, and by other contemporary or slightly later groups along the river Tisza in eastern Hungary. First to be noted are two pottery figurines from Střelice (*Ill. 91*). They stand with out-stretched arms, a very ancient ritual attitude, they are steatopygous, but possess very small breasts, and their heads are knob-like. This was not because heads should or could not be modelled for there is a third figurine, from the same site, generally similar but with a well marked face in a properly rounded head. From the important settlement excavated by Dr Jiří Neustupný at Hluboké Mašůvky, also in Moravia, another exceptionally tall statuette (36 cm.) is shown in *Ill. 90*. It is steatopygous, and again with tiny breasts, but the arms are well modelled, and there is a very natural outline to the whole figure. The hands are evidently intended to be turned upwards, and together with the upward looking face, give a remarkably realistic impression of supplication. At this point may be recalled the outspread arms and hands of the painted pot figure from Traian (*Ill. 76*). The flattened

face, line of jaw, and somewhat splayed nose, all point to the same plastic manner that informed the pieces from Karanovo and Keros, and although all the points cannot be analysed here, there is nothing in this Moravian output to suggest the work of people who thought themselves to be peripheral backwoodsmen. It should be added that there is a restored seated statuette of this context from Dr Anton Točík's excavations at Nitriansky Hrádok in south-western Slovakia. These examples only in part prepare for an extraordinary pottery find, now carefully restored from its broken pieces, by Dr J. Csalog, and excavated by him in the remains of a collapsed house at Szegvár-Tüzköves close to the Tisza near Szentes (*Ill. 89*). This is a large seated male figure. The body is hollow having been built up as a vase in the first instance. The stool, legs, arms, and head are solid, the whole being made of a strong, well-gritted grey clay that was then covered with fine clay that fired to a brick-red colour with

◀ 89 A large seated male pottery figure restored from fragments found in a collapsed house at Szegvár-Tüzköves, Hungary

90, 91 A figurine from Hluboké Mašůvky, Moravia, has all the appearance of a suppliant, its upturned head and hands held forwards and upwards. *Ill. 91* (*right*) shows two pottery figurines from Střelice in an ancient ritual attitude with outstretched arms

flecks of grey. Parts of the body, especially the upper legs, were then painted with red ochre. The lower legs did not survive. Despite the puny arms, the figure conveys a great sense of bulk, and a weighty, even forbidding, dignity. The neck is seen to possess more natural proportions than hitherto met, and the back of the head is well shaped. Again, there is the upward looking face, but Dr Csalog is surely right in claiming that a mask is here intended covering the true face. This opens tantalizing speculations as to the real shapes and colours of masks worn for ritual occasions by these ancient Europeans. The identity of the object held over the right shoulder has not as yet been satisfactorily determined. Details of the chevron motif on the belt, and the technique of manufacture of the whole piece, indicate a product of the locality, and there is little doubt that it had once stood in a shrine. Some further aspects are best discussed in connection with the object next to be described, but it may be added that this idol-like figure was set up by people with a very mixed cultural background in which peoples of various neolithic groups along the Tisza were intermingling and receiving amongst themselves copper prospectors whose point of departure had been in the southern Balkans if not directly in Anatolia. The importance of the second half of the fourth millennium BC for much stirring, and new impulses again comes into view. From another site in the same region, at Hódmezövasárhely-Kökénydomb, Professor J. Banner excavated an elaborate anthropomorphic vase (*Ill. 93*) clearly related in structure and posture to the foregoing. This is a female subject, sitting on a similar stool, and most striking is the deeply incised pattern covering the lower body and legs. It is unfortunately not known if figure-vases of this kind had lids embodying head and face. It is possible that a face could have been incised above the breasts on the wall of the vase, but there is no unbroken example and in the present case the plain upper edge has been restored conjecturally. As to the type of decorative pattern, it is at home in the neolithic Tisza Culture, and Dr Csalog has shown that basketry and plaited reed-work was its foundation. There are normal vase shapes covered with this kind of pattern, suggesting perishable containers, but one displays a face with eyes inlaid with

92 A painted pot in the form of a large seated goddess with obsidian eyes from Hacılar, level I. Other similar examples of this type of pot are known from this site and also one exceptional double or 'twin' form

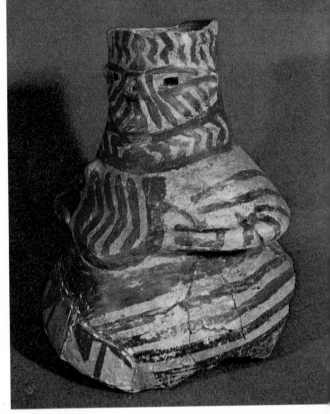

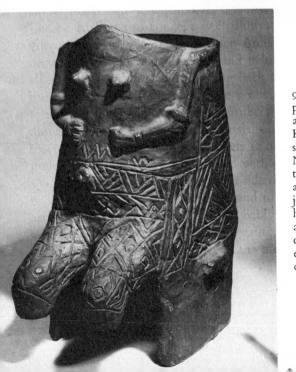

93 This seated female pottery figure was found at Hódmezővásárhely-Kökénydomb and still shows traces of red paint. No unbroken specimen of this type has been found, and it is a matter of conjecture if such figure-vases had lids embodying a head and face. In the present case the smooth upper edge has been restored conjecturally

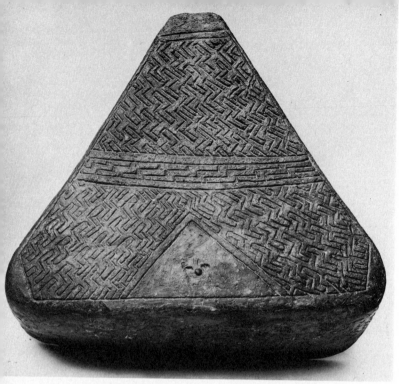

94 A face is represented by a rudimentary pair of eyes and a nose in the plain triangle at the bottom of this massive baked clay triangular altar or offering table from Hódmező-vasárhely-Kökénydomb, Hungary

a whitish clay. To return to the seated vase-figure, the pimple-like breasts recall those in *Ills. 90, 91*, while the arms, bracelets and stool ally it to the masked figure. In both cases there are bosses at the upper end of each side of the stool indicating the tenon method of holding the seat and legs together in the joinery of the living world. It is interesting, with these pieces in mind, to look back to Anatolia to see the red-on-cream painted anthropomorphic vase with inset obsidian eyes excavated by James Mellaart at Hacılar in south-western Anatolia (*Ill. 92*).

Amongst the large quantity of material excavated at the Kökény-domb settlement was a massive baked clay triangular altar or offering table, as it must seem to be (*Ill. 94*). A face is represented by a rudimentary pair of eyes and a nose in the plain triangle, and the rest of the upper surface is divided into two zones separated by a band, all being decorated in variations of key or step patterns most skilfully organized, and executed with great care. The pattern was presumably incised while the surface was still damp. It is unlikely that a mould was used, and here again plaiting and basketry provide

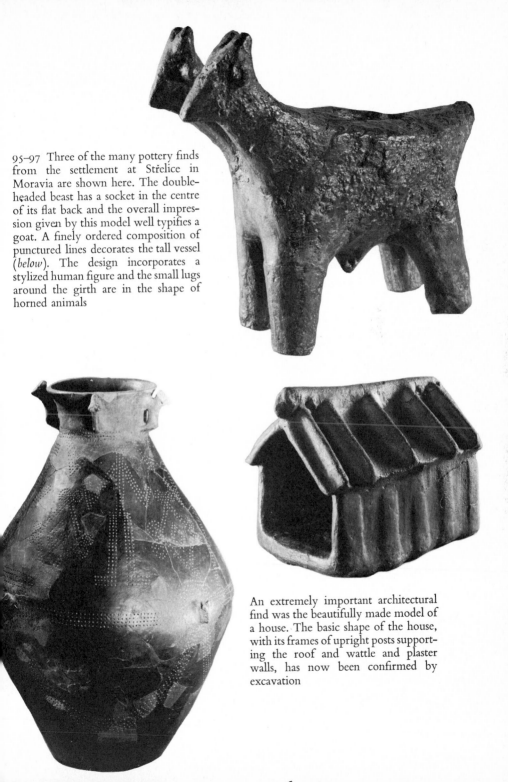

95–97 Three of the many pottery finds from the settlement at Střelice in Moravia are shown here. The double-headed beast has a socket in the centre of its flat back and the overall impression given by this model well typifies a goat. A finely ordered composition of punctured lines decorates the tall vessel (*below*). The design incorporates a stylized human figure and the small lugs around the girth are in the shape of horned animals

An extremely important architectural find was the beautifully made model of a house. The basic shape of the house, with its frames of upright posts supporting the roof and wattle and plaster walls, has now been confirmed by excavation

the most likely exemplars. The people of the Tisza Culture lived in an area of great reed beds, and other flora associated with water, so that the utilization of these substances would have been an important element in their material equipment. A fragment of a baked clay house gable-end decorated in this manner has also been found showing the transference of a traditional appearance to a new medium of construction. Returning to the roughly contemporary settlement at Střelice in Moravia, it is possible to see other aspects of plastic and surface art. The double-headed goat with a socket in the centre of its flat back, catches well the essential features and stance of this creature (*Ill. 95*). The tall vessel (*Ill. 96*) displays a finely ordered composition in punctured line incorporating a stylized human figure, and at the girth are small lugs in the shape of horned animal heads. Up the neck climb four small animals of uncertain species. The dark burnished surface with the lighter colour of the punctured pattern enhance further the graceful lines of this vessel. Finally from Střelice is the well-known house model (*Ill. 97*), a beautifully made, and well fired object. Excavations now reveal such rectangular houses with frames of upright posts which would have supported the roof, and with wattle and plaster walls. The finial of the ridge pole is a ram's head, more clearly seen in examination of the original.

The neolithic peoples of the north-western zone of Europe are not known to have cared greatly for figurines, but they were not ignorant of their purpose as has been shown by the finding of roughly carved fragments in chalk from the south of England. One example was likely to have had wooden legs. The most remarkable, because it is not of a formal type, is the lumpish female figure carved from a small block of chalk, and found in a ritual deposit in a flint mine at Grimes Graves in Norfolk. The context of the find indicates that this certainly was intended as a fertility 'goddess', and this is sufficient comment (*Ill. 98*).

The neolithic and copper working communities of the Middle Danube, living in a land of vast plains of fine loess soil, had no opportunity to develop stone carving for monumental purposes. Would that they had been able to do so for to seek for such stone

working it is necessary to visit areas in the far west where much less rich economic and material cultures existed. Aegean practices again provide the background for at least some elements in monuments and stylistic representations, but to follow all the evidence, still very disjointed, would involve an exercise in archaeological detail, and in evaluations of the curious rather than of things in any way beautiful. There are a few noteworthy exceptions, but on the whole, Western stonework is of greater interest for technique than for visual gratification. It is well to begin with a marble work from the Cyclades. This is a statue, nearly five feet high, and of Early Cycladic context, from the island of Amorgos (*Ill. 100*). Its size is not generally appreciated as there are many similar marble representations that are of figurine dimensions. Points such as the massive neck, the small breasts and thin little arms, all link with various pieces already discussed, but for makers of cult figures in the far west, the wedge nose, as well as breasts and arms, were important.

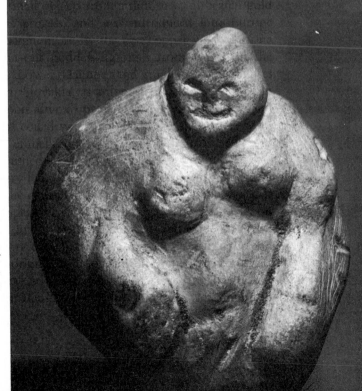

98 Certainly intended to represent a fertility 'goddess', this curious little lumpy chalk figure was found at the end of a gallery in the neolithic flint mines at Grimes Graves in Norfolk

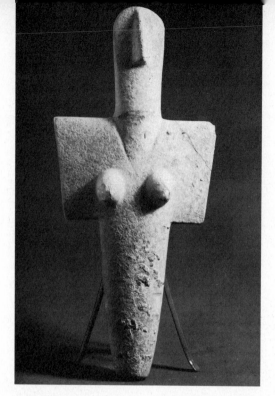

99, 100 Two female figurines from opposite ends of the Mediterranean have several features in common, the most striking being the angular nose. The example (*left*) from Senorbi in Sardinia is the finest example of local adaptation of what is essentially a Cycladic type of statuette, exemplified by the largest found (*opposite*) from an Early Cycladic context on the island of Amorgos

The downward turned feet were also remembered in uncouth renderings. Recollection of such Cycladic statues must surely explain in part at least those grotesquely carved stone slabs, the *statue-menhirs* of Languedoc, and more widely scattered related pieces. In some of these, the same rendering of breasts, arms and noses, can be recognized. The feet are reduced to what looks like the fringed ends of a scarf hanging down on the lower edge of the slab face. Rather more successful are carved figures at the entrances of chalk-cut tombs in the valley of the Petit Morin, Marne. By whatever route the cult figure reached this remote region, the wedge nose, and small close set breasts were faithfully reproduced.

The number of actual Aegean objects of any kind brought in boats to the other end of the Mediterranean must have been very small with a proportionally infinitesimal chance of survival for modern discovery and recognition. The archaeological record is more likely to provide examples of local adaptation. A case in point is the marble statuette from Senorbi, in Sardinia (*Ill. 99*), which

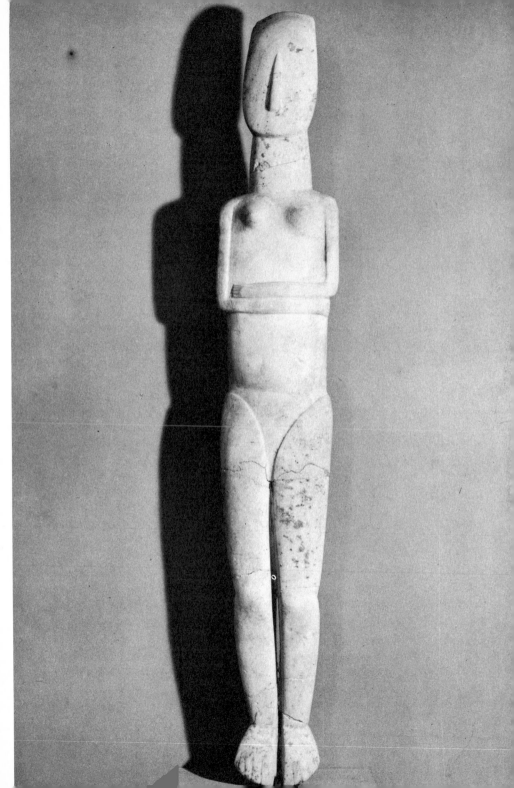

in its severe reduction of detail, and handling of round and flat surfaces is the finest piece in this art tradition throughout the lands of the western Mediterranean. Beyond Sardinia no marble statuettes or figurines have been found, and more barbarous renderings had to suffice while other aspects of the goddess came to be emphasized. In southern Spain and Portugal flat stone figurines and ornamented plaques show numerous combinations of stylistic elements embodying eastern Mediterranean memories, but greater interest was directed to producing cult objects, figurines of a very abstract sort, in which emphasis was given more than anything else to the eyes. Thus the 'eye-goddess' of some writers, and she was important for the way in which her cult spread eventually to the British Isles, and even to northern Europe. The carved limestone cylinder from Almeria (*Ill. 103*) is representative of a group, the finest being carved in alabaster. Everything has been reduced to geometry, but the precision of the carving, and the elaborate construction of the eyes may be noted. Related, and perhaps originally in more common use, are leg bones of animals finely incised with similar *oculi*, and a mass of supporting decoration. Such light, easily carried, objects may have been important in propagating this repertoire of cult embellishment, but they have only been preserved in the moisture-free climate of Andalusia and Valencia. The carved phalange-bone in *Ill. 102* is from Almizaraque, Almeria, and was found with others in the remains of a burnt down structure, probably a shrine. An even finer piece carved on an antler tine is that from Ereta del Pedregal, Navarrés, Valencia (*Ill. 101*), showing two pairs of eyes cut in bas-relief with accentuating arcs. Between these *oculi* is a zone of alternating hatched and plain lozenges, and the lower shank is covered by rows of triangles executed in the same manner. The Valencian oculos-idols have been found mainly in caves whereas those from Andalusia belonged to a culture closely identified with finely built stone tombs whether in dry-walling with corbelled vaults, or megalithically constructed Passage Graves. An individual contribution to this cult art was made by Passage Grave builders in the province of Alentejo where they used locally available black Silurian schist to carve plaques replacing the figurine styles of the

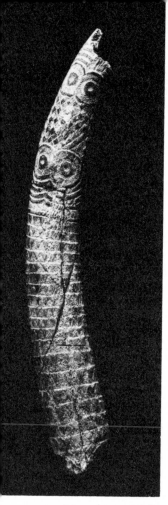
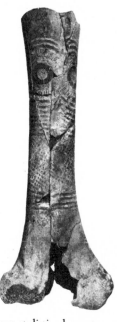

101–3 Many eastern Mediterranean stylistic elements appear in western Mediterranean art. Notable is the *oculos* motif that spread as far as the British Isles (*cf. Ill. 108*). Illustrated are three examples from Spain in bone and limestone. *Ill. 101* (*left*) carved on antler tine comes from Ereta del Pedregal; the carved phalange–bone (*centre*) from Almizaraque, and the carved limestone piece, *Ill. 103* (*right*), from Almeria

south-east of the Peninsula. Some were cut to allow for a spatulate head, rarely shoulder and arms, and the majority approximate to a trapeze in outline splaying from narrow head to broader foot with rounded corners, and gently curving sides. A fine, sharply incised pattern covers one face, and some decoration is occasionally to be found on the other. The incised decoration was generally in-filled

107

with a white paste, but the smooth black areas, when wiped clean after this process, show up in a strong negative pattern. The specimen here illustrated (*Ill. 104*), although worked on a piece with some natural blemishes, is typical of the great majority. The outline has been reduced to the simplest form, and nothing remains to declare an anthropomorphic identity. Only knowledge of the many variants which actually show eyes and other facial elements would lead to recognition of the blank dependent triangle with perforation at the top as a nose, and the horizontal bands on either side as cheek markings; perhaps going back to tattooing. The single perforation was presumably intended for suspension, but a pair are sometimes present and take the place of eyes. The very fine cross-hatching makes the background for a pattern mainly composed of long inverted triangles with plain smooth surfaces.

104 Extreme stylization of an anthropomorphic form is seen in this schist plaque from Portugal. The outline has been reduced to its simplest form and all traces of its anthropomorphic derivation have disappeared. It is only by being able to trace varying stages of adaption after the original that it can be recognized as such

The eye-motif is also found in Almeria on the walls of some few pottery vessels. The footed bowl (*Ills. 105, 106*) was found in one of the tombs in a large cemetery of chambered tumuli close to a defended settlement at Los Millares. The settlement, which appears to represent an actual colonization by a group of people of East Mediterranean origins, probably was founded in the late fourth millennium BC, but there is no evidence to date this pot at so early a time in the life of the colony. There are two pairs of eyes incised on the wall of the bowl, and there is a group of three deer, evidently a stag and a pair of does. Intervening are panels of swags and rectangular compositions. Just above the stag's hindquarters will be seen an hour-glass, or filled-in X, motif in deep puncture. This probably represents a human figure. It is found again on a vessel from Vélez Blanco, and one may recall the more obvious X-figure

105, 106 The eye-motif is also occasionally found on the walls of pottery vessels. The example shown comes from the cemetery at Los Millares, Almeria, and has distinct *oculi* on one wall and a group of three deer on the other wall. The intervening decoration consists of incised swags and rectangular panels

107 The Folkton 'drums', squat cylinders of chalk elaborately carved, were found in a child's grave in Yorkshire. Each 'drum' bears an *oculos* motif, rear panels of geometrical decoration and circle and star designs on the top

at Traian (*Ill. 76*). The only other known example of a group of deer incised on pottery in this way also comes from Los Millares. This subject, whatever its implication in conjunction with the eye-goddess, seems likely to have been a contribution of indigenous hunter art; schematized descendents perhaps of the Levantine group.

The diffusion of cult along with migrants, or prospectors by sea, from the southern and western parts of the Peninsula to western France, Britain, Ireland, and even to the west Baltic region, is by no means as well documented as that along the Balkan and Danubian line already summarized. There is no easy explanation as to why pottery vessels with moulded eye-brows and nose should have been made in Denmark and the Baltic coastlands of Germany, but these, with the exception of a small group in western France, between Angoulême and the sea, are the only real comparisons for those in Almeria. Details in technique remove the possibility that this is a matter of chance convergence, and these northern *oculi* pots have been found in megalithic Passage Graves although not of the oldest type represented in the North. It is interesting that the shapes of these vessels (*Ill. 109*) are in the tradition of the funnel-beakers so that the embellishment has been accepted from afar. Such vessels are of course few in number. The three vessels in the illustration

110

108 A variant on the *oculos* motif may be seen on the carved stone ball centre left of the illustration (*opposite*). These balls, from Scotland, are found especially concentrated in Aberdeenshire and are elegantly carved ▶

are from tombs in Denmark, the one in the foreground being from Svinø, and the two behind from Kyndeløse. Apart from the eyes, the dot filled triangles alternating with plain ones, and the chevron line below the rim of the pot on the left, are noteworthy for their link with the Spanish phalange-idols as well as with stone-cut designs at tombs in Ireland. Again, it ought to be emphasized that there must have been other media, now perished, which more easily conveyed this tradition of symbol-art over perilous seas, and selectively to remote peoples and lands. Thus Britain is reached, and, from the grave of a child under a tumulus at Folkton, East Yorkshire, a threefold confrontation with the eye-goddess is made (*Ill. 107*). These are drums or squat cylinders of chalk elaborately carved, each with an *oculos* motif, with rear panels of geometric composition, and on the top, circle and star designs of which the example here is reminiscent of the phalange-idols, but closer to stone-cut compositions in Ireland, or to designs on slabs from the once existing megalithic tomb at Calderstones near Liverpool. The face on the drum, here seen in the centre, incorporates eyebrows and nose in relief, but the eyes are mere small lumps with no rays or other exaggerations. The lozenge mouth between the apices of two triangles is not easily paralleled although an Anatolian proto-type has been suggested. The treatment of the surfaces between the saltire of the drum on the left suggests chip-carving in wood, and this may have been the substance in which such cult objects were more usually to be seen. In Scotland, and especially concentrated in Aberdeenshire, have been found elegantly carved stone balls of small size (*Ill. 108*). These are all isolated finds without archaeo-logical context, but two related carvings, spiked balls, were found in the Late Neolithic settlement at Skara Brae in Orkney. One ball, centre left in the illustration, reveals a trilobate pattern which is clearly a variant of the *oculos* motif just observed from Folkton. Other faces of this ball show related motifs, including spirals, wit-nessing close relationship to patterns cut on the walls of megalithic tombs of the Boyne group in Ireland. What determined the shape and actual employment of these balls is unknown, but as objects in their own right they have more claim to consideration in the present

109 Staring *oculi* motifs appear on a few pots found in megalithic Passage Graves in northern Europe. Those illustrated are from Denmark. In the foreground is one from Svinø, the two behind are from Kyndeløse

connection than many more clearly magical representations from farther south.

The application of cult art to stone surfaces, the production of so-called 'megalithic art', presents many problems as to how and where it first came about in western Europe. It is generally established that mural decoration is not found in tombs in the Iberian Peninsula where figurines and schist plaques are normal grave deposits, but in the north-west of the Peninsula where grave goods are poor, and cult objects absent, some wall decoration was undertaken. There is a little stone-cut work of isolated motifs and patterns, and there have also survived painted compositions covering the whole face of slabs forming the sides of megalithic chambers. The question must certainly arise as to whether wall painting was not a

113

more widespread practice, but it is certainly unfortunate that no evidence for it has survived in Almeria and other southern regions where climatic conditions should have been equally favourable. As the evidence stands, there are two great provinces of megalithic stone-cut art: Brittany and Ireland, and although both share with the Peninsula a basic symbolism, both display such emphatic and large scale divergent achievements that they cannot have relied solely on that one southern source. It is only in exceptional cases that stones in megalithic tombs in these two provinces were treated with a composition that was intended as monumental art in any proper sense. For the most part, odd motifs, and elements of disintegrated patterns, were cut on stones in ritually significant positions in the tomb; possibly visible, but frequently so incorporated into the structure of wall or roof as never to have been visible after having been built in. Interest in the present context must be directed to stones showing qualities of design beyond the mere fulfilment of magical needs.

114

110 Recent excavations by Professor M. J. O'Kelly at the site of New Grange have revealed that the well-known kerbstone in front of the entrance was wedged into a shallow foundation before the work of cutting the design began. It has also been shown that it was in position before the tumulus was built up and that areas of decoration at one end could not have been worked after the adjoining kerbstone had been positioned next to it

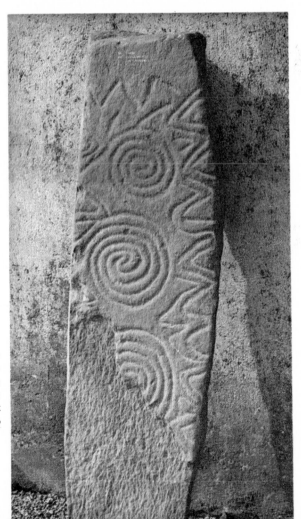

111 From Clear Island in Co. Cork comes this decorated stone, an isolated example in the style of megalithic Passage Grave art. It is not even certain that this stone formed part of a megalithic tomb

115

The finest achievement in this western stone-cut art forms the principal element in the encircling ring of great kerbstones of the massive tumulus at New Grange, Co. Meath, Ireland (*Ill. 110*). This long slab stands in front of the entrance to the passage leading to the great corbel-vault chamber, both containing many decorated stones. Professor M. J. O'Kelly, who is currently directing excavations and conservation at New Grange, and who has contributed this colour photograph in advance of his own publication, points out that the arrangement of the kerbstones is such that all must have been in position before the tumulus was built up, and that the decoration on this stone covers areas at one end that could not have been worked after the next adjoining kerbstone had been brought into contact. Important also is the revelation of a base line for the decoration showing that the slab was already in position, wedged into a shallow foundation, before the work of cutting the design had begun. The stone had been chosen for its smooth slightly swelling surface. The decoration was executed in a batter or pock technique making wide and deep channels forming a reduced and roughened background for a positive composition of smooth spirals, curves, and lozenges. It is clear that the New Grange entrance stone displays an integrated overall composition, and that factors of visual splendour both in position and content entered into the original concept. What experience or ability to borrow separate ideas from dissimilar monuments in far off lands can have operated to achieve this fine effect? Stones sculptured with symmetrical patterns of spirals in Maltese temples, and vestiges of spiral painted walls in Minoan Crete and around the eastern end of the Mediterranean generally, give as yet only a very vague background for the concept of the New Grange stone. To press a case for Mycenaean influence, which would anyway not have to rely on the diminutive stele of the Shaft Graves, involves chronological difficulties as present arguments of weight indicate that New Grange should be older than the rise of Mycenae as a centre of widespread influence. A more immediate question is what analysis can be attempted of the entrance stone pattern. It must surely be agreed that this is decoration as much as, or more than, cult embellishment. Looking from

left to right, there is a vertical row of double-outline lozenges, and this is followed by a large arrangement of three interrelated spirals. Beyond these to the right are two horizontally placed spirals, slightly different in size, and lying between upper and lower pairs of concentric arcades. Then comes a large lozenge-shaped space determined by the curves of these spirals and further arcading at the extremity of the stone. It will be seen that the arcade pattern is continuous along the lower boundary from one end of the stone to the other, and that from the upper edge there depends a straight channel separating the triple-spiral group from the right-hand area of decoration. Although it is now clear that this stone was never intended to appear decorated in any position other than where it now is, it is possible, if only as an exercise in ingenuity, to consider the pattern conceived vertically but applied to a horizontal surface. If viewed so that the lozenges form the top end, the arrangement of detail approximates to the organization of patterns on some few upright stones here and elsewhere in Ireland. Can this be an extreme stylization of the tomb-goddess recumbent in front of her holy place? Is an arm to be read into the separating groove? Such an interpretation is by no means pressed, but it may stimulate further study of this impressive creation; probably the oldest work in terms of monumental art in western Europe.

A stone, much smaller and less well known, was found on Clear Island, Co. Cork (*Ill. 111*), and it probably once formed part of a megalithic tomb. It would appear to have been an upright and its central panel of spirals and indented border pattern on either side present points of comparison with New Grange. The chevron row across the top has parallels elsewhere within the Irish province, but not all these share the spirals. This stone is a very agreeable greenish-grey colour and a detail (*Ill. 112*) of the middle left portion shows the fine regularity of the pocked technique. There has been some difference of opinion as to what tools were used to produce this percussion method of cutting the patterns. There is no practical necessity to invoke copper or bronze tools for any stone work in megalithic tombs in Ireland or Brittany, and Professor O'Kelly's experiments suggest the use of a strong flint punch with a wooden

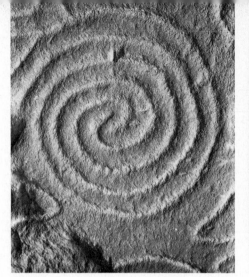

112, 113 Two details showing the punch technique of decoration. *Ill. 112 (left)* is a detail from the Clear Island stone (*cf. Ill. 111*) and *Ill. 113 (right)* is a detail of stone 22 at the Passage Grave at Barclodiad y Gawres, Anglesey

mallet. From a tomb that is an outlier on Anglesey of the Irish Passage Grave, or Boyne, group, *Ill. 113* is a detail of stone 22 at Barclodiad y Gawres. On this stone the general arrangement is similar to that on the Clear Island stone, but lozenges replace spirals in the centre. The percussion is less deep, and somewhat less regular in width. The running together of the various elements of the design is a common feature throughout the stone-work of the Irish province, and is well exemplified here. The decorated stones at Barclodiad y Gawres are of special interest in that, with one exception, the whole face of each of three slabs is covered by an integrated pattern. At this tomb, the excavators wondered if the pocked lines might have been to form a keying surface for colour, but it seems unlikely that the development of a stone-cutting technique had been brought about merely to serve this end.

In Brittany the spiral plays only a very minor role in tomb art. On the other hand, there are a number of boldly executed motifs some of which are directly pictographic while others involve dense curvilinear repetitions. The percussion technique is standard practice in this province also, and is seen in a detail from stone 21 in the passage of the great tomb on Gavrinis in the Golfe du Morbihan (*Ill. 115*). The central panel of this stone displays three rows of

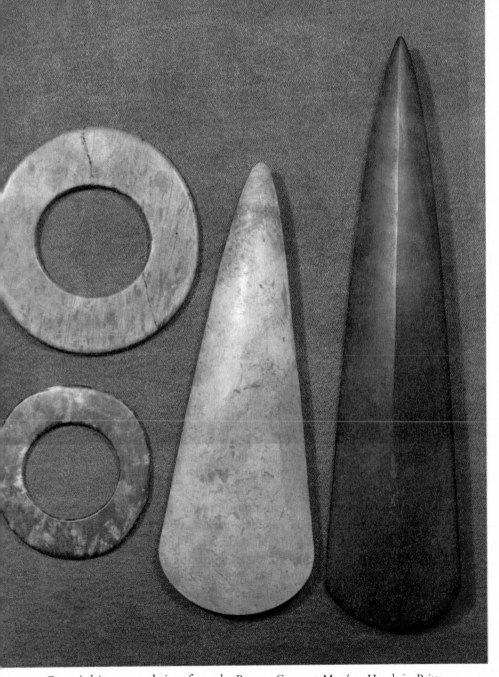

114 Green jadeite axes and rings from the Passage Grave at Mané-er-Hroek in Brittany

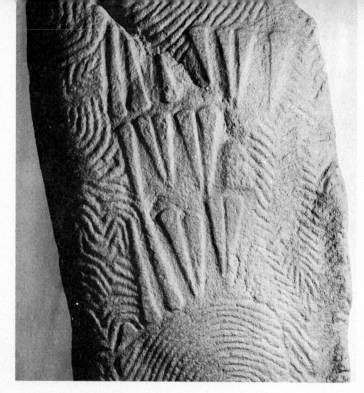

representations of pointed-butt stone axes of a kind well known in this region, many being made of specially selected fine rock including a translucent jadite (*Ill. 114*). These axe representations stand out in high relief, the whole background having been reduced by percussion. The surrounding curvilinear patterns are more profuse and compact than Irish examples, but Gavrinis is altogether remarkable for the dense ornamentation of all wall surfaces in passage and chamber. The end stone in the chamber of the tomb known as La Table des Marchands, Locmariaquer (*Ill. 116*) witnesses one of the most extensive applications of percussion reduction over the face of a stone so that the subject matter stands out in high relief. This photograph achieves an effect that might have been obtained had light been allowed to percolate into the chamber through a hole in the original covering of stones now long disappeared. The gable shape of the stone lent itself to a border pattern of a form known elsewhere in other tombs in the Morbihan, from which spring out short curved lines. Within the border pattern in the present case are

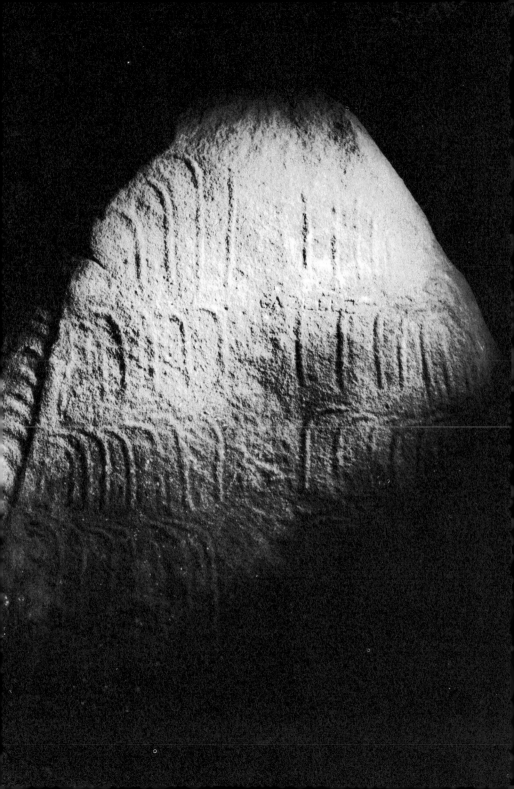

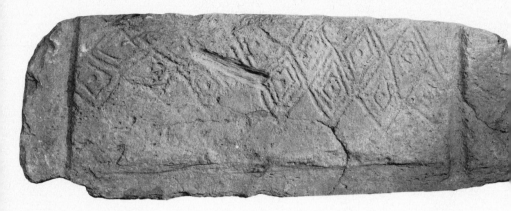

117 A stone slab from a Bronze Age cist grave at Badden, Argyll, shows that the mason was preoccupied with a timber technique. The grooves at either end are rebates to hold the end slabs and are better suited to a construction in wood

four horizontal rows of symmetrically placed curved objects, and there is an empty panel down the centre. The curved objects are like things held in the hand by some of the *statue-menhirs* in Languedoc, and also recall crook-headed cult objects made of schist from tombs in southern Portugal. Very varying interpretations have been put forward about this composition at Locmariaquer. In the present writer's view it, and other versions, suggest a hut shrine with straw or grassy roof. Inside this one, are rows of votive objects some attribute of the tomb-earth-goddess if originally only a hoeing stick. Whatever its meaning, it is a finely arranged design done on a large scale.

The technique of stone-cutting by percussion, and some of the motifs commonly employed, seem to have gone on in use over a long period of time, and to have been adapted to rather different funerary purposes by people much involved in the bronze industry, and with quite different European traditions. The stone slab found at Badden, near Lochgilphead, mid-Argyll, is a witness to this interesting situation (*Ill. 117*). The deep grooves at either end of the slab are rebates to hold the ends of shorter slabs at right angles so that a rectangular grave for a single person could be constructed in a technique more appropriate to timber. The peculiarity is the presence

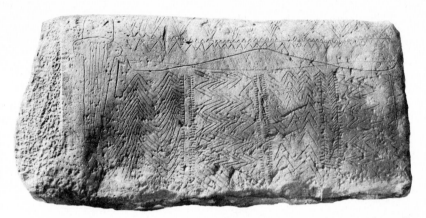

118 From a grave at Göhlitzsch comes a side slab decorated as if it were the wall of a house. The engraving represents wall-hangings and the belongings of the dead man, his bow, quiver and axe, hanging on the wall

of a pattern of lozenges executed by percussion, and in general aspect akin to the Boyne style. The Badden lozenges may have retained some inference of magical virtue, but it is also possible in the context of this kind of grave that they were intended to represent wall decoration or textile hangings such as the dead would have enjoyed in his house when alive. It is necessary to return to Middle Europe to find this concept well illustrated, but in a stone lined grave found at Göhlitzsch, Sachsen-Anhalt, the walls were richly decorated to represent hangings and belongings of the dead. This all is in line with a tradition going back to the Pontic steppes and the region of the Caucasus where remnants of textiles have been found in timber-built funerary chambers under tumuli. The technique employed on the Göhlitzsch slabs involved a very deep and sharp picked line, perhaps more likely to have resulted from a metal punch, and these lines were infilled with red and white colouring. One of these slabs (*Ill. 118*) shows a side of the 'dwelling'. Textiles in various patterns cover the wall, and to the left is a quiver with arrows. Next there is a small axe, probably of a metal type, and then a bow with recurved ends and bowstring. Here is quite a different outlook from that which informed the undertakers at Los Millares and New Grange.

Finally a little space must be given to the abiding skills of stone grinding and flint chipping. The continuous production of implements and weapons had gone on over the millennia, and the demand was not lessened through the initial discovery of metals but only from region to region as bronze became cheap enough for common use. Knowledge of metal shapes by people to whom it was still a much prized rarity led to an interesting response in some regions. Versions of exotic shapes were turned out in stone and flint faithfully incorporating details that were not essential to the efficacy of the product in stone. This art of substitution was carried to a high level in the Northern cultural region already noted for its tradition of fine pottery. *Ill. 119* shows four finely ground hard stone 'battle-axes' from scattered finds in Sweden. They belong to the so-called Boat-Axe Culture, a self-explanatory term, and they were made about the beginning of the second millennium by people whose ancestors and relations on the Pontic steppelands used copper or bronze shaft-hole axes. On these stone specimens, a thin longitudinal ridge represents a casting seam that would occur in the making of a metal axe in a bivalve mould. Similarly, the drooping blade has been given the shape that the metal form would have taken when hammer-treated after casting. Nor are the shoulders on either side of the shaft-hole necessary for strength in stone, but a wise precaution in the metal prototype. The axe on the left is closest to the pan-European type, but the other three, with a further rendering in stone of a collar projecting from the underside of the axe above the perforation, show a Swedish elaboration accentuating yet another metallurgical feature. There is both art and craft in these stone battle-axes showing high mastery of a difficult substance.

Some centuries later, flint workers in Denmark and southern Sweden were confronted with the challenge of bronze daggers brought north from central Germany. The result was a triumph of their craft, however doomed it was to be, and the flint dagger from Hindsgavl, Odense (*Ill. 120*), is a splendid example of fine regular flaking, executed on both faces, while the overall shape of a bronze weapon with blade, shoulders, hilt and pommel, are skilfully reproduced.

119 The Boat-Axe Culture is noted for its very finely ground stone axes. The examples illustrated come from scattered finds in Sweden. Evidence of this culture's contact with metal-using cultures may be seen in the casting seam on some axes which is faithfully reproduced in stone

120 The flint dagger from Hindsgavl is another superb example of flint workers copying a metal prototype

The Art of the Metalworkers

The development of the art and craft of working in copper, and gold, but principally in bronze that harder and more efficient alloy of copper with tin, brought about a great change in the nature of finely made objects. There was a new direction of interest towards personal adornment, and equipment whether for peace or war, and the first seeking for magnificence at the feast. A general decline in cult art as understood in the previous chapter had set in, but pottery styles continued to wax and wane with some very fine products emerging at various times and places. During the earlier part of the second millennium BC, prehistoric communities throughout the Eurasian zone became increasingly engrossed with participation in a new and stimulating material pursuit. It was not the first impact of bartered trinkets in gold and copper brought north from Anatolia or the Aegean that caused any change in outlook or mode of life, but it was the successful exploitation of metal sources, and the development of long distance organization to bring together separately won substances, copper and tin for bronze, that gave prehistoric communities an entirely new vision of space relations, of organization and diplomacy, and of economic problems beyond the seasonal fruits of the earth. These are the prosaic factors in modern analysis of such a situation, but for the participants how stimulating to the imagination must have been the relief from monotony afforded by sight of new faces, the passage of caravans, and the extension of individual and social identity through the possession of distinctive and gratifying objects of great negotiable worth. It must follow that the place of metal craftsmen became ever more assured, and the demands of patrons as well as the challenges of advancing techniques, and of competition, resulted in a great and varied production of highly skilled personal work. For the period of about a thousand years from the middle of the sixteenth century BC when

121 Made of thin beaten gold this pair of so-called basket-ear-rings were found in a youth's grave at Radley, Berkshire. Also found was a Bell Beaker, and a date no later than the seventeenth century BC is generally accepted for the burial

the European Bronze Age became fully established, and until after iron had replaced bronze as the basic economic metal, gold and bronze were by far the most important media for workmanship of quality and elegance, and it was within this period, too, that the concepts of barbarian taste were formulated that were to be prolonged at least as far as the Vikings. In contemplating the objects now to be described it is therefore admiration for craftsmanship that is mainly, but not exclusively, to be evoked.

The production of small objects from a thin sheet of beaten gold is the oldest technical process, and was introduced into Europe during the fourth millennium BC by the first copper workers. One may instance little cut-out goddess-figurines from Russe on the southern bank of the Lower Danube, and small perforated discs from Tibava in eastern Slovakia, as amongst the earliest. Work in gold wire followed soon after to provide simple finger rings, and tubular beads either of coiled wire or folded over sheet. The sheet work was sometimes embellished with small bosses, often hardly more than pimples pushed up from the underside. These simple processes enjoyed a very long life turning up in different shapes and contexts throughout the continent for some two thousand years. It would be difficult to speak of any formalized jewellery, and scraps of gold leaf and wire could so easily be reduced, and made up again, that it is remarkable any evidence at all survives. Towards the end of this archaic goldworking tradition appear some few recurrent types, and of these the so-called basket-ear-rings are of greatest interest. The pair from Radley, Berkshire (*Ill. 121*), were found in

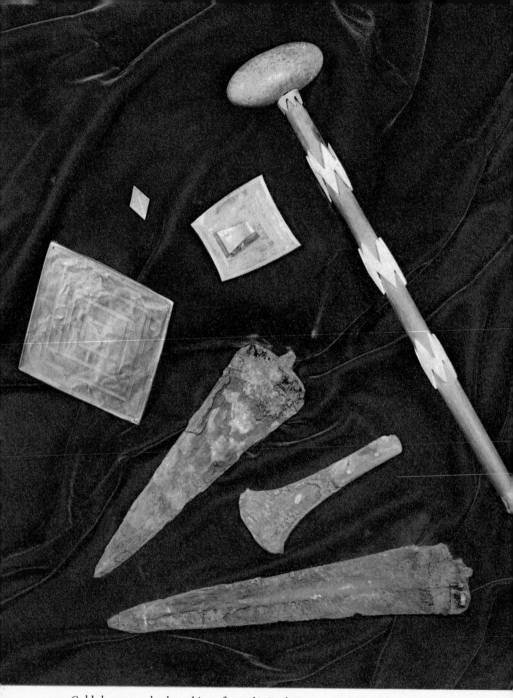

122 Gold, bronze and other objects from the Bush Barrow near Stonehenge, the burial of a chieftain of the Wessex Early Bronze Age, *c.* 1500 BC. The sceptre, a modern reconstruction, has its nearest parallel in the dentated bone shaft mounts from Shaft Grave B at Mycenae

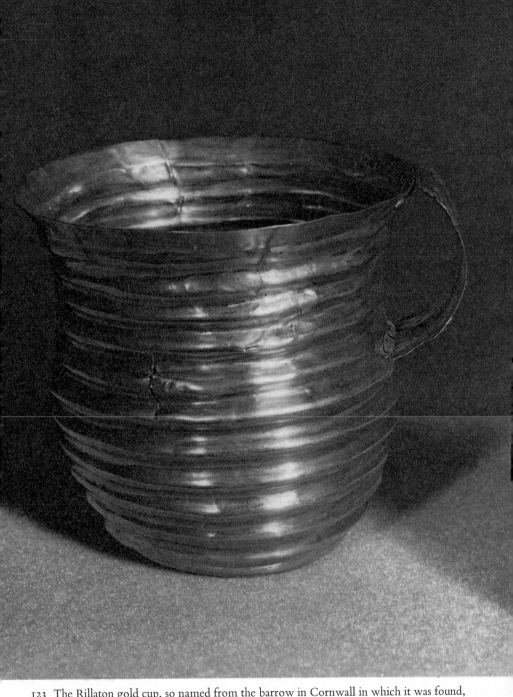

123 The Rillaton gold cup, so named from the barrow in Cornwall in which it was found, is a masterpiece of the Bronze Age goldsmith's art. It is hammered up from a single lump of gold and the handle is a separately added piece, held by gold rivets and washers, a technique that has parallels at Mycenae

a youth's grave with a Bell Beaker, and a date no later than the seventeenth century BC is generally deduced. The ear-rings are seen coiled up as found, and they each consist of a thin elongated oval sheet of gold with a spike extending from one side to form an ear-hook. For wearing, it was only necessary to uncoil the spike and bend it again to go through the ear lobe, then the curved sheet appeared as an open ended trough or basket. In these, Radley, examples there is a simple kind of repoussé decoration produced by means of punched up ribs. A pair run parallel to the main outline, one rib lies along the centre of each spike, and there are two clusters of close-set slightly oblique ribs in the middle portion of each ear-ring. These ribs are of greater than ornamental interest for the basket ear-ring has a more complex history than might appear. The oldest known version was in fact a complicated gold wire confection of which specimens are best known from Treasure A from Troy, ascribed to the second city (c. 2500–2200 BC). The ribs on the Radley ear-rings suggest coils of thick wire probably of intermediate central European types of heavier workmanship than the delicate Trojan specimens, and all this exemplifies a situation to be met with again of goldsmiths knowing only simple techniques attempting to simulate more complicated processes which they had not yet learnt. Some few gold basket-ear-rings with lightly incised linear decoration probably speak for an Iberian influence, and similar ear-rings have been found in Portugal. The Peninsula had received its own tradition of gold working from the same ultimate East Mediterranean sources as those which had penetrated into middle Europe by the Danubian axis.

A more positive phase in patronage for fine metalwork began in certain favoured areas of Europe towards the end of the sixteenth century BC. The evidence comes from a relatively small number of rich burials, especially from the Wessex area of southern England, and from Saxo-Thuringia, but also from scattered finds, and within the Carpathian Ring from hidden treasures, somewhat later in date, that betoken the downfall of prosperous magnates who do not seem to have had a custom of rich grave offerings. These accumulations of precious objects and greatly expanded individual paraphernalia,

indicate new princely attitudes, and they follow most interestingly both in pattern and time on the changes in Greece which brought about the totally unprecedented wealth of the Mycenaean Shaft Graves. The principal pieces surviving from the 1808 excavation of the Bush Barrow, near Stonehenge, best introduce the barbarian scene (*Ill. 122*). The corpse may be envisaged as having been laid on its back fully dressed and accoutred. A lozenge-shaped piece of sheet gold with incised decoration lay as a pectoral ornament, and had probably been sewn on to some garment. To his right lay the two daggers with the gold scabbard or belt hook, and probably here too was the small gold lozenge attached to some perished object. Nearby were the durable elements of the sceptre: the polished stone head, and the five carved bone mounts for the wooden shaft. The axe, made of copper, lay above the right shoulder. The decoration of the two gold pieces may be described as chased, being done on the outer surface with a fine graver probably of bronze. These plates have as yet no direct external antecedents. The belt hook was made in two pieces, the foot of the hook being hammered over to grip the back plate. The sides of the hook as well as the back plate were decorated with incised lines. The flat dagger blade was made of copper, and possessed a wooden hilt and sheath. The hilt's pommel had been embellished with a close pattern made up of several thousand minute gold pins, each one mm. in length. The extraordinary delicacy, both of making these pins and of inserting them in the wood of the pommel so that their heads overlapped to form a continuous scale-like surface, demanded skill of the highest order, and the method employed is not yet understood. The other and longer dagger blade is made of bronze, and is a more effective piece having a sturdy midrib. The method of casting these dagger blades is uncertain in the present stage of research, but they were very carefully finished, the whole surface being ground and polished. The gold work is probably insular, the dagger blades and axe have parallels in Saxo-Thuringia, but the sceptre raises a peculiar problem. First it must be said that the polished mottled brown head is formed of an egg-shaped fossil (*amphipora ramosa*) which could have been picked up in Devon. Attractive stones perforated and mounted as

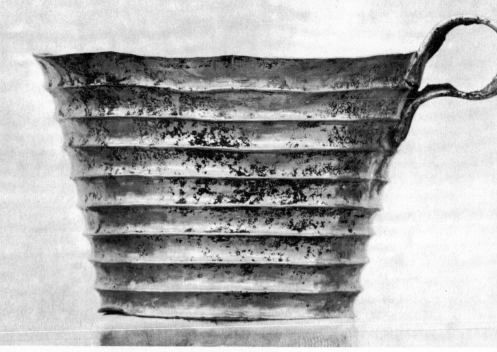

124 This gold cup from Shaft Grave IV at Mycenae with its ribbed walls is technically allied to the Rillaton and the Fritzdorf gold cups, *Ills. 123, 125*

functional or ceremonial mace-heads have older antecedents in Britain but also widely in the Ancient World. The carved bone mounts which seem to have belonged to the same object have a single and most distinguished parallel. The very special carving of these dentated tubular mounts for the shaft is closely matched in slightly smaller specimens from Shaft Grave *Iota* in Grave Circle B at Mycenae. There is small likelihood that such particular carvings were of common or widespread use in Bronze Age Europe, and the sceptre was an acknowledged symbol of god-derived authority in Homeric tradition. The mere existence of this object in the Bush Barrow, whether or not the stone head is a barbarian addition, points to a Mycenaean precedent in funeral style. The beginning of Late Helladic I, the period of the Shaft Graves, is placed on considerations of Egyptian history that may bear on it, and of Egyptian and Mycenaean archaeological correlations, to the mid-sixteenth century BC. The Bush Barrow might then well fall about 1500 BC.

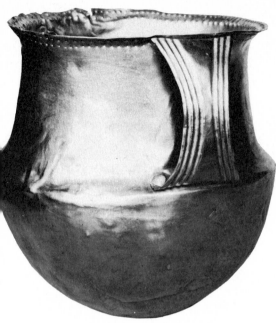

125 The Fritzdorf gold
cup has close parallels,
particularly in its style of
handle and attachment,
to the Rillaton gold cup,
Ill. 123, yet this type of
cup probably also in-
fluenced the shape of the
amber and shale cups
found in certain Wessex
Culture graves subse-
quent to the Bush Bar-
row interment

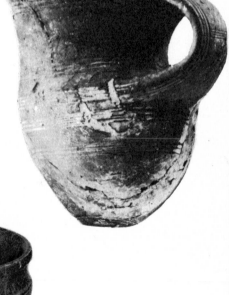

126, 127 The shale cup from the Salisbury area
(*right*) is typical of numerous specimens in this
material. The finest examples of this type of cup
occur in amber, as the example (*below*) from a
Wessex Culture grave at Hove, Sussex. It is
carved from a single piece of amber and is a little
squatter than the specimens in gold and shale,
probably due to the shape of the original lump
of amber

There was no precious drinking cup discovered in Bush Barrow, but the fashion for such was soon known in Britain, and reveals points of technique that point to Mycenaean exemplars. Outstanding is the small gold cup from Rillaton, Cornwall (*Ill. 123*) which was found in a grave with a fine bronze dagger of somewhat later type than those in the Bush Barrow. The Rillaton cup was hammered up from a lump, and the thin walls were strengthened by being corrugated or fluted horizontally. This seems to have been done by working on the outer surface, the interior of the cup being filled with some semi-resistant material such as pitch. The cup's base also shows a pattern of concentric ribs. The handle is a strip of gold bent over at either end and held to the wall by circular-headed gold rivets beneath which lie lozenge-shaped gold washers that reduced tension on the thin wall. The handle is decorated by a series of broad grooves following the line of either edge, and this is an important stylistic link. The Rillaton cup is clearly a product of much experience as well as feeling for shape and the properties of the material. If it ever becomes possible to identify the source of the gold it will be easier to say if it is likely to have been an actual Mycenaean import, or if made in Britain, but necessarily at the hands of a man trained at such a centre. The technique of horizontal fluting is well known at Mycenae, and is exemplified here (*Ill. 124*) in a gold cup, one of a pair, from Shaft Grave IV of Grave Circle A. In this the ridges are more angular than in the Cornish vessel, the shape is different, and the broad-headed rivets were not supplied with washers.

A gold cup of yet another shape, but with links in both directions, was found at Fritzdorf near Bonn, in the Rhineland (*Ill. 125*). It was found hidden in a large pottery vessel which has not survived. This is a single splendid piece of smooth sheet gold again beaten up from a single lump, and it has recently been suggested that the carinated shape derives from the form of a plain gold kantharos found in Shaft Grave IV. The Fritzdorf cup has only one handle, not a pair as on a kantharos, but that handle is almost identical to Rillaton both in shape and decoration, and in the employment of lozenge-shaped washers behind the rivet heads. As befits a larger vessel, Fritzdorf

has four rivets at either end of the handle while Rillaton has three. The double line of pimple bosses around the everted rim of the Fritzdorf cup should be noted, and these were executed by free hand repoussé after attachment of the handle, and are not very regular. There is a small concavity, or omphalos at the centre of the rounded belly of this cup. The shape of the Fritzdorf cup explains in all probability that of a number of cups in amber and shale found in certain Wessex Culture graves subsequent to the Bush Barrow. Such is the amber cup from Clandon in Dorset, and all the shale cups for which *Ill. 126*, of one in the Salisbury Museum of unknown find-spot, stands representative. The amber and shale cups appear to have been turned on some kind of simple lathe, and much dexterity was involved to make provision for the handle. These handles faithfully reproduce in shape and decoration the type of Rillaton and Fritzdorf. The finest of amber cups comes from a Wessex Culture grave at Hove, Sussex (*Ill. 127*). It was found in a tree-trunk coffin with a bronze dagger and a ceremonial stone battle-axe. The shape is broader and squatter than the other cups, but this was probably determined by the shape of the lump of amber to be carved. The zone of close grooving below the neck is similar to thinner bands on the shale cups, and the handle is decorated in the same way. A very splendid and valuable possession that presupposes a setting for its owner of corresponding values and complexity. The shale for making cups was obtained around Kimmeridge in Dorset, but the amber had to be imported, and it is believed to have been gathered on the coast of Jutland whence it was traded south, up the Elbe, most of it going on to Mycenaean Greece, but some travelling west to patrons in southern England. From Jutland, amber seems to have been mainly exported in the raw lump, and the question as to where it was carved, either into cups, or into spacer beads with complex borings, remains difficult of solution.

It is probable that the people of the Wessex Culture obtained gold from Ireland where it occurred until much more recent times in nugget form in streams of the Wicklow mountains. It is remarkable that Irish Bronze Age chieftains do not seem to have been buried with gold ornaments, but about the fifteenth century BC Irish

goldsmiths were perfecting an attractive crescentic neck ornament usually referred to as a *lunula*. This was formed of a thin sheet of gold hammered flat and cut out, and normally decorated in geometric patterns by a tracer around the edges and over the terminals of the upper face. The lunula found near Killarney, Co. Kerry (*Ill. 130*) is one of the finest examples, and the detail of one terminal (*Ill. 129*) shows well the nature of the tracer work with a prominent pattern of blank lozenges. There are Irish bronze axes with similar decoration, and a question exists as to what is the relationship of all this to the art of the Irish Passage Graves, and the schist plaques of Portugal. In Ireland, lunulae have always been found in circumstances suggesting hidden treasure or votive offerings. Some travelled overseas, but there is a scatter of related types in north-western Europe that seem to derive from a common source with the Irish, and this is now sought in the Iberian Peninsula where a less elaborate form is known from a find at Cabeceiras de Basto in Portugal. Farther afield there is the long-known silver lunula from Villafranca near Verona in northern Italy. A question arises as to whether lunulae are not sheet-metal versions of bead necklaces, and those of the developed Irish type, such as this one from Killarney, may so be in two ways: by origin of its southern prototypes, and by influence from a particular type of bead necklace widely known at the time of the Wessex Culture. This is the crescentic necklace with flat spacer beads spanning the arms that was known in amber both in Mycenaean Greece, and in southern England. Amongst contemporary communities in Scotland jet was substituted for amber, and a number of well preserved necklaces of this substance have been found in burials. That from Poltalloch, Argyll (*Ill. 128*) is an outstanding example. The position of the beads have been carefully recorded in several cases, and the restringing is reasonably accurate. The dot-line decoration on the Poltalloch spacers resemble the patterns effected by complex borings in amber spacers so that the strings showed through the translucent substance in this manner. With a similar jet necklace was found in a burial at Melfort, Argyll, a pair of fragile bronze bracelets of which one only survived (*Ill. 131*). This bracelet was not cast but beaten up from a small ingot, and

136

128 In Scotland jet was substituted for the more valuable amber, but similar styles for neck-laces were followed in the variant material. The spacer beads in particular, as seen here in a specimen from Poltalloch, Argyll, reflect the complex borings found in amber examples and the dotted decoration represents where the strings would show through in a translucent amber bead

decorated by repoussé with small lenticular bosses. The outline of the bosses was touched up with a tracer, and the same tool made the encircling lines. It looks very much a piece of most painstaking work by a man who was making do with bronze instead of gold.

129, 130 The Killarney *lunula* is one of the finest examples of its type. It is a vexed
question whether the lunulae are in fact metal copies of necklaces after the style of
the Poltalloch necklace, *Ill. 128*. The style of the linear decoration on the detail
(*opposite*) should in particular be compared with that of *Ill. 128*

The great tumuli containing chieftain burials in Saxo-Thuringia
have already been mentioned. These dominated a wide countryside
intensely occupied since the beginning of the neolithic, and the
river Saale is its principal natural feature, while not far away were
the metalliferous resources of the Harz mountains, and in the other
direction the great water highway of the Elbe. These chieftains'
graves, of which some six are known, were richly equipped with
bronze daggers related to those from Wessex, and there are other

131 Found with a jet necklace similar to the Poltalloch specimen, this fragile bronze bracelet from Melfort, Argyll, was one of a pair. It was beaten out of a single bronze ingot, great care being taken in the repoussé work of the small lenticular bosses and the touching up with a tracer. It gives the impression of the work of a smith making do with bronze instead of gold

important archaeological links, but the gold work was of a different tradition. From the tumulus near Leubingen, Kr. Sömmerda, south-west of Halle, came a pair of substantial gold dress pins of a type well known in bronze, a coil of gold wire probably a hair ornament, two coiled finger rings, and a heavy bracelet of solid gold with chased rib decoration (*Ill. 133*). As opposed to sheet-work in the west, here introduction is made to bar-work, and little is yet known of the antecedents or range of the goldsmiths who wrought for the chieftain at Leubingen. Bar-work in gold was to reach the west in due course, perhaps from more than one direction, and there to have its own particular western characteristics. Other remarkable Saxo-Thuringian gold pieces include the plain bracelet, and pins, from the Helmsdorf barrow, and in the hoard, one of several, from Dieskau, a solid gold axe and a silver ring. The axe is of a simple shape well known regionally in utilitarian bronze, but the concept of turning out golden weapons for display or ritual stems from ancient oriental practice, and more immediately from a fashion for such things amongst magnates living along the river Tisza in eastern Hungary, and in Transylvania. Witness the solid gold axe with elaborate butt (*Ill. 132*) from Tufălau (Cófalva), and here were found in all five gold axes, as well as spiral decorated gold discs

140

132, 133 The gold axe (*above*) from a hoard of five found at Tufălau must have been produced by casting in a mould, as with the more usual bronze axes, but intended solely for use as a parade or ritual item. The hoard of gold (*below*) comes from the burial of a chieftain at Leubingen. The introduction of bar-work is apparent here as against the more familiar sheet-work of the west

(*Ill. 134*), lock-rings like those in *Ill. 135*, and other pieces. There is no doubt that apart from the material, this axe is a finely made and well proportioned object. These heavy pieces must presumably have been produced by casting in a mould as were certainly a whole series of bronze battle-axes from the same region; many of these latter being decorated with finely incised running spirals. In the same spirit must be explained a solid gold sword found in recent years at Perşinari-Ploieşti in the Rumanian province of Muntenia. The surviving fragment suggests a Mycenaean prototype. The gold-leaf discs from the Tufălau (Cófalva) hoard, of which two are here illustrated (*Ill. 134*), display an able design of running spirals with dotted border patterns all executed by repoussé. Their connection with Mycenaean motifs is undeniable, but not so certainly with anything from the Shaft Graves nor from Mycenae itself amongst strongholds of the period of expansion in the fifteenth and fourteenth centuries B C. Whatever the circumstances of the amassing of wealth and luxurious fancies by Carpatho-Danubian magnates may have been, their metalwork both in gold and bronze proved a powerful stimulus throughout middle and northern Europe in the period that followed the Leubingen and Wessex Cultures.

134 Two gold spiral decorated discs from the same hoard at Tufălau as the gold axe, *Ill. 132*. The decoration of a running spiral in its variant forms is a favourite theme throughout the Mediterranean as well as in Europe

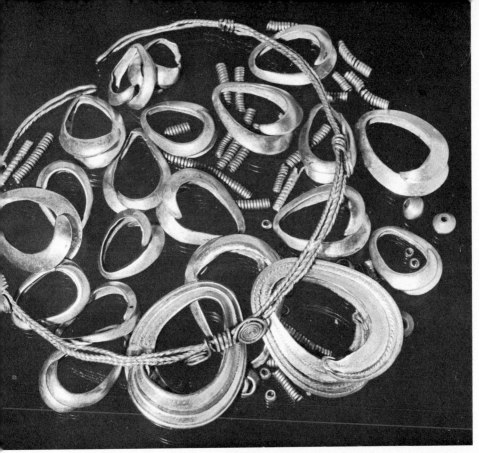

135 A gold treasure from the Bronze Age village at Barca in eastern Slovakia is interesting in providing apparent prototypes for many ornaments in bronze as far west as Britain and Ireland

In pursuing this change, an important find is the gold treasure from a Bronze Age village excavated by L. Hájek at Barca near Košice in eastern Slovakia (*Ill. 135*). The elegant claw-like sheet gold objects are lock-rings for adorning tresses of hair, and are a well-known type in the Carpathian region, and found in bronze as far east as the Caucasus. There are also coiled wire hair ornaments of ancient type, and then the bracelet, or small arm ring, composed of strands of twisted bar bound together with plain wire some terminating in spirals. Two main strands are seen to be unfinished or torn out. The Tufălau (Cófalva) hoard also contained a small twisted gold armlet with spiral terminals, and ornaments of this kind are

143

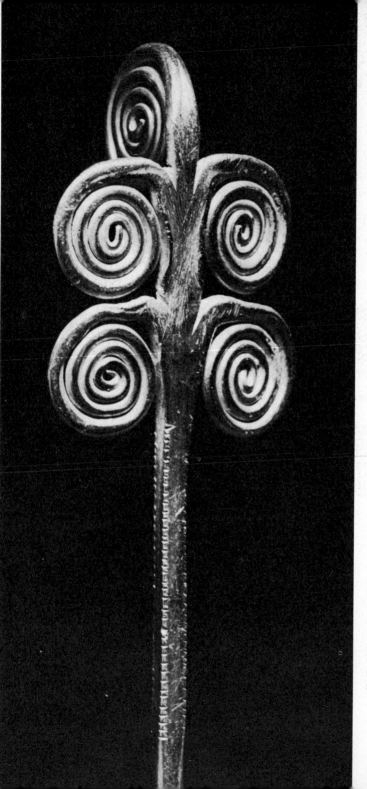

136 This unique, large, gold pin comes from a hoard found at Trassem, near Trier. The manner of cutting and curling the gold into spirals and the nicked decoration on the edge of the shaft can be clearly seen

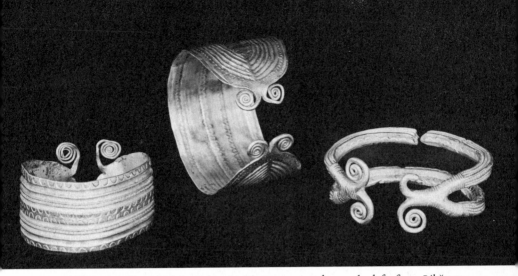

137 Gold bracelets from finds in Bohemia. The two examples on the left, from Libčeves, are of rigid sheet gold whilst the example on the right, from Větrušice, is of unusual style with two separate bars joined at the ends and terminating in spirals

likely to have been the forerunners of less precious versions in bronze that were popular in northern Germany by the thirteenth century BC, and had their influence on fashion in both Britain and Ireland.

Note must next be taken of some handsome gold bracelets from finds in Bohemia (*Ill. 137*). The two on the left in the photograph are of thicker, therefore more rigid, sheet than anything so far discussed. The decoration is chased, the inside surfaces being quite smooth, and the most characteristic feature is the splitting of the terminals with the strips turned back to form spirals. The other bracelet is unusual in that it is constructed from a pair of bars brought together at the ends, and again with turned back spirals. Bracelets of this general kind in bronze are common over a wide area, but seem to have originated amongst Bohemian craftsmen. A unique large gold pin with multiple spiral head was found in a hoard at Trassem near Trier (*Ill. 136*). The photograph shows how the gold was originally cut and coiled into spirals, and how the shaft was squared up with the edges finished by nicking. Spiral headed pins had a high antiquity in the Levant, and this piece may be older than the other objects in the hoard, but the technique seems close

145

to that of the Bohemian bracelets, and another item in the Trassem hoard was a twisted-bar gold arm-ring proper to this phase in gold-work. There is a bronze pin with eight small spirals round its head from Føllenslev, Holbaek, in Denmark, that may well be a copy.

The appearance of the wearers of all these gold ornaments must be very conjectural, and unless the objects are found in graves it can seldom be deduced even to which sex they were appropriate. Some clue to the well dressed appearance of women of the Bronze Age along the Danube is obtained from ceramic figurines known from a number of sites near Belgrade, and further downstream. From a cremation cemetery at Cîrna, close to the Danube in Oltenia, are known some nine complete figurines of which *Ill. 138* is a good example. The colour is a reddish-brown, and the incised decoration is in-filled with white paste. The full, bell-shaped, skirt is hollow, and the upper portion of the body is reduced to a flat highly stylized projection. The arms distinctly sweep round to indicate hands resting above the waist, and the head is little more than the apex of the whole. The decoration for the most part seems to represent em-broidery, and there is a general likeness to Rumanian peasant dress as it still survives in the Banat. It is difficult to be sure about representations of metal ornaments although some have been claimed, and much cruder clay figurines from the Barca excavations display a type of pendant well-known in gold and bronze. The woollen textiles preserved in tree-trunk coffins of Bronze Age people in Denmark provide direct information on more simple northern clothing, and the way in which some regional kinds of bronze ornaments were worn.

A return must now be made to the subject of twisted gold orna-ments, this time in Britain and Ireland, and beginning with the substantial neck ornament, properly a torc (*torquis*), found in 1960 at Moulsford near the Thames in Berkshire (*Ill. 139*). It consists of four bars of square-section that have each been twisted to produce a scintillating effect. The ends are enclosed in a pair of caps made of single sheets curled round and splayed outwards where they are held by a circular closing piece hammered down over their edges. The surfaces of sides and ends of these caps are ornamented with

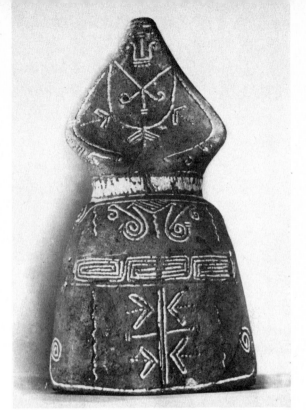

138 A pottery statuette, one of several from a cremation cemetery at Cîrna, Rumania, in the form of a stylized female figure. It has been claimed that the decoration possibly represents embroidery, such as is found today on the garments of Rumanian peasants

finely traced hatched lines and related motifs (*Ills. 140, 142*). Also to be noted is the thin twisted bar binding together the four major strands (*Ill. 141*). It is suggested that there was at least one other binder now lost. Professor C.F.C. Hawkes has drawn attention to the combination of gold working traditions in the Moulsford torc. There is the solid twisted-bar fashion newly introduced from east of the Rhine, and there is the fine tracer decorated sheet-work stemming from Irish and Wessex practice. A point interesting from more than one aspect is whether Moulsford and similar gold pieces should be regarded as copies of cast bronze mock torsion neckrings introduced to these islands at about this time from northern Germany, or whether it can be maintained that mock torsion bronzes were never more than humble approximations to gold. In view of the low survival chances of gold ornaments to stand witness, there is no point in pressing a resolution, but the Moulsford torc is not so far removed from the Barca armlet (*Ill. 135*) in principles of

147

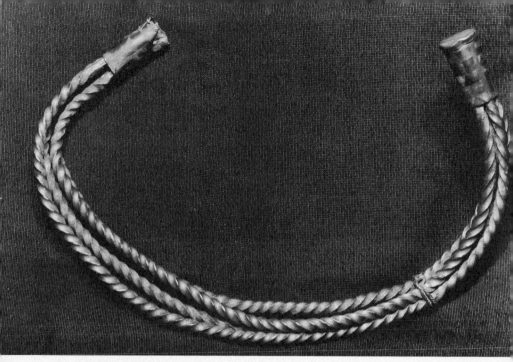

139 The Moulsford torc illustrates a combination of goldworking techniques; the solid twisted-bar technique from east of the Rhine and fine tracer decorated sheet-work, familiar from Wessex and Irish examples

construction. An informative and interestingly varied gold hoard was found deep in a bog in 1959 at Derrinboy, Co. Offaly, Ireland (*Ill. 143*). There are a pair of cuff-like bracelets in which all edges have been hammered over to produce a strong rim. The decoration consists mainly of ribs executed in repoussé, but some work was done with a punch on the outer face. There are a pair of tress-rings fashioned in the same way as the bracelets out of rectangular sheets of gold bent to a cylinder with ends touching, and edges hammered over. Their decoration consists of very fine close set horizontal lines apparently done with a graver, and covering the whole surface. Then there is a length of thick copper wire, and finally a unique ornament, presumably a neck-ring, made of a sewn leather thong around which was closely bound a thick gold wire. The terminals are held together in a small plain cap similar in shape and function to those of the Moulsford torc (*Ill. 140*). The continuous gold wire used to cover the leather core was over fifteen metres in length. It

140–2 Three details of the Moulsford torc illustrate (*above left*) a side view of one of the terminal caps with its finely drawn tracer decoration, which may be seen again in the fine quartering on the top of the cap (*left*). (*Above right*) A detail of the single binder and the twisted-bar technique. It has been suggested that there was at least one other binder around the torc

149

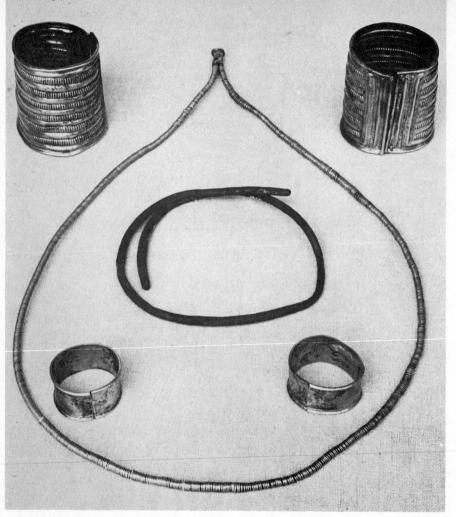

143 The Derrinboy hoard was found in a bog and dates from the Middle Bronze Age. Of particular note is the neck-ring made of a sewn leather thong which was then bound with a continuous piece of gold wire fifteen metres long

is D-sectioned, and one mm. wide. This operation alone speaks for the high technical mastery of Irish goldsmiths at this period. The Derrinboy bracelets follow a type well known in northern Europe during the twelfth to tenth centuries BC, and the close binding of the neck ornament certainly approximates in effect to the tight ribbing of mock torsion bronzes, for these resulted from skill in preparing the mould not from manual twisting.

The gold armlet from Stanton, Staffordshire (*Ill. 144*) belongs to a fairly large group of ornaments of Irish origin that are roughly contemporary with the Derrinboy hoard. These are either torcs for the neck, armlets, or very large specimens such as those from Tara, Co. Meath, or Ysgeifiog, Flintshire, North Wales, which are likely to have been made for votive purposes. The principle of construction in this group was to groove and hammer up longitudinal flanges from a round-sectioned bar. The extremities were left smooth and round while the main length assumed a cruciform section. This flanged section was then twisted, and the result produced deeper, more scintillating, ridges than those achieved in a bar-twist torc. It is thought that the principal reason for Irish goldsmiths resorting to the flange-twist method was that they were as yet unable to use solder. Lighter ornaments, both ear-rings and neck-rings, could be made if two rectangular strips of sheet gold were folded down the centre and these folds soldered back to back so that four thin strips stood out at right-angles. The whole could then be twisted, and such confections, especially as ear-rings, were first made around the shores of the eastern Mediterranean, whence the art travelled west first to the Gulf of Lions.

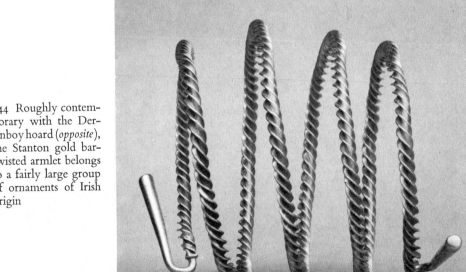

144 Roughly contemporary with the Derrinboy hoard (*opposite*), the Stanton gold bar-twisted armlet belongs to a fairly large group of ornaments of Irish origin

145-7 The sheet-gold shoulder ornament from Mold in North Wales is the largest surviving piece of gold-work from the British Bronze Age. Details shown here illustrate

In area and elaboration, the largest of all pieces of gold-work from the British Bronze Age is the broken sheet object found wrapped round the bones of a skeleton in a grave under a tumulus near Mold, Flintshire, North Wales (*Ill. 145*). The discovery was made in 1833, and was subject to no care or accurate observation. A large quantity of amber beads were found in the grave but mostly perished when 'tested' over a fire, and only one now survives with the gold fragments in the British Museum. This again is an unparalleled piece. It was made of a continuous sheet of quite thick gold evidently beaten over a block or form to the required shape of a stiff cape or pèlerine. The surface was then entirely covered with repoussé ribs and bosses forming an elaborate pattern rather like rows of beads, but the flow of the lines, sweeping down at the chest and back, and up at the shoulders, suggests the fall of cloth (*Ill. 147*). The gold sheet was strengthened at the back with strips of bronze, and numerous holes along the edges also suggest sewing to a leather or textile backing. The magnificence of the work can be further appreciated from the photographs of detail, and the fine milling round each of the larger bosses, and parallel to the ribs, show the extraordinary care that was lavished (*Ill. 146*). The rich ornamentation of the Mold cape can only be compared with that on three quite differently shaped objects. These are the rigid cone-shaped

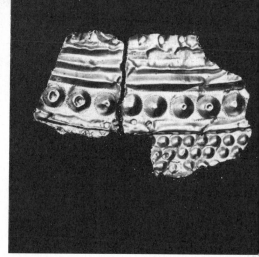

(*above right*) the milling around the bosses and along the ribs, and (*below*) the variety of repoussé bosses

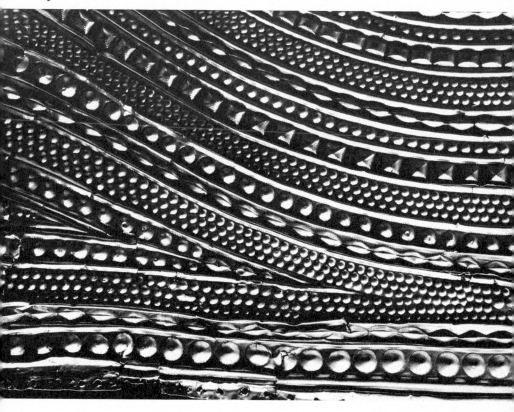

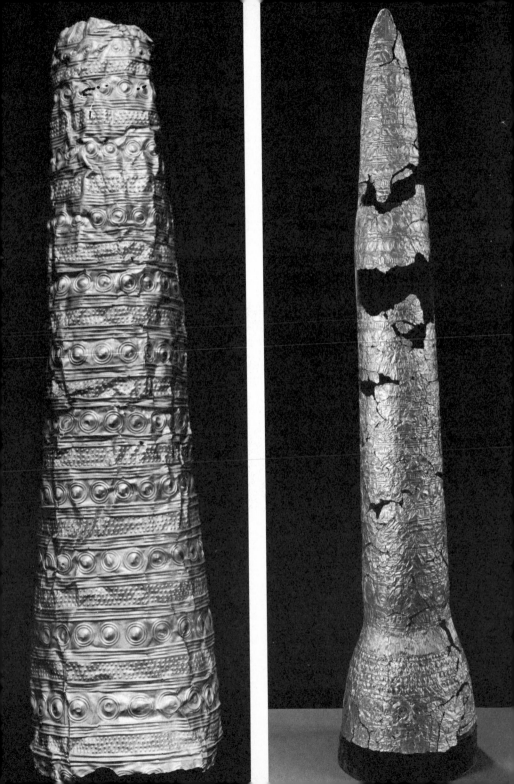

'hats' found one at Avanton, Vienne (*Ill. 148*), and one at Schiffer-stadt, Speyer, and the gold leaf skin of a now perished post-like object found at Etzeldorf-Buch near Nuremberg (*Ill. 149*). All are profusely covered with boss and ridge ornament. With Mold, they all share zones of small rounded bosses, and plain ribs. Lenticular bosses are shared by Mold, Schifferstadt, and Etzeldorf, but large circular bosses with encircling ridges are unknown to Mold but common to the three continental pieces. It will be recalled that lenticular bosses occur on the Melfort bracelet (*Ill. 131*), and Mold displays some quite unique shapes. Boss-and-ring is a dull repetitious motif turned out in great quantity in gold and bronze in central and northern Europe from about the twelfth century BC continuing for many centuries, but its origins were more southern. On all accounts at present, it seems likely that Mold, possibly a product of Irish gold, stands near the head of this kind of work with the other pieces following. The bronze axes found with the Schifferstadt piece help to fix a position that is not likely to be later than 1000 BC, but sheet-gold work with this kind of profuse decoration was to last somewhat longer, and a piece likely to be of the tenth or ninth century BC is the diadem from Velem Szentvid, south-west of Köszeg in western Hungary, close to the modern frontier with Austria (*Ill. 150*). The diadem is a noble piece, but less interesting in detail of its ornament for paucity of motifs. A dot-boss with five encircling rings is the major feature, and otherwise the space is filled up with panels and lines of short repoussé strokes and zig-zag lines. It is probable that the dot-and-circle motif was executed with a die stamp made of bronze into which the gold sheet was beaten from behind. The diadem was also backed by a bronze strip, and the few surviving fragments show ornament corresponding to the gold overlay.

Before the end of Mycenaean civilization which collapsed at the close of the thirteenth century BC, many techniques in metal work-ing, and skills such as spoke wheel construction, and chariot building, had been learnt by trans-Alpine craftsmen. In the ensuing period, when Greece no longer drew off the resources of the barbarian world, the dwellers within the temperate land-mass to the north 155

◀ 148, 149 A gold 'hat' from Avanton, Vienne (*left*) and (*right*) gold leaf from a post-like object found at Etzeldorf-Buch near Nuremberg

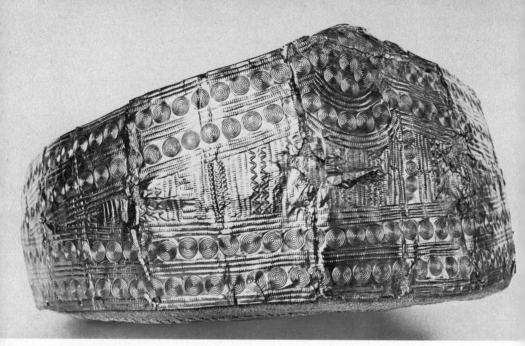

150 A gold diadem with repoussé ornament from a hoard at Velem-Szentvid, Hungary. The design was probably produced by beating gold sheet into a bronze die, and then backing it with a bronze strip

increasingly turned to making things for their own use. For one thing, there was much more metal available if compelling markets in the far south no longer existed. Much importance seems to have been attached to drinking vessels, and the gold cups from Angyal-föld, Budapest (*Ill. 151*) show an advanced stage in this craft probably contemporary with the Velem diadem. Of the four cups in the Angyalföld hoard, the three here illustrated are in Budapest, and the other is in the British Museum. Beaten bronze vessels with repoussé ornament are known from finds of the twelfth, perhaps late thirteenth, centuries B C, and of these the group found at Dresden Dobritz show leading types (*Ill. 152*). The broad ends of the handles with wide rivet heads are a technical advance, and while the cups are made of a single sheet, the larger vessel is made of two pieces: a foot and a body formed of a sheet bent round and riveted. There were a pair of cup-shaped perforated bronze strainers in this hoard, and it has been suggested that wine drinking services may have made their first appearance north of the Alps at this period.

151, 152 Illustrative of the importance attached to drinking vessels are the gold cups from Angyalföld, Budapest (*above*), and the sheet bronze vessels (*below*) from a hoard at Dresden Dobritz

153 The Trundholm 'sun-carriage', from a peat bog in Denmark, shows connections with the wheeled cauldron carriages of the eastern Mediterranean and the wheels are the four spoked variety found in Egypt and Mycenaean Greece

The difficulty of dating some gold work at sight is exemplified by the cup found in a grave at Gönnebeck, Holstein (*Ills. 155, 156*). The associated objects included a bronze sword of a type that makes the assemblage perhaps as much as two centuries older than the date ascribed to the diadem from Velem Szentvid, yet the cord-like ribs and boss-and-ring are not very different. The Gönnebeck type of cup was copied in pottery both in Germany and in Ireland whence some few had doubtless come in the course of the opening up of trade connections that brought the influence of the mock torsion bronze neck-rings amongst other elements. In Denmark there have been a large number of finds of gold cups in peat bogs apparently votive offerings. It is considered that these were imported from farther south in Europe, and those in *Ill. 154*, which are dated later than Gönnebeck, help to fill out the time span of the style in general.

154–6 The great wealth of objects in gold and bronze found in graves, hoards and casual finds in Denmark, southern Sweden and neighbouring Germany testifies to the prosperity of the northern Bronze Age peoples. *Ill. 154 (above)* shows an animal-headed handle cup from Lavindsgaard and two vessels from the Borgbjerg hoard and *Ills. 155, 156 (below)* show a gold cup from a grave at Gönnebeck

The animal-headed handle of the cup on the left in the photograph, which is part of a hoard found at Lavindsgaard, is an embellishment not known outside Denmark, and examination shows that it was not part of the original work. The other two vessels are items of the Borgbjerg hoard, and individual motifs can easily be paralleled in the other pieces illustrated. The great wealth in gold and bronze objects found in graves and hoards and casual finds in Denmark, southern Sweden, and neighbouring parts of Germany, testifies to the prosperity of the northern Bronze Age peoples. Their initial purchasing power seems to have rested on their export trade in amber, and they were not content merely to import other peoples goods, but to acquire raw materials so that they developed one of the finest bronze industries in Europe from about the beginning of the fourteenth century BC. The famous 'sun carriage' found in a peat bog at Trundholm in Denmark (*Ill. 153*) is more likely to have been a native masterpiece than an import, but it must have had a considerable body of experience of more southerly origin behind its manufacture. The carriage of six wheels, on which all moves, is akin to certain four-wheeled model carriages bearing 'cauldrons', and all possess wheels with four spokes which was the basic type in use by chariot builders in Egypt and Mycenaean Greece. The idea of wheeled ritual vessels had long been established in the Levant, but first made its appearance north of the Alps, with so many other things, towards the end of the thirteenth century BC. The sun disc consists of two slightly convex plates elaborately but differently ornamented with spirals and concentric circles, one face at least had been covered with fine gold leaf pressed on so that it accommodated the underlying ornament. The horse is a remarkable feat of hollow casting, and the clay core shows through a break in the back. As an animal it is somewhat stiff and formalized, experimental rather than stylized, but it was modelled with no rough steppe pony in view. Better horses were needed to run under chariots. The horse's tail is hollow and presumably held a tuft of hair.

A revealing monument of about the same time is the stone lined grave found under a large cairn at Kivik, Skåne, southern Sweden. The stone slabs have suffered various mishaps, but of eight slabs seven

157, 158 Two carved slabs from a stone-lined grave at Kivik, Skåne, show the orderly style found in this unique Swedish monument with its neat frames and subject-matter. The four-spoked chariot wheels in *Ill. 157 (left)* should be noted, *cf. Ill. 153*

were certainly carved, and of these here shown are two (*Ills. 157, 158*). Unlike the stone-cut decoration of megalithic tombs described in the last chapter, and the various magical carvings on rock surfaces in Scandinavia, where the subject matter runs freely over the surface of the stone without restraint, the Kivik slabs possess regular bordering frames, and the subject matter is arranged in a most orderly manner. The technique appears to have been very close reduction of the surface probably with a metal tool. The carvings show in the photographs darker than the natural stone owing to modern painting. *Ill. 157* shows slab no. 7, as it has been replaced and recorded, and this is the most informative so far as subject matter goes. The iconography cannot be examined in this space, but it will

161

be seen that there are three registers within the panel: chariot and men at the top, wild creatures in the middle, and a procession led by a man at the bottom. At least one other panel was organized in this way, but there are four panels arranged like that of slab no. 3 (*Ill. 158*) in which schematic horses, or detached wheels, or undetermined objects, alternate with a geometric pattern. A schematic ship is revealed on one of the Kivik slabs, and this is a subject of common occurrence amongst the carvings on natural rock surfaces in southern Scandinavia, not to be classified as art, and also it is found engraved on bronzes, especially on those thin blades assumed to be razors.

The razor from Hvirring, Aarhus (*Ill. 159*), and the razor and tweezers from Solbjerg, Aalborg (*Ill. 160*), are good examples of the fine curvilinear incised decoration that developed in Denmark during its fifth Bronze Age phase. This was the final period of glory for the northern craftsmen in bronze before iron reduced their hold. A finely designed ship with possible sun symbols and a stylized bird, a cock judging from its tail, are seen on the Hvirring blade, while a composition of five ships is arranged on the face of the Solbjerg razor. An upturned projection of the keel as a double prow will be noted, and there is evidence in the full sized wooden ship found at Hjortspring, dating to the third or second century BC, to suggest that this was a real boat building device which had been practised around northern waters for the previous thousand years. The objects in *Ill. 161* are part of a great bronze hoard found at Røgerup, Fredriksborg, belonging to the sixth and last phase of the Danish Bronze Age when iron, and fashions of the Hallstatt Culture of Middle Europe were flowing in. Now bronze working had to be directed more exclusively to dress ornaments, but in addition to new pin types, a variation in neck ornaments was introduced. This is the so-called 'Vendel-ring', a misapplied antiquarian ascription. These bronze neck-rings are remarkable for the way in which the direction of twist has been changed several times between one terminal and the other.

The greatest bronze casting operation undertaken in Denmark during the period after *c.* 1000 BC was the production of large horns, the famous *lurer*, which have been found mainly in pairs, and

159, 160 During the fifth Bronze Age phase in Denmark a fine curvilinear incised decoration appears. On the razor (*above*) from Hvirring may be seen a very fine ship and a composition of five ships appears on the razor (*below*), found with the pair of tweezers at Solbjerg

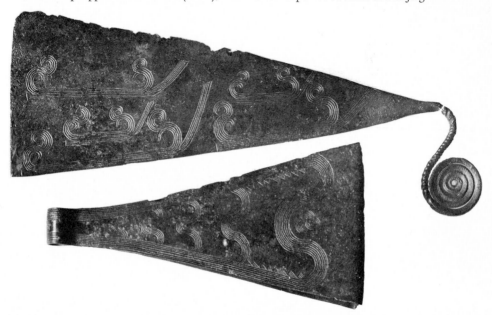

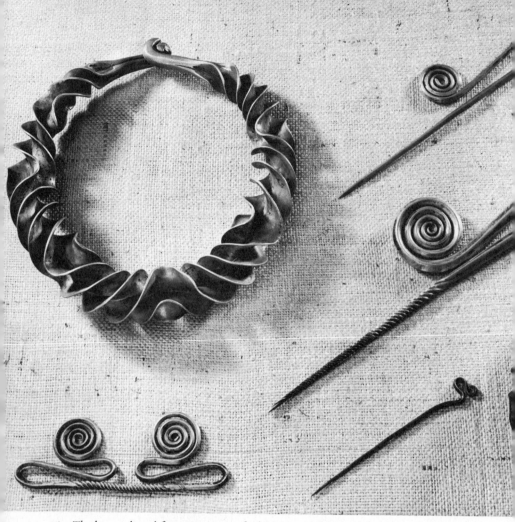

161 The bronze hoard from Røgerup, of which part is illustrated, belongs to the last phase of the Danish Bronze Age when Hallstatt fashions from Middle Europe were becoming more apparent. The 'vendel-ring' (*top left*) is remarkable for the way in which the direction of the twist changes several times

in fair condition thanks to deposition in peat bogs. The example (*Ill. 162*) is one of a pair from Maltbaek, Ribe, and its overall height is about one metre. The proportions and sweep are particularly fine, and the simple decoration of the bell is more pleasing than the heavy boss decoration of some other horns. The tube was cast by the *cire*

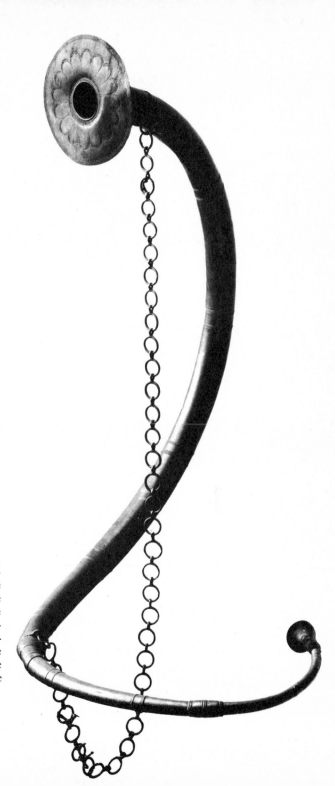

162 A bronze *lur* or horn, one of a pair from Malt-baek, is a typical example of this Danish Bronze Age musical instrument. Made in three separate pieces, together with bell, mouth-piece, and chain, the tube was secured by a simple locking device and could be taken apart

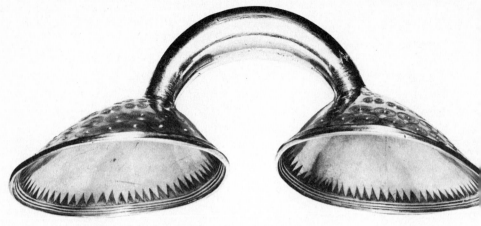

163 One of the largest of its class, the gold dress-fastener from Clones shows strong Northern European influence in its style

perdue method in sections which were then joined together by rings of bronze of a lower melting point than the metal in the tube sections. The bell, mouthpiece, and chain were all made separately, and the tube could be disjointed into two parts by a simple locking device. The lurer, like simpler bronze horns found in Ireland, were not musical instruments in the fullest sense being capable only of sounding a limited number of notes. The pitch is the same in each pair and the sounding of resonant blasts on ceremonial occasions, or to discomfit the foe, seems to have been their most likely use.

A final glance at Irish gold-work shows further strong influence from Northern Europe. The penannular dress-fastener with large cup-shaped terminals found near Clones, Co. Monaghan (*Ill. 163*) is one of the largest of its class. The method of wearing such ornaments was evidently to place the cups against the chest over the join of a cloak from which two loops were braced across the foot of the bow on either side. In this way the whole ornament would have been visible except for the inside of the cups. This device was an approximation to a type of northern brooch (*fibula*) of the eighth century BC with arched bow and disc terminals, but also with an attached pin. The Clones dress-fastener is decorated all over the convex surfaces of its terminals with concentric ring and pellet motifs, another exotic feature, but note also, in the detail

photograph (*Ill. 164*), the fine tracer work forming hatched chevrons at the junction with the bow, and on the bow itself beyond the zone of encircling grooves.

Of the same Irish school and date are delicate sheet-gold ornaments known as gorgets, and they too were largely inspired by Northern European fashions in neck ornaments, and not derived from lunulae in any direct way. Gorgets have never been found in burials so that there is some uncertainty as to how they were worn, but it is generally assumed that they were placed close to the neck below the chin with the terminals at the shoulders. The sheet is curved to form a swelling surface, and the rib and cable, or boss decoration was effected by repoussé, but with tracer work on the surface to finish off details, especially the kind of cable pattern so well shown on the gorget found at Gleninsheen, Co. Clare (*Ill. 165*). The dished circular terminals with pointed central boss, and similar surrounding motifs, are a refined version of the boss-and-ring

164 The detail of the Clones dress-fastener (*below*) illustrates the concentric ring and pellet motifs and also the fine tracer work at the junction of stem and bowl, also seen in other Irish pieces, *cf. Ills. 129, 130*

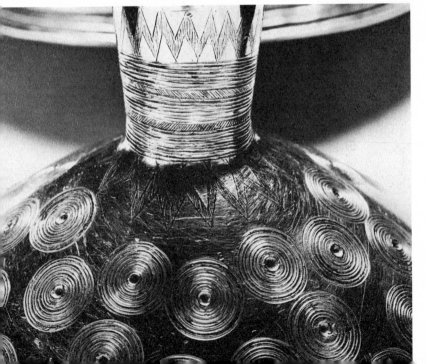

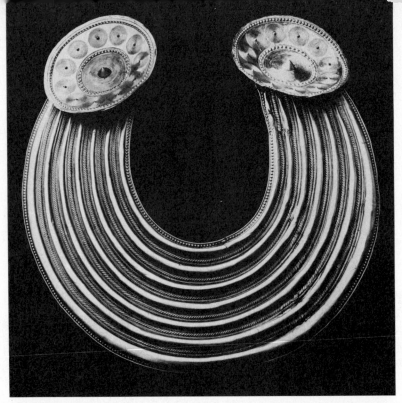

165 A fine example of a gorget, a delicate sheet-gold neck ornament with repoussé decoration largely inspired by North European fashions, found at Gleninsheen. The technique of attaching the circular terminals by hammering over their edges demonstrates the lack of reliance placed on solder

ornament now familiar. A most interesting point about these terminals is their method of attachment to the collar. Each terminal consists of two discs held together by hammering over the edges of one to grip the other. The discs had already been decorated; the lower less elaborately than the upper, but the lower was held to the squared-off end of the collar either with gold wire running through perforations, or by sliding the end of the collar through a slit in the lower disc, bending it over and burnishing to make the join secure. This latter method was used in the Gleninsheen gorget. It would appear that Irish goldsmiths regarded the use of solder as undependable for its use was certainly known by this time in the west.

In roughly contemporary bronze sheet-work, insular smiths were

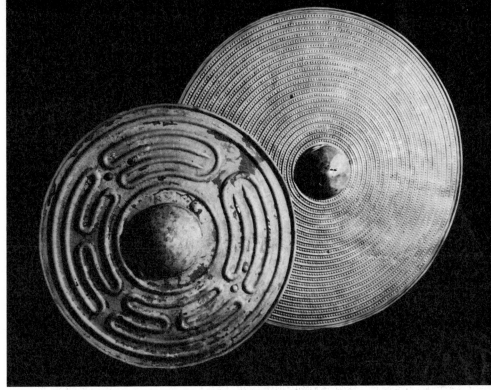

166 Two fine bronze shields from Auchmaleddie and Yetholm in Scotland could only have been intended for use as parade items as they were hammered up from a single sheet of bronze with only edge strengthening and a separate central umbo

now turning out impressive and finely made bronze shields. These were hammered out of a single piece with edges turned over a stout wire, and a central hole cut to fit a separately made umbo with handle at the back. These shields would have been useless against contemporary weapons, and must have been perfected for display and votive ends. Repoussé ornament in ribs and bosses is general, and the larger shield in *Ill. 166*, found at Yetholm, Roxburghshire, in southern Scotland, one of three from the same locality, is amongst the finest examples. The shield in the foreground of the same illustration comes from Auchmaleddie, Aberdeenshire, and was found with another shield of the Yetholm type. The meander pattern which was beaten up in rib form is of some interest

as it occurs also on a bronze shield from Coveney Fen, Cambridgeshire, and is known incised on various bronzes from Northern Europe. Although hardly known in Middle Europe from surviving pieces, this motif, with other geometric patterns, derives from the same East Mediterranean sources that had already informed the Greek Geometric Style.

In the Danubian region, accessible to the head of the Adriatic, there had flourished that school of beaten gold and bronze working responsible for the drinking vessels and other things already discussed, and to this source belongs also a series of crested helmets in bronze like that from the river Weser at Bremen (*Ill. 167*). This is a particularly well finished and pleasing specimen, and the smoothness of the cap contrasts with the angularity of crest and spikes. Elaborately decorated helmets of this shape are known from Italic warrior graves in southern Etruria of the eighth century BC, but these result from a southward flow of 'East Alpine-Hungarian' styles which eventually come into contact with Etruscan culture.

It would be misleading to speak of a latent interest in representational plastic art when so few witnesses, such as the Trundholm horse, survive. The ravages of time are such that they have obscured the reality of such an art being more widely and continuously practised than can now be suspected. In the case of small solid cast objects the chances are better, and it is known that from about the twelfth century BC small bronze water birds, swans or ducks, were being made; presumably on account of some auspicious attribute of these birds. This iconography is much in evidence somewhat later, at the period which saw the gradual change over from a bronze to an iron working economy both in Middle Europe and its Italian province. Bronze of course remained the metal for fine work in dress ornaments, drinking vessels, and ritual objects, and the water birds are often combined with sun and ship symbols in repoussé compositions. The solid cast birds are more interesting evidence of artistic ability, and in *Ill. 169* is seen a pair of socketed bird terminals found at Svijany, Liberice, Bohemia. They are very typical of the whole range in the sweep of their necks, and somewhat accentuated beaks. The bird with jangles looped on has a smooth

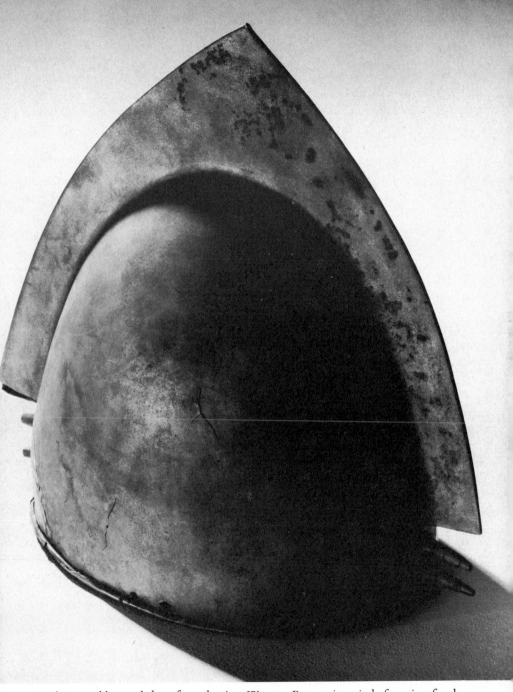

167 The crested bronze helmet from the river Weser at Bremen is typical of a series of such helmets originating in the Danubian region

undecorated surface but its eye is clearly marked, while its companion, a bolder piece, bears pronounced incised markings, and possesses a much larger eye. This pair were probably mounted as terminals on the framework of a model cult-carriage. Swimming up one of the legs of a ritual stand, not mounted on wheels, are the four birds from a grave in the famous prehistoric cemetery at Hallstatt in the Salzkammergut (*Ill. 170*). The name of this site, on account of the richness of the cemetery and its repute since the middle of the last century, has been taken to designate the first iron-economy culture that grew up north of the Alps, and whose influence between the mid-seventh and early fifth centuries BC spread widely in all directions. The kind of work exemplified in this bronze stand from Hallstatt marks a high point in elaboration of the long story of barbarian craftsmanship. Stylized repoussé water birds, and various bosses, can be discerned on the sheet-work above the legs, and, with the twisted leg struts, all speak for a mixture of traditional skills with a stimulus of Italic influences in the production of elaborate ritual objects learnt from Oriental exemplars. The swans and cygnets confronted by a pair of crows or ravens on the shaft from Dunaverney, Co. Antrim, in north-eastern Ireland (*Ill. 168*) show how far the Hallstatt birds could migrate both in idea and standard of production. This may be an imported piece from the Continent. The function of the hooked shaft is not clear. The double hook is solid bronze, and the remainder is a hollow casing, in sections, for an original wooden handle. It is more likely to have been a goad for pricking horses between the ears than a flesh hook.

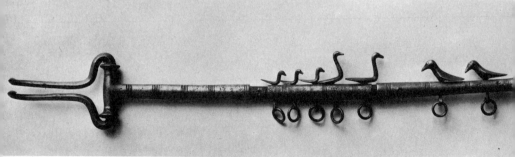

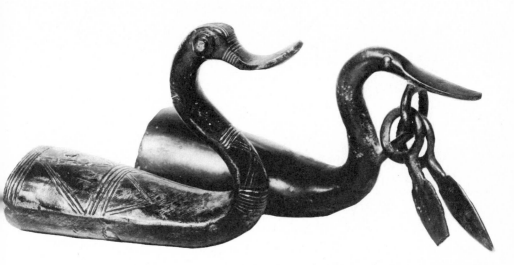

168–70 From about the twelfth century BC onwards the representation of water birds, ducks or swans, became a popular motif. The swan-headed terminals (*above*), possibly from a model cult-carriage, were found at Svijany in Bohemia and date from the Late Bronze Age. They are very typical in the sweep of their necks and accentuated beaks. Of later date and from the eponymous site of Hallstatt is the ritual stand (*right*), a detail of which shows four birds swimming up one of the legs. In the sheet metalwork above the legs may be seen stylized repoussé water birds and bosses. The idea of Hallstatt birds moved far from its home in Central Europe and the goad illustrated (*opposite*), from Dunaverney, Co. Antrim, has a pair of swans and their cygnets confronted by a pair of crows or ravens

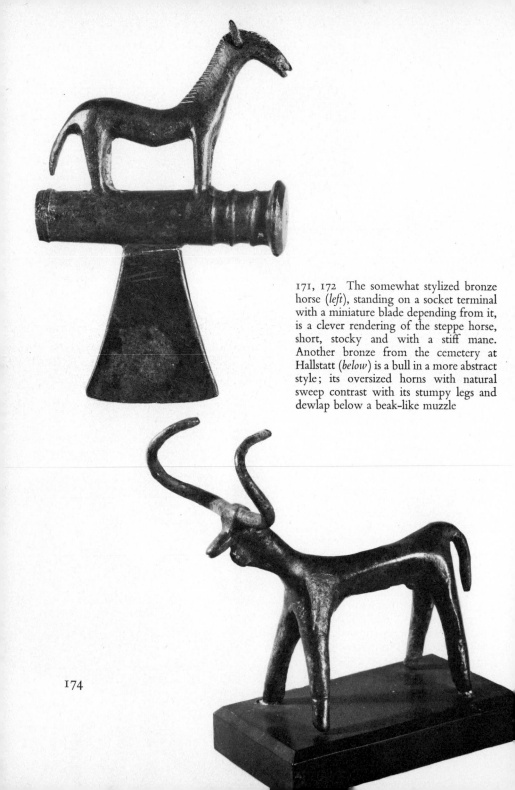

171, 172 The somewhat stylized bronze horse (*left*), standing on a socket terminal with a miniature blade depending from it, is a clever rendering of the steppe horse, short, stocky and with a stiff mane. Another bronze from the cemetery at Hallstatt (*below*) is a bull in a more abstract style; its oversized horns with natural sweep contrast with its stumpy legs and dewlap below a beak-like muzzle

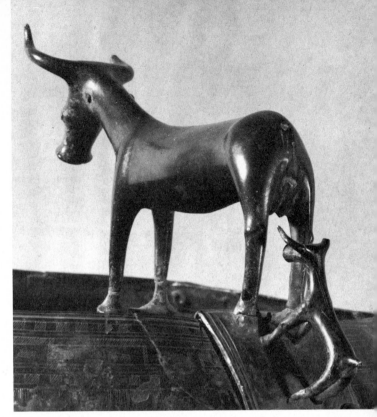

173 A pastoral scene is enacted on the rim of this bronze bowl from the Hallstatt cemetery. A cow with curving horns is shown passing over the rim, her fore-legs supported by a strut from the bottom, and followed by her calf, which strangely also has a pair of horns. Both animals are cast in solid bronze

Further insight on this kind of art is afforded by some other animals from the Hallstatt cemetery. Outstanding is the cow and calf as they appear to pass over the rim of a bronze bowl (*Ill. 173*). These are also solid cast figures, and the heads are particularly formalized without losing the gentle quality of the scene. One must doubt the appropriateness of such horns on the calf, but it has been suggested that the cow's are those of aurochs. The great European wild cattle, last met in these pages at Lascaux, and hunted in the forests of Germany to the Middle Ages, could well symbolize the reviving properties of whatever the bowl contained. The fore-legs of the cow are supported by a strut from the bottom of the vessel. The fine geometric ornament around the rim should not be missed. The bronze figurine of an animal in a very different style comes from the same grave at Hallstatt as the water birds just discussed (*Ill. 172*). It is presumed to be an ox, and below the beak-like muzzle, 175

the dewlap has not been ignored. The horns are fanciful, and the body with stiff massive legs suffice for essentials. This is a different idiom within the same culture; there is no significant chronological gap between any of these pieces.

There are several engaging horse figurines from Hallstatt, and of these the somewhat severe portrayal in *Ill. 171* is of special interest. This is not a stylization of just any horse, but a clever rendering of the characteristics of the small steppe horse, described by Herodotus, and for which there is archaeological evidence in Hungary and the east Alpine region from the ninth or eighth centuries BC. The proportional shortness of leg to size of neck and head, and the convex profile of the head with set back ears and stiff mane, as well as the set of the tail, are all typical, and contrast with the more agreeable appearance of indigenous domestic breeds for driving and riding illustrated in other figurines from Hallstatt and elsewhere. This little horse stands on a socket terminal with a depending miniature axe blade.

The inhabitants of the Hallstatt region derived their wealth in the main from an export trade in salt immediately available to them by mining, and by extraction from springs. This explains the great concentration of fine metalwork that found its way into the graves, and amongst other exotic objects should be mentioned finely fluted glass cups. Pottery, although it occurred in the cemetery, would have been less easy to transport into the mountains if of the finest quality made elsewhere, nor can it have had the same appeal. With the spread of Hallstatt Culture styles across the North Alpine zone, from Bohemia to Burgundy, a high excellence in native ceramics was attained. The shapes chiefly emulate metal forms, and great attention was given to a highly polished surface. The wheel was not yet employed north of the Alps. Painting was brought in again after a lapse of millennia, but was now west-central not east-central as it had been. This painting was in black, brown and red, and the motifs are simple geometric patterns especially filled-in triangles, and vertical lines. The open bowl from Straškov, Bohemia (*Ill. 174*) has a light grey surface, and black painted triangular motifs. The photograph shows the highly burnished effect with which the surface was

174 A painted dish, black on polished light grey, of the Bylany Culture, from Straškov, Bohemia

175 A pottery dish with deep cut decoration from Tannheim, Württemberg

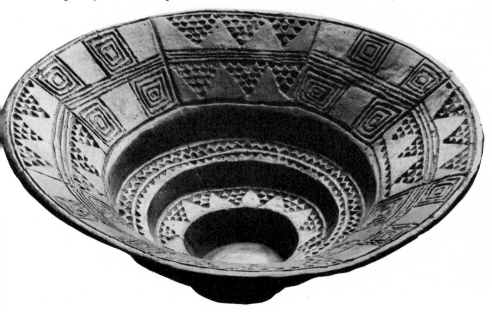

176 A pair of repoussé decorated gold ear-rings from a grave at Hallstatt of the late sixth century BC

finished after painting and firing. A popular method of producing a highly polished surface was to cover the vessel in whole or part with a coat of graphite, and sometimes, especially in Switzerland, strips of tin were affixed to make up a shining pattern. The wide dish from Tannheim, Württemberg (*Ill. 175*) is a distinctive form that was sometimes painted but usually left to other means of decoration. In this example a characteristic method of bold modelling of the walls and deep cut-out ornament is seen, triangles and zig-zag lines playing a prominent part.

In one of the later graves at Hallstatt, probably of the late sixth century BC, were found a pair of gold ear-rings (*Ill. 176*) each consisting of a narrow rectangular strip with ear-spike at one end, and repoussé decoration. The strip was curled to form a ring. Gold had been scarce, at least from the evidence available, from the seventh to the mid-sixth centuries BC, but in major chieftains graves thereafter gold made its appearance, and this was at a time when other

177 A gold repoussé decorated neck-ring from the waggon grave burial of an Iron Age chieftain at Bad Cannstatt

evidence shows that a valuable trade was beginning to open up with the Greeks at Massilia, and perhaps also from the head of the Adriatic. The Greek traders sent north not only bronze wine jugs, but Black Figure drinking cups and amphorae of wine. They handled Etruscan products as well, but then abandoned this barbarian trade to the Etruscans who used direct routes across the Alps. The gold in Hallstatt chieftains graves is, however, made up in native and traditional styles, but there is one important exception in the gold penannular ring with winged horses from the princess's grave at Vix, Châtillon-sur-Seine, which was clearly a gift from the south. The most usual native gold ornament in these chieftains' graves was a broad strip with repoussé bosses, ribs and other motifs, and these objects were bent round some kind of perished backing, apparently to form a thick and rounded collar. None have, however, been observed in undisturbed position. *Ill. 177* shows a gold ring of this kind from the waggon grave at Bad Cannstatt near Stuttgart,

179

178 A gold cup from Bad Cannstatt found in the same waggon burial as the gold ring in
Ill. 177

and with it, as well as the metal parts of the vehicle, was a gold cup
(*Ill. 178*). Both show in their workmanship and choice of ornament
the old mid-European tradition that has been followed in previous
pages. Another, and larger vessel of the same period is the gold bowl
from Altstetten, Zürich (*Ill. 179*) which has a unique decoration in
all over repoussé bosses broken only by smooth areas in the shape
of apparent sun and crescentic moon symbols, and by indeterminate
animals lower down. These mark the end of the ancient craft of
beaten gold drinking vessels.

Hallstatt influences reached to the Iberian Peninsula in the wake
of migrants who had brought with them a Celtic language, and
there, as back home north of the Alps, tribes of Celts were recog-
nized by the early Greek geographers of the late sixth century BC.
The exploitation of gold and tin in the Peninsula may have played
a part in supplying the needs of the Hallstatt chieftains in the home-
land area, but in the new territories the Celts came greatly under

179 A gold bowl from Altstetten, Zürich, has a unique overall decoration of smoothed symbols against a repoussé boss field

the cultural influence of the Iberians, and a mixed style in techniques and ornament grew up. There is a fragmentary silver head-piece from Caudete de las Fuentes, Valencia, which is covered all over with small repoussé bosses except for a few larger bosses and broken crescentic shapes left in reserve very much in manner and appearance like those of the Altstetten bowl. It would not be unreasonable to suppose an Iberian trained craftsman contributing to the decoration of a gold vessel in a north Alpine workshop at this period. Certainly for the Valencian piece one expects an Iberian background both for the style, and the availability of silver. Another 'Celtiberian' piece is the handsome gold neck ornament from Cintra, Portugal (*Ill. 180*). The cup-like embellishments, and the hooked neck-plate, are peculiar to the Peninsula. The fine chased decoration over the swollen mid portions of the hanging bars recalls the tracer work on the Clones dress-fastener (*Ill. 164*), and suggests that this kind of work survived long in the far west which had its own interconnections

up and down the seaways. The Cintra collar may be as late as the fourth or third century B C, but it bears no relation to the kind of Celtic art that is the subject of the next chapter.

In looking back over the span of time encompassed in this chapter certain high points can be discerned. There was the activity, in some way connected with Mycenaean Greece, during the fifteenth century B C that furnished barbarian leaders in life and death with gold and amber. There were the more widespread dealings, mainly in the twelfth century B C to do with beaten bronze, hollow casting, and new styles of ornament, and this phase saw, too, the development of skills not easily demonstrated such as the building of spoke-wheeled vehicles. The eighth century B C was important for further changes in gold-work, for shields and helmets in bronze, and for an increased interest in geometric ornament. Within the sixth century B C, Europe north of the Alps came into direct contact with the early Classical World. Trade was the motive on both sides, and native craftsmen could now examine Greek and Etruscan metalwork, and observe entirely new forms of surface decoration. Meanwhile they continued to make things in their own tradition. Mind and eye were not yet ready to respond in their own way to all the visual and technical excitements increasingly brought before them. How are the patrons and craftsmen of this important period to be envisaged as they went about their business? Certainly not in abject discomfort. Modern archaeological excavations reveal a life that cannot have been so different from that which followed long afterwards in the early Middle Ages. Chieftains lived in strongholds with substantial wooden buildings often as big as many a timbered manor hall ten to fifteen centuries later. At the Heuneburg, above the Danube in Württemberg, a native stronghold was modified so that a great wall with bastions could be erected in sun-dried brick after the manner of contemporary colonial Greek cities, and nearby, in a rich burial under a great barrow, were found fragments of finely woven woollen textiles some with a thread pattern stitched in silk. Apart from the elegancies of Greek wine drinking services, great bronze cauldrons were now in use for improved cooking. These things, rather than stylistic and chronological assessments of durable

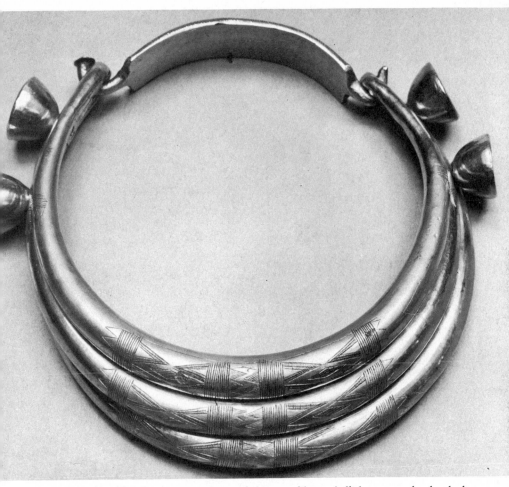

180 The gold collar from Cintra, Portugal, has cup-like embellishments and a hooked neck-plate which are typical features of such ornaments in the Iberian Peninsula. The fine chased decoration, however, should be compared with that found on some Irish gold-work, *cf. Ill. 164*

objects, bring home the nature of life in Hallstatt courts, and it is not so difficult to comprehend the opportunities for experimental work, for instruction, and interchanges of ideas, that were to evolve the first true art style north of the Alps since the end of the Ice Age. 183

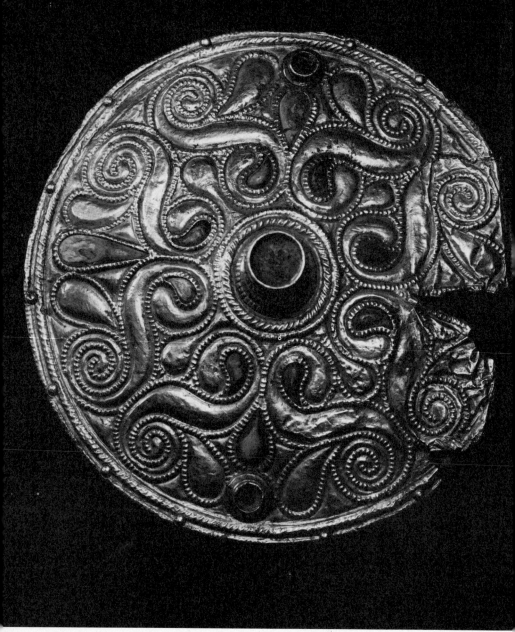

181 The Auvers disc, probably a lid, is made of two slightly convex bronze discs, the upper one of which has an embossed pattern onto which sheet gold foil was hammered. Originally there was coral inlay in the centre stud

The Art of a Barbarian Nation

The first conscious art style to be created in Europe north of the Alps emerged in the mid-fifth century BC amongst those Celtic peoples who had been enjoying a trade in luxuries with Greeks and Etruscans, principally from Marseilles by way of the Rhône and Saône. Perhaps it was irritation at the uniformity and staidness of Etruscan products that urged Celtic men of skill to try their own hands and find a satisfying idiom without foregoing the convenience of southern manners and fashion. Other factors were certainly involved for there was some geographical shift in the centre of patronage, now to the Middle Rhine, where the earliest objects in the new art style were mostly concentrated, and best known from princely tombs.

In his magisterial study *Early Celtic Art*, now so unfortunately out of print, Paul Jacobsthal described how the Celts then awoke 'open-minded and active, they transform what had before been no more than commerce into a live source of artistic inspiration'. This artistic inspiration was not manifest just in crude but honest emulation, but in the deliberate transformation and redirection of ideas and motifs so that while general analyses of Celtic decorative compositions can be made, it is never possible to point to particular borrowings. Such were not relied upon. It is of course important to recognize that Celtic art was essentially a decorative art whatever magical or supernatural implications could also be worked in. The embellishment of surface was of prime concern so that in stone cutting, and pot-making there is not the same break either with tradition or with foreign prototypes where form is concerned.

This art of the barbarian nation known as Celts to the Greeks is also sometimes referred to as La Tène art from a site on the shores of Lac Neuchâtel in Switzerland. It is best to confine La Tène as a term to the archaeology of the Celts as a whole, following that of 185

Hallstatt, as this provides an independent system of reference for the context of the objects illustrating Celtic art. Although not greatly involved in the pages to follow, it may be convenient here to give an outline of current terminology. The La Tène Culture may be taken as having come into existence, along with Celtic art, by the mid-fifth century B C and to have continued into the first century B C until Celtic territory fell under Roman or German occupation. In Britain it lasted into the first century A D, and in Ireland it continued in modified form for many centuries afterwards. For the continental territories, three main phases are distinguished: Early, Middle, and Late La Tène, and other systems, allowing for a greater precision in distinguishing changes in the early phase, divide early into La Tène A and B, or Ia and Ib, then Middle is called C, or II, and Late is called D, or III. Jacobsthal found it practicable to isolate certain major styles in Celtic art; the Early Style of innovation and experiment, from the mid-fifth century to sometime after the mid-point of the fourth century, then growing into the Waldalgesheim Style which continued into the early decades of the third century B C to give rise simultaneously to the Plastic Style, and the Sword Style. The latter is represented in the great deposit of weapons at La Tène considered to date about 100 B C, but Celtic art on the Continent had virtually come to an end by this time for its spirit had flown overseas to Britain and Ireland where Insular Styles, reliant on Waldalgesheim and drawing on the Plastic and Sword styles, come into evidence from about the mid-third century B C. On the Continent from about the end of the third century B C, the Celts found a new artistic outlet in coinage. For correlation with the phases of La Tène culture it may be said that Waldalgesheim overlaps Early and Middle La Tène, and that the Plastic and Sword styles are confined to the Middle phase. It will be realized, in contrast to historically documented art styles, how indeterminate is the chronology here sketched, and this indeed has to rely on comparatively rare associations with more closely datable Greek and Etruscan objects. It must always be a matter of discretion as to how long these southern imports had been in circulation before accompanying their Celtic owner to the grave.

Jacobsthal showed that there had been three principal sources of inspiration in Celtic art. There was the background of Hallstatt geometric abstraction, and archaic oriental symbolism such as the sun and water bird; there was floral ornament derived from sub-archaic Classical forms, and there was an Oriental contribution principally in animals and masks, human or phantom. None of these are found isolated as direct copies even in the Early Style, although a preponderance of floral or animal motifs tends to occur from piece to piece. It is clear that most of the exotic sources of inspiration were to be found together in Italy, that reservoir in the fifth century B C of obsolescent Greek and Oriental styles, and where dull Etruscan imitations were being produced in quantity. Etruscan trade through Marseilles, and later directly over the Alps, is well attested, but it is clearer now than when Jacobsthal wrote, that genuine Greek products of the middle and late fifth century B C, for example Attic Black Figure ware and Rhodian oinochoi, whether from Marseilles or from the Adriatic, were already in Celtic hands in Late Hallstatt courts. The question as to whether the oriental elements in the Early Style of Celtic art were filtered only through Italy, or whether there can have been at this period direct contact beyond the Carpathians with Scythians and Persians is beyond a simple answer. It is certain that there was no direct borrowing from the Scythians, and no feeling amongst the Celts for the kind of graphic art that the Scythians commanded from Black Sea Greek workshops. The Persian problem will be brought up again in connection with silver, but there are hints in gold and bronze work of the Early Style that a link, independent of the Etruscans, by way of the Lower Danube informed the Celts of some Persian ideas and techniques.

Although no Celtic workshops have as yet been excavated, and it is unlikely that much informative metalwork would have been left lying about, it has been possible to distinguish pieces as the work of one school, perhaps even one man, and there is much yet to be done in this kind of detailed study. In some few cases Jacobsthal could point to a Greek, or other southern hand, in the making of a trans-Alpine bronze vessel or scabbard, and such men would have been

quick to adapt their skill to native barbarian taste as did their fellows along the Black Sea for Scythian custom. The discussion of examples of Celtic art that now follows cannot run over every aspect, nor every type of object to which this art was applied, but a selection has been made to show the broad nature of its content.

The disc from Auvers, Seine-et-Oise (*Ill. 181*), possibly a lid, is constructed of two slightly convex bronze discs, the upper bearing embossed ornament onto which was hammered a sheet of gold foil. There is a central knob with seat for coral inlay, and there is a pair of coral inlaid rivet heads near the edge. Matt-surfaced petals have coral inlay and there were originally twelve of these. Otherwise shining gold curvilinear and swelling forms make up a composition of four lyre-shaped motifs against a field of petals or other schematic floral items. Each item has a bold beaded outline repeated as a rope pattern around the knob and edge. The Auvers piece is an object in itself, but the thin strip of openwork gold from Eigenbilzen, Belgium (*Ill. 182*), exemplifies a Celtic fondness for embellishing imported objects that were seemingly thought too plain. A famous example is an Attic Red Figure cup from a grave at Klein Aspergle, Württemberg, that was covered over with a floral design in gold foil, and the Eigenbilzen strip probably adorned one of the bronze flagons that were found, amongst other things, in the same grave. This strip illustrates in its central register a Celtic utilization of the Classical lotus and palmette. The latter has been reduced to a trefoil filling the space between the major out-curving petals of each lotus, and these big petals show that same smooth swelling surface of the Auvers lyres. Other points of technique are very close, and both pieces are typical of symmetrical repetitive floral compositions of the Early Style.

Openwork technique gives introduction to the oriental element contributing animal forms and masks. The bronze belt-clasp from Hölzelsau, Niederinntal, Austria (*Ill. 183*), is a piece of cast openwork rivetted to a plain back-plate. The openwork comprises a large lyre with stylized animal-head terminals. Between the in-turned pair of heads is a little human figure with hands outstretched to the beasts muzzles. Possibly they are horses, and they also occur

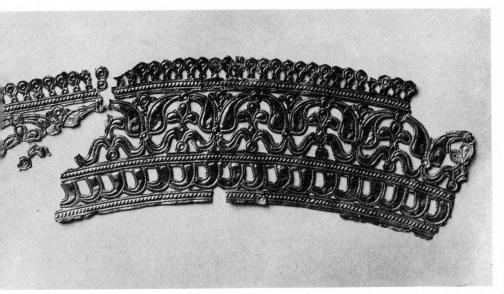

182 The thin strap of openwork gold from Eigenbilzen was probably used to embellish a bronze flagon. Celtic artists were fond of adorning imported objects in this way

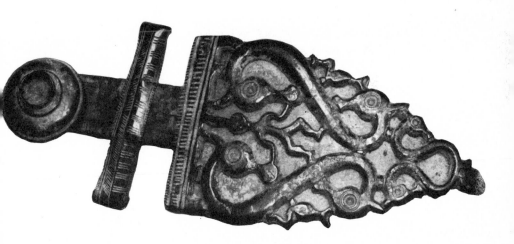

183 An example of cast openwork in bronze, from Hölzelsau, is riveted to a back plate to form a belt-clasp

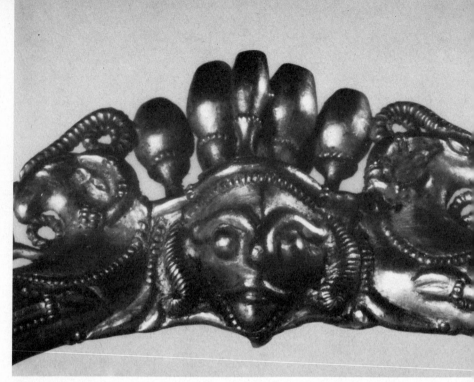

184 A detail from the centre of the gold bracelet from Rodenbach which well illustrates the oriental motifs to be found in Celtic art, in its human face and supporting animals

at the ends of the loop below the foot of the lyre. Note, too, the Hallstatt-like birds on either side outside the main composition. The animal or bird-ended lyre, and the man between two beasts, are well known oriental concepts, but here the immediate source was Italy. The central detail (*Ill. 184*) of the magnificent gold bracelet from a particularly rich grave discovered at Rodenbach, Rheinpfalz, further illustrates oriental aspects. First there is the human mask, possessed rather than impassive, with bulging eyes and strongly marked eyebrows, but the lower face is fine featured and with its flowing moustache is truly Celtic. Closest to oriental prototypes are the rams on either side, and Thracian, following Persian originals, must account for the pointed eye and split hoof best seen in the animal to the right. The Scythians also shared some of these features but did not originate them. Apart from specific details such as these the whole appearance of neck and arm rings of the Early Style speak

190

185, 186 The finest Early La Tène brooches often have highly decorated extremities. The example (*right*) from Panenský Týnec, Bohemia, has at the head, over the spring, a swooping bird, and at the foot, over the catch-plate, a sheep's head with an elegant surrounding diadem. The detail (*below*) is of the foot of a brooch from Parsberg which, in the forbidding formalism of the mask, is in direct contrast to the grace of the *fibula* illustrated (*right*)

for Persian inspiration. This is most evident in the neck torc and bracelets from Rheinheim, Saarland (*Ill. 188*) with their wonderfully encrusted terminals, but here again the choice and arrangement is wholly Celtic. The photograph of one of the torc terminals (*Ill. 189*) reveals a bird of prey mantling over a human head, rather sharp featured and with bulging, ecstatic, eyes. The bird seems to be an owl, and there is a small owl mask below the bollard-like knob.

The leading Early Style brooch (*fibula*) was given a substantial cast bronze bow with ornamental extremities. The specimen from Panenský Týnec, Bohemia (*Ill. 185*), shows a closely evolved linear pattern on the bow and catch-plate. The foot is in the shape of a sheep's head with elegant surrounding diadem, and at the other end, over the spring, is a bird with out-stretched wings. This brooch is perhaps the most charming of all the minor works in the Early Style with a feeling for grace, and nature, not easily paralleled. In contrast is the foot of a brooch from Parsberg, Oberpfalz (*Ill. 186*). Here is the forbidding formalism of a contorted mask. Details of the linear ornament on the bow will be recognized from pieces already examined, and the beginnings of running curvilinear patterns can be observed in the way separate 'phrygian cap' and leaf motifs have been placed together.

The Early Style saw something beyond the development of new concepts of ornament. Celtic artists began to reject the shape of those squat Etruscan wine flagons, and some few masterpieces of their own making have survived. A pair of tall slender beaked flagons of Celtic workmanship were unearthed, with a pair of Etruscan stamnoi, at Basse-Yutz, Moselle, Lorraine (*Ill. 190*). The construction is too elaborate to describe here, but the shape is a striking reversal of the prototype illustrating that evident principle in the Early Style to do the opposite to what was introduced. Here especially may be noted the greater proportion of height to width, the sharpness of the shoulder, and concave walls coming down to a well moulded foot. The beak strikes out high and overreaches the shoulder. The handle is a captive fabulous creature serving in a capacity long endured by his Persian forebears. He has been deprived of hind legs, but in his head and ears, and foreleg spiral joints, his pedigree is also made

187 Detail of the lower handle terminal of one of the Basse-Yutz flagons, *cf. Ill. 190*

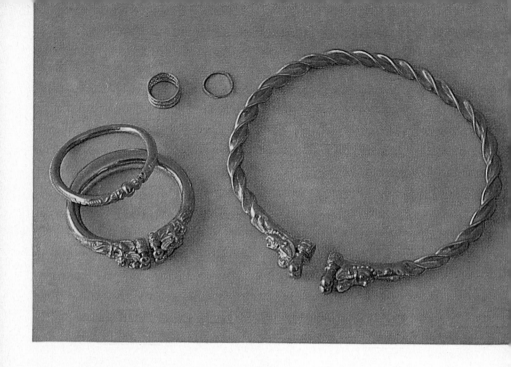

188, 189 Persian inspiration is v
apparent in the neck torc and bra
lets from the grave of a princess
Rheinheim, Saarland. In the det
(*below*) a bird of prey is se
mantling over a human head w
bulging, ecstatic eyes, *cf. Ill. 184*

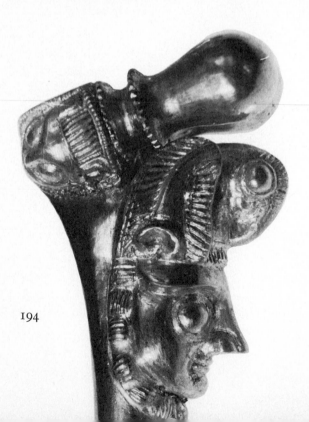

194

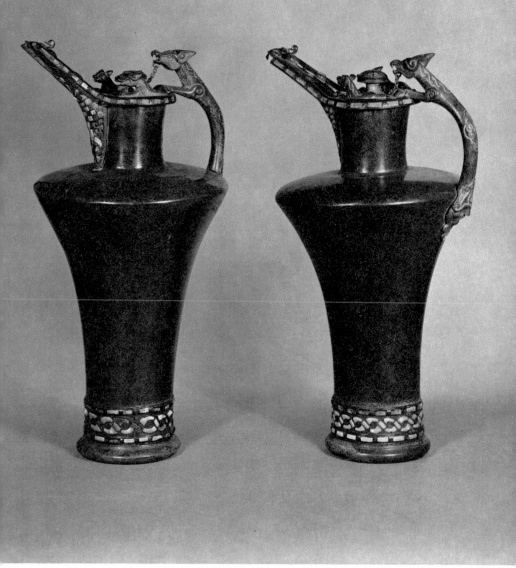

190 A pair of beaked bronze flagons with coral inlay of the Early La Tène period from Basse-Yutz, Lorraine

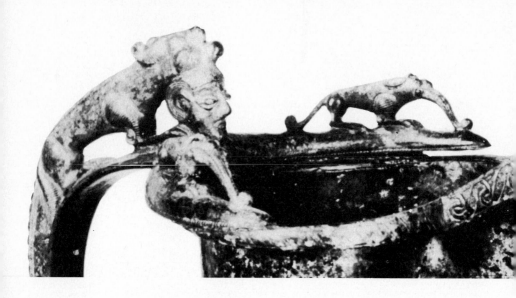

known. His mane has almost become a floral pattern, but the stroke-work representing his pelt is common to all contingent oriental styles. In the middle of his back is a panel of floral composition of a kind that was to become characteristic in later stages of Celtic art. It must suffice to mention the little Hallstatt duck apparently float-ing down the wine stream, and the pair of fabulous beasts that recline on either side of the neck. The lower terminal of the handle (*Ill. 187*) shows what has happened to the creature's hindquarters. The body spreads out into a great mask with large coral settings for eyes and beard. The loops and curls show, here too, how far Celtic design was escaping from floral exemplars. The presence of a mask in this position follows in the line of *silenoi* on Classical metal vessels. Per-haps the least to be admired element in modern eyes was the use of coral inlay. In the Basse-Yutz flagons, the massing of coral around the foot and at the throat of the beaked spout would seem to have drawn the eyes away from the simplicity of the curving walls. Had they been too difficult to embellish even with tracing? Or can one give credit for restraint in leaving them plain? The coral, origin-

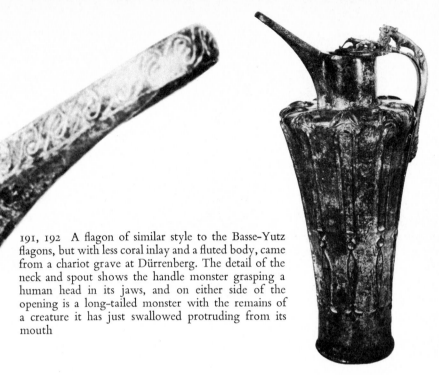

191, 192 A flagon of similar style to the Basse-Yutz flagons, but with less coral inlay and a fluted body, came from a chariot grave at Dürrenberg. The detail of the neck and spout shows the handle monster grasping a human head in its jaws, and on either side of the opening is a long-tailed monster with the remains of a creature it has just swallowed protruding from its mouth

ally red, has faded to white. The handle animals have coral eyes as well as the terminal mask, and its use is lavish all about the upper rims. The circumstances of trading coral to the Celts is unknown, but they were the only people to use it for inlay, and by some means, still obscure, they learnt to use red enamel which they employed in preference to coral later on.

The beaked flagon from a chariot grave at Hallein-Dürrenberg, near Salzburg (*Ill. 192*) is closely related to the pair just discussed. Jacobsthal accounted it a less successful piece, but there is much to be said for the absence of coral, and if the sharpness of outline is lessened, the raised and fluted body pattern is original and effective. The handle again incorporates an animal, but he is complete as to hind quarters, and crouches on a strap of metal forming a bridge to the neck. The lower terminal is an intense, great eyed, human mask without moustache or beard, set in a frame of openwork lyre-leaves with inverted palmette-derived finial. The detail of the upper portion of the flagon (*Ill. 191*) shows that the handle monster grasps a human head in its jaws, and on either side of the opening

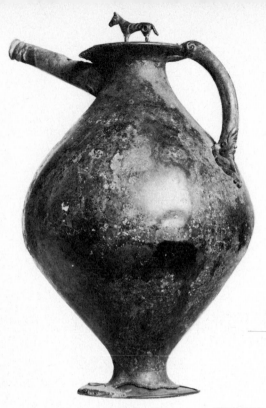

193, 194 A well-proportioned wine flagon with globular body and standing on a pedestal foot was found at Waldalgesheim. It has a cylindrical spout and the body is covered with a decoration of dotted lines. At the foot of the handle is a particularly fine head of an elderly man (*opposite*), with a leaf-crown above his head

is a long-tailed monster with the tail of some hapless creature still protruding from its mouth. These are oriental subjects that seem to have particularly impressed the Celtic imagination. The edge of the beak-spout displays a version of the bounding-dog linear pattern. Wine flagons with globular body on pedestal foot, and with a cylindrical spout, are also characteristic of Early Style workmanship. A tall, high footed, flagon of this type was found with the goldwork and other things in the Rheinheim grave, and the specimen from Waldalgesheim (*Ill. 193*) is a well proportioned example informative on many counts. The body was covered with a series of bands of lightly engraved geometric and floral patterns done in dotted lines; all now hard to see. The handle is relatively plain, but there is a ram's head at the top looking downwards, and the curled right-hand horn is seen in the photograph. At the lower end is a particularly handsome, and quite natural, face of an elderly man, composed and well-dined (*Ill. 194*). The details of this face, and of

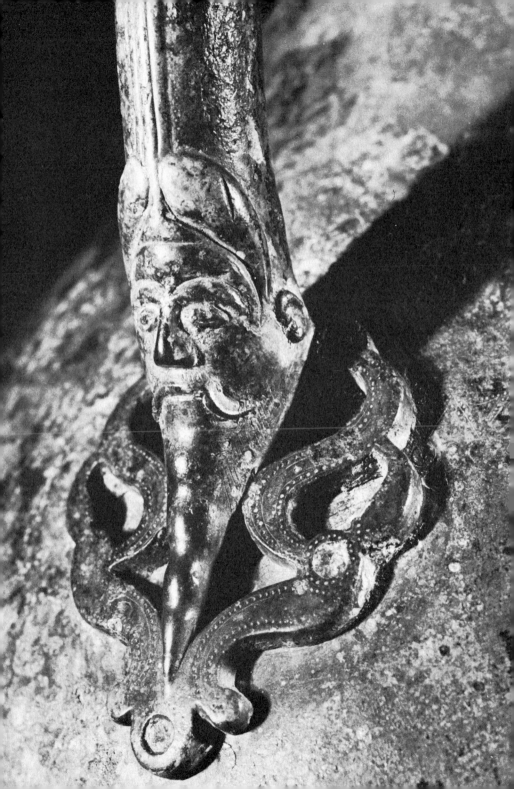

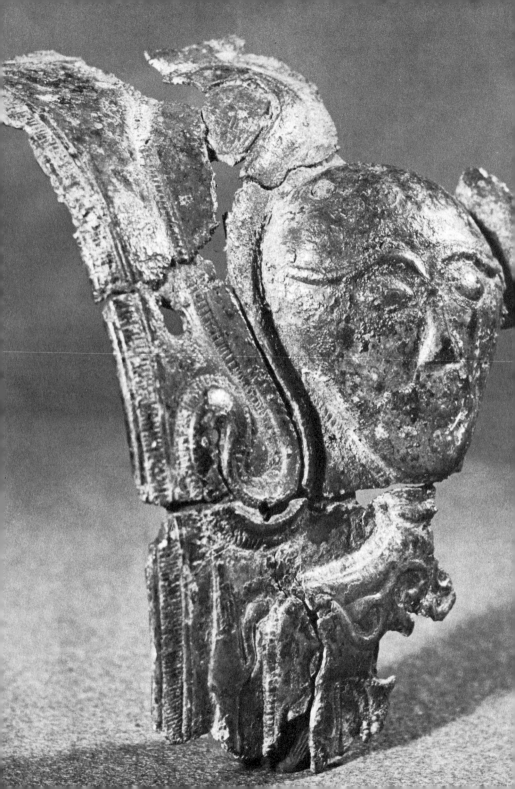

the flanking openwork of lyre-leaves speak for themselves, but the 'leaf-crown' curving up over the forehead must receive some comment. This is a major feature occurring in slightly different forms above many faces in metal and stone work, and much space has been given by Jacobsthal and others to its meaning. It certainly seems to be a ritual attribute, but to the present writer it has no strange Egyptian or other exotic antecedents. It is found earliest in metalwork, and it is worth while to point out that on the handle attachments of an Etruscan stamnos from the important fifth century BC grave at Klein Aspergle, Württemberg, just such comma-like lobes, but with the points upwards, fill spaces above the heads of silenoi. All the Celtic artist had to do was to follow his normal inclination and rearrange their position. At the same time the lobes were given curving, fleshy, surfaces, and endowed with those magical implications that seem to run through all Celtic composition.

The Waldalgesheim flagon was a piece of the Early Style, and it was older than the other objects in this chariot grave. The other metal objects were decorated in a more developed style clearly progressing out of what had gone before. It is useful that both styles should so conveniently be represented together suggesting that Waldalgesheim stands near the head of the style thus nominated by Jacobsthal. Jan Filip has more recently suggested the term Mature Style, and this is equally appropriate in its way as this second phase in Celtic art does see the relinquishment of all direct ties with the old southern and eastern influences. Some new ones occasionally creep in, but do not materially alter the direction now taken.

The most distinctive achievement of the new style was a breaking away from symmetry, and the development of lively free running compositions rather like patterns of water in a fast running stream. Amongst the more remarkable things from the Waldalgesheim grave are a pair of broken bronze plaques which fortunately supplement each other, and of which one is seen in *Ill. 195*. A portion of a running pattern is seen on the chest. The head continues the old tradition, but is more pear-shaped and certainly uncanny. A leaf crown is provided that is no more than a pair of large spiral-tailed commas or swollen leaves, and the supernatural aspect is emphasized

◀ 195 Bronze plaque from Waldalgesheim showing a repoussé half-figure with leaf-crown and raised hand

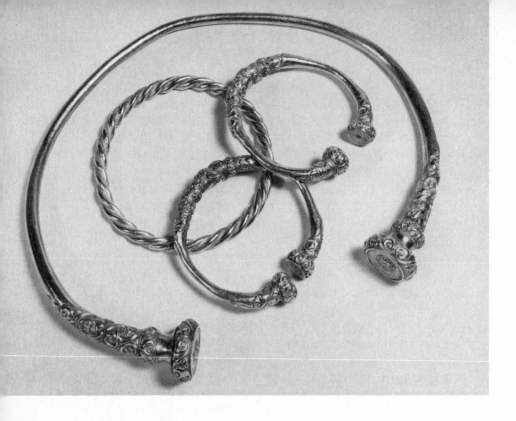

by the raised arm and hand; the latter very slender and elegantly poised. The other plaque shows that both hands were so raised in this ancient and widespread pose. The almond shaped eyes, and the splayed nose will be found to recur, and enough has survived to show that a torc surrounded the neck. The actual torc and other gold ornaments from Waldalgesheim are very splendid (*Ill. 196*). The characteristic buffer terminal is now in evidence, and the raised ornament runs richly and freely in spirals and loops. The closed twisted arm ring, with beading between the ribs, rather offsets the torc and bracelets. In these latter three, it will be noted that the plain portions of the gold hoop swell towards the areas of decoration. An enlargement (*Ill. 197*) of the centre portion of one of the bracelets shows how a pair of faces have been incorporated into the swirling scheme of spirals, and all have the appearance of being tied on with crossing lines of beading. At this point a bronze object found in the Thames at Brentford may be brought into view

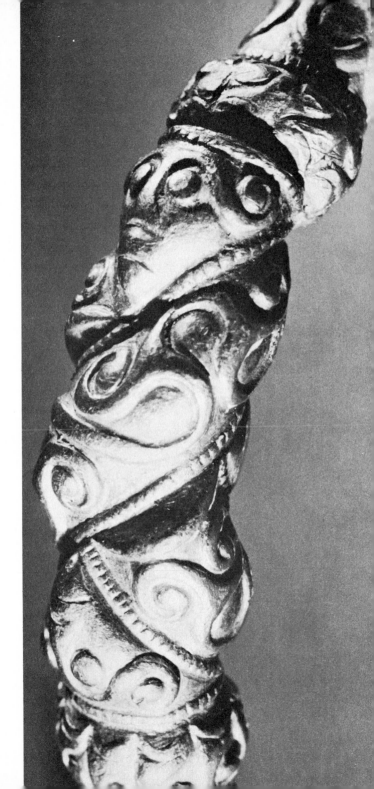

196, 197 Found in the same grave as *Ill. 195* were a gold torc and other gold ornaments of a very sumptuous style (*left*). A detail of the centre portion of one of the bracelets (*right*) shows how a motif of two human heads has been incorporated into the swirling design of spirals

(*Ill. 198*). The decoration is a typical Waldalgesheim Style pattern reduced to a circle. Stylistically, it is one of the earliest pieces of Celtic art in Britain although it is argued as to whether it was made here or in the continental homeland. It is an illuminating exercise to work out the construction of this pattern, and one element, which remained popular thereafter, harks back to a motif noticed on the handles of the Basse-Yutz flagons (*Ill. 187*). This might be described as a decapitated palmette, and it occurs three times around the edge of the circle in the raised positive pattern. At the same time there is a counter-pattern formed by the reduced background, and in this the palmette disappears being only the field for a pair of back-to-back pointed commas. This kind of dual pattern was especially favoured by the insular artists. The Brentford object is a bronze 'horn-cap' with the decoration on the diaphragm on the top. Two such horn-caps attached to curving sockets, but undecorated except around the ends of the sockets, were found in the Waldalgesheim grave, and, against earlier interpretations, M. E. Mariën has recently shown that these were probably ornamental finials for the chariot yoke. The Waldalgesheim Style spread widely with the militant expansion of the Celts, and is found in Italy and Transylvania executed at the hands of artists of widely differing competence.

198 One of the earliest examples of Celtic art in Britain, the Brentford horn-cap, was found in the Thames. It has a typical Waldalgesheim pattern which is contained within a circle and was possibly the decorative end-piece of one of the finials of a chariot yoke

Pottery of the Early La Tène period had a splendid tradition behind it in fabric and finish so that full advantage could be taken of the new shapes suggested by metal vessels of the kind just described. In no area was pottery brought to a higher standard than in Champagne which had been colonized from the Middle Rhine. The selection of vessels from various finds in the department of the Marne (*Ill. 199*) reveals the ability of potters who had not yet the advantages of a wheel that spun although a hand-turned device was probably employed. The angular vessels are the earliest in the group, and most closely follow metal forms while rounded shoulders show greater consideration for the use of clay, and follow that move already noted in the Waldalgesheim spouted flagon to smooth contours. Painted designs flourished at this stage giving opportunity for generous scrolls of a mature Celtic sort. Within the painted pottery styles of Early La Tène are known some few attractive horses both from the Marne and from Switzerland.

Until very recently it was assumed that the Celts first learnt about the possibilities of monumental stone sculpture from their southern trade contacts in the Early La Tène period. A crudely carved slab, with face and chevron line below, that was found in a Hallstatt tumulus at Stockach, near Reutlingen, Württemberg, could be regarded as a probable freak, but in 1962 a remarkable stone statue of a warrior, copying a Graeco-Italic style, was found during the excavation of a Late Hallstatt tumulus near Hirschlanden, northwest of Stuttgart. There was evidence that it had originally stood on top of the tumulus, but had fallen and fortunately became covered over with slipped material from the mound. This point is mentioned as it is necessary to realize how few have been the chances of survival for any visible stone sculpture of human figures of pre-Christian times. They were generally recognized as objects of heathen origin, and possible continuing cult, and great efforts were made during the Middle Ages to destroy them. One must be content therefore to note what has survived without drawing conclusions as to how representative in content and quality the survivors may be.

The stone sculpture of the La Tène Culture is known from hardly more than half a dozen pieces from Württemberg and the Rhineland

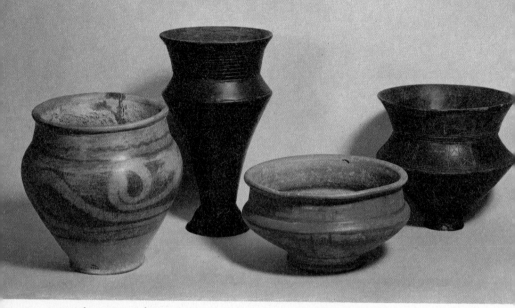

199 The pottery of the La Tène period is much influenced by angular metal shapes copied very accurately, as may be seen in this group from the Marne area

so far as the Early period is concerned in the Celtic homeland. There is a rather different and more sophisticated group in Provence; Celtic in spirit and iconography, but closely reliant on adjacent Mediterranean styles. This all seems to be later than the German group, and falls mainly in the third century BC. In the Iberian Peninsula there are some groups of simple animal sculpture and of warriors, which represent some accommodation of Iberian resources for Celtic needs. In Brittany (Armorica), and in Ireland, there are carvings related to the German group. In the Late La Tène period there was a widespread practice of head carving in a style partly derived from Provence, and even open to Roman influence. Some examples will be shown later, but here the earliest work in stone having connections with metal pieces already described must be reviewed. Without implications as to relative position of date, it will be best to begin with the tall sandstone block from Holzgerlingen, Württemberg (*Ill. 202*). This is a Janus, and the best preserved face is shown. The horns have been reliably restored, and are claimed to represent a leaf-crown. The right arm and hand are carved for each side of the Janus. A belt is indicated, and below this

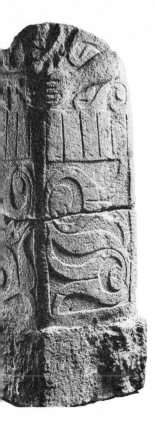
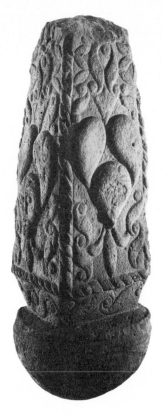

200–2 Few examples of Celtic monumental sculpture survive, due mainly to the religious zeal of the Middle Ages. Much of the decoration of the known examples may be paralleled in the spirals of the metal pieces and more particularly in the leaf-crowns. *Ill. 200 (above left)*, from Waldenbuch, is the lower portion of a sandstone block decorated with scroll carving of Waldalgesheim style and a carved left arm. Part of another pillar, from Pfalzfeld *(centre)*, has a rounded base and tapers towards the top. All four faces are carved with a human head and stylized foliage; the leaf-crown above the head should be compared with *Ills. 194, 195* from Waldalgesheim. *Ill. 202 (right)*, a tall sandstone block from Holzgerlingen, is a Janus statue and the carefully restored horns are claimed to represent a leaf-crown. Unlike *Ill. 200*, it has a right hand and arm above the belt carved on both sides

the stone is less carefully dressed. The face does not attempt to follow the bronze masks. The eyebrows form a straight ridge so that the eyes appear in heavy shadow unaided by carved outline. The nose is splayed and well marked, and the mouth is a severe slit. There is a general atmosphere of intensity if not ferocity in this sculpture, at least as seen full face, nor is it likely that a side view was contemplated by the sculptor. It seems unlikely that this stone can have been intended as a memorial to a man, but rather that it was a cult figure of some supernatural personage. The single arm provides a link with a stone from Waldenbuch in the same region (*Ill. 200*). This must have been a fine pillar before its upper portion was broken off. A single left arm was carved. and other details suggest that the figure was therefore not a Janus, but single-faced. The arm is rounded and fleshy with a much more reassuring message than that at Holzgerlingen. The angular carving to the left of the hand may represent an openwork metal belt-plate of a kind known from La Tène graves, but the most striking feature is the scroll carving in the Waldalgesheim style that covers large areas of all four faces of the block. It is noteworthy that this decoration is not carried round the edges of the stone. Each face has its own panel, and the edges, although carefully rounded by dressing, suggest reliance on some different concept. This in fact is illustrated on the pillar from Pfalzfeld, Hunsrück (*Ill. 201*) which is likely to be an older piece, or at least closer to the formative stage in this kind of sculpture. Here it will be seen that the edges have been carved in a deep rope-pattern, and this, as well as the overall shape, especially the form of the base, proclaims knowledge of Etruscan monuments. An early eighteenth century AD drawing of the Pfalzfeld stone shows that it tapered upwards although its summit was already broken. Local tradition was that a human head had crowned it, and this could well have been something akin to the head from Heidelburg (*Ills. 203, 204*). Was the Pfalzfeld pillar a stone version of a Celtic sacred tree? Impossible to decide, but one must remark on the pear-shaped heads so like those of the bronze plaques from Waldalgesheim (*Ill. 195*) each with their great swollen, bladder-like, leaf-crowns, as they gaze out from amongst a symmetrical arrangement of scrolls.

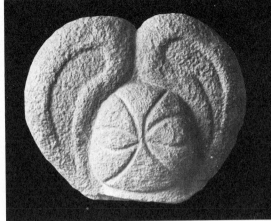

203, 204 The Heidelburg head is adorned with a massive leaf-crown. The face shows round eyes and trilobate markings on the forehead. The back of the head (*right*) apparently displays magical symbols

The scroll-work, not even approaching the running patterns of Waldalgesheim, together with the Etruscan elements, show the sculptor to have been working in the Early Style, but his treatment of the four heads shows that he was not far removed from the transition. Jacobsthal took the Heidelburg head to be a Janus, but the faces are not alike, and it is difficult to think that the eyes could have been executed so differently from one to the other. The less evident 'face' (*Ill. 204*) is here taken as intended for the back of the head, but endowed with magical symbols. The trilobate markings on the forehead, above the staring eyes, repeat a pattern not now easily seen on the Pfalzfeld heads. The Heidelburg leaf-crown is an accomplished piece of massive sculpture closely following in outline the comma shape which seems to have been the true form.

A complete monumental stone of great interest in Ireland cannot be excluded from this section. This is the rounded block of granite at Turoe, Co. Galway (*Ill. 205*) which seems to have survived on account of its non-commital shape and decoration. The organization of a complicated unitary pattern over this dome is excellent and the positive composition shows up against a background that has been

209

reduced by pocking. The girdling step-pattern is less carefully executed. A smaller rounded granite boulder at Castle Strange, Co. Roscommon, is carved in the same style but with large spirals. A much less well decorated stone at Kermaria in Brittany is usually quoted as the nearest relative for the Turoe stone. The Kermaria stone was a small tapering pillar after the fashion of Pfalzfeld, but the Turoe stone seems to have retained some direct memory of rounded Etruscan *cippi*, and it is difficult to suppose that it is a reduction of the idea of an anthropomorphic figure, or of a tree. J. Raftery, in drawing attention to the complexity and competence of the Turoe pattern, likened it to motifs on painted pottery in Brittany. This is a useful link to have established, and one supported on other archaeological grounds. The Turoe pattern may be described as an advanced composition in the Waldalgesheim Style, and should probably be dated to the first half of the third century B C.

The stone head in *Ill. 206* is one of a pair beneath the claws of a sculptured monster found at Noves, Bouches-du-Rhône. A human arm projects from the monster's mouth, and the whole thing is intended as horrific. It is evidently based on Etruscan, and other oriental traditions, in which the theme of the devouring beast was common. The treatment of the pair of heads is interesting because they embody a more genuinely Celtic feeling. The ridged eyebrows, triangular nose, and slit mouth are already familiar. The eyes are unusual, having all the implications of death. The tapering shape of this kind of head may have contributed something to those of Pfalzfeld and Waldalgesheim. It is just possible that the arrangement of the beard derives from some source that also influenced such handle-attachments as that of the beaked flagon from the fifth century B C grave at Klein Aspergle. The date of the Noves sculpture is uncertain, some call it La Tène II, but it is at least certain that this cheerless face never qualified for a drinking vessel. The theme of a monster with heads under its forepaws became known in Ireland where a very crude, but unmistakable, version has recently been brought to notice at Tomregan, Co. Cavan.

By Middle La Tène times, in the third century B C, Celtic society had seen great changes. The old centres of wealth and patronage

205 The Turoe Stone, in Co. Galway, is decorated with
an elaborate La Tène style composition ▶

207 A gold torc, one of five from a hoard found at Fenouillet, which shows a variant of the Plastic Style of La Tène art

do not seem to have survived the period of Celtic expansion, and now more widely dispersed chieftains of lesser status, and their warrior supporters, prepared themselves for a less sumptuous Otherworld. Personal ornaments in bronze become very much more frequent, and to these, and to such massive pieces as chariot fittings, the Plastic Style was applied. Jacobsthal described the difference between Waldalgesheim relief and that of the Plastic Style as a change from work that could be drawn in one plane to work that was deeply three dimensional. The compositions in this later style are also much more florid, even grotesquely bulging, and thus inevitably heavier and more static than before. The Sword Style retained more qualities of originality, but it is not pursued here as it is confined to lightly engraved linear designs mainly on bronze sword scabbards, difficult for satisfactory reproduction at reduced scale.

◀ 206 Detail of the human head beneath the claw of a sculptured monster from Noves

208 A gold torc made of tubular sheet metal decorated with fat spiral scrolls from Clonmacnoise

There are a number of very fine gold torcs in the Plastic Style, and of six found together at Fenouillet, Haute Garonne, the one illustrated (*Ill. 207*) is that rare thing a Celtic neck ornament that has at least the appearance of being twisted. It is in fact mock torsion. The buffer terminals are much closer together than in most earlier torcs, and the deep ornament of the terminals is a conglomeration of tooth-like protuberances. Nothing here of scrolls or tendrils, although another famous torc, from Aurillac, Cantal, is in effect a gold wreath of jungle exuberance. The gold torc from Clonmacnoise, Co. Offaly (*Ill. 208*) follows another Gaulish type though

214

209, 210 The bronze neck-ring with red enamel insets (*above*) is one of several similar examples from female graves in the cemetery at Nebringen. *Ill. 210* (*below*) is a massive tubular gold collar with repoussé ornament from Broighter

211 The Needwood Forest gold torc, a multi-strand torc, is a type that appears to be peculiar to Britain

probably itself made in Ireland. In this, the buffer terminals are closed. The hoop is hollow, and one section is removable from between the terminals and the unique feature at the other side. The principal motif is a spiral-ended scroll with swelling centre part. This torc, with the Turoe stone, provides leading evidence for a direct Gaulish contribution to Celtic art in Ireland while another piece, the gold collar from Broighter, Co. Derry (*Ill. 210*) speaks for workmanship in a tradition developed in Britain, and carried there from Belgium as the collars from the treasures at Snettisham, Norfolk, and Frasnes-lez-Buissenal, Tournai, would indicate. These thick hollow gold tubes originally had iron or other cores with resin coating against the gold. The terminals of the Broighter collar are fastened by a skilled locking device. The decoration is in an insular development of the Plastic Style with leaf forms, trumpets, and prominent coils against a hatched background. The thin ridges, stringy stalks, that wander over the surface, are a feature of Celtic art in Britain in the first century BC, and can be seen on the bronze helmet from the Thames at Waterloo Bridge.

212–14 A bronze torc from Courtisols (*above left*) is ornamented in the Plastic Style with faces and scrolls, and the bronze armlet from La Charme (*right*) has heavily moulded ornament which also includes human masks of an almost negroid appearance. A bronze neck-ring from Barbuise (*below*), with somewhat awkward projections, has decoration on the hoop, which is connected with that on the ring from Nebringen, *Ill. 209*

215–18 Various bronze chariot pieces from a grave at Mezek, southern Bulgaria, are shown in *Ills. 215–17* and the staring eyes on the terret (*opposite*) should be noted. A related pair of linchpins of iron with bronze demoniac masks (*opposite below*) comes from a cemetery at La Courte, Belgium

A type of neck ornament that appears to be peculiar to Britain is represented by the multi-strand torc from Needwood Forest, Staffordshire (*Ill. 211*). This gives an impression of richness without the heaviness of the tubular collars. The terminals have large perforations ornamented simply with wavy lines and dots. This piece probably dates from the later part of the second century BC, and was followed by similarly constructed torcs with ring terminals carrying heavy angular embossed motifs such as were found also at Snettisham and elsewhere. Bronze ornaments in the Plastic Style offer a great variety of shapes. One of the finest is from Courtisols, Marne (*Ill. 212*), and its principal decoration worthily carries on the tradition of forbidding masks. A massive bronze bracelet from La Charme, Troyes, Aube (*Ill. 213*), requires no analysis of its bold design except to note the back to back human masks that in earlier pieces Jacobsthal described as a Janus in one plane. The masks on this bracelet possess an almost negroid appearance especially in the lips, and this is a feature also found in some other masks of the Plastic Style. In the period of transition from Early to Middle La Tène, which takes on different aspects from region to region, a series of neck-ring types is found that lie somewhat outside the grander styles. The disc neck-rings with enamel inlays, and with minor scroll work on expanded sectors of the hoop, are mainly concentrated about the Upper Rhine and in Württemberg. A specimen from a cemetery at Nebringen, south-west of Stuttgart (*Ill. 209*) is representative of this type now confirmed as a woman's

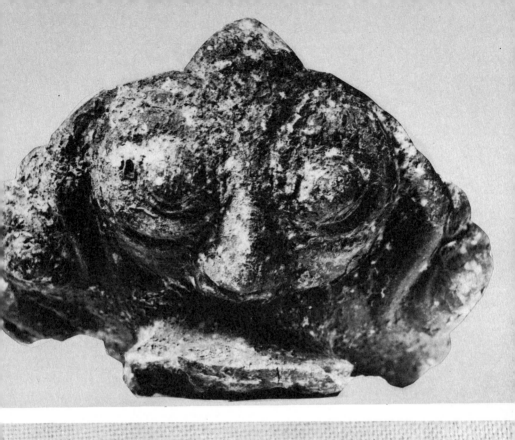

ornament. The ring is made in two pieces with tenon joints on either side of the decorated sector. The neck-ring from Barbuise, Aube (*Ill. 214*), with elegant but surely inconvenient projections of triple ball arrangements, is typical of that part of Gaul. The decoration on the hoop connects with the ring from Nebringen, but here a small jovial face is the centre element between a pair of spiral scrolls. Such masks, as well as others of sterner aspect, occur at much larger scale on chariot fitments. A terret at St Germain-en-Laye, of unknown provenance, shows three faces that have an uncanny leer. Less well known are various chariot pieces from a Celtic expeditionary's grave at Mezek in southern Bulgaria. First there is the claw of a broken terret, or loop, that was probably fixed on the yoke (*Ill. 217*), the face looks upwards to the loop, in reverse to the photograph which allows recognition of the deeply moulded rotund features flanked by large snail-like swirls. One of five surviving smaller terrets (*Ill. 216*) shows a rather similar animal mask on either face of the claw, and the linch-pins, of which the best preserved is illustrated (*Ill. 215*), display a lumpy abstract pattern. These chariot fitments are likely to have been made somewhere not nearer Mezek than Bohemia. A related pair of linch-pins, but of iron with bronze heads come from a cemetery explored at La Courte, Leval-Trahegnies, Hainault, Belgium (*Ill. 218*). These have been studied by M.E. Mariën, who in describing the clearest mask 'd'allure démoniaque', shows reason for placing them in the Waldalgesheim Style, and thus earlier than those from Mezek. This Belgian pair had enamel inlays now lost, and the treatment of the eyes suggest an eastern Celtic school which gave rise in the Plastic Style to such pieces as the bronze open-work from Brno-Maloměřice of which this heavy-eyed snouted mask is an outstanding item (*Ill. 219*). This collection of bronze sheet open-work has been variously identified as the embellishment for a wooden spouted-flagon, or a chariot yoke.

It would appear that there was a strong centre of workmanship in the Plastic Style in the territory of the Boii, and most remarkable of its products are the fragments of a bronze cauldron which came to rest in a hole in the ground, probably a votive offering, at Brå, near Horsens, in eastern Jutland (*Ill. 221*). There is a definitive study

219 Detail of the face on a piece of bronze openwork in the Plastic Style, one of a number of pieces found together at Brno–Maloměřice in Moravia. Its exact use is not known, but it was possibly used to embellish a wooden spouted-flagon or a chariot yoke

220 A pair of placid silver ox-heads connect this torc from Trichtingen with the heads on the Brå cauldron, Ill. 220. The core of the torc is solid iron coated with silver and it should be noted that the oxen each wear a twisted torc around their necks

221 The ring handle and attachments are fragments of a bronze cauldron, probably a votive offering, from Brå. Each of the three great bronze-coated iron suspension rings of the cauldron was flanked by a pair of placid ox protomes. The owl head in *Ill. 222* is on the inner side of this piece

222 In sharp contrast to the placid ox protomes on the exterior of the Brå cauldron (*Ill. 221*) is this fearsome - looking owl's head at the inner end of the ornamented spray

223 The bronze cauldron from Rynkeby has very stylized ox protomes which indicate a date in the first century BC, yet the human face between them is completely different from the style of previous Celtic heads and derives from an eastern prototype

of this find by O. Klindt-Jensen, and it can suffice to draw attention to the placid ox protomes, flanking, in pairs, each of the three great bronze-coated iron suspension rings. These ox heads represent an acceptance by the Celts of an oriental motif best known from much earlier Urartian work, but one that must have remained in vogue in some nearer region to be accessible to Celtic artists in the third century BC. The central rib of the ring attachments is ornamented with a spray in relief of typical Celtic composition, and this runs to an inward looking owl head of fearsome countenance (*Ill. 222*). The connection with Maloměřice is clear, nor should the owl mask on the Rheinheim torc be forgotten (*Ill. 188*). The Brå cauldron was altogether a masterpiece in construction and ornament. Related in its amiable ox heads is the silver torc from Trichtingen, Württemberg (*Ill. 220*). The core is a solid bar of iron. Note the twisted torcs around the necks of the ox terminals. Both the adoption of silver, commonly in use in south-eastern Europe, and of naturalistic animal forms foreshadow their full acceptance in the last two centuries BC. Another Celtic piece that made its way to Denmark was the bronze cauldron found at Rynkeby, Funen (*Ill. 223*). The

223

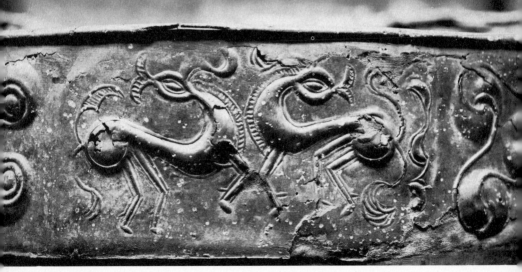

224–6 The Aylesford bucket came from a cremation grave and was old and an heirloom when it was buried. The overall view, *Ill. 224* (*opposite*) shows the stave-built construction which is also known from other examples found in England. Belgic features are apparent in the roundness of the horses' bodies on the upper hoop, *Ill. 225* (*below*), yet the treatment of their floral-type heads and the human heads on the handle attachment, *Ill. 226* (*right*) is of a more archaic style

stylistic treatment of the ox protomes indicates a first century BC date of manufacture, and the human face, with provision for eye inlays, is in quite a different tradition than anything yet seen from Celtic hands. Both the hair style, and the concept of figured vessels, derive, like the ox protomes, from eastern sources, and there is an increasing body of archaeological evidence to show how this came about. The Rynkeby cauldron had inner plates around the neck that also were ornamented, and one of these survives showing a pair of confronted beasts, boar and probable lion, recalling in style and subject a decorated silver belt-plate of Thracian work from Loveč in Bulgaria. In England, figured cauldrons are unknown, but stave-built wooden buckets, or tubs, with decorated bronze hoops and mounts, depend on some common source with Rynkeby. The bucket from Aylesford, Kent (*Ill. 224*) combines archaic modes such as the nature of the mask on the handle attachment (*Ill. 226*), and the floral treatment of the horses heads on the upper hoop (*Ill. 225*), with 'modernizing' Belgic features in the roundness of the horses bodies, and the heaviness of the interlocked comma-leaf pattern. This bucket is an insular product, and was old when placed in a cremation grave

227 The tankard from Trawsfynydd, Merioneth, is a fine example of the British craft of stave-built wooden vessels. It is covered with sheet bronze bent inwards over the staves and the openwork handle is a good example of the composition style of the last phase of British Celtic art

with Roman imports. The craft of stave-built wooden vessels was a British skill that survived the Roman occupation and the Anglo-Saxon settlements. A piece dated on stylistic grounds to the first century AD is the tankard from Trawsfynydd, Merioneth (*Ill. 227*). The bronze sheet is bent inwards over the staves, and there is an elaborate wire pattern worked around the base into the feet of the staves. The open-work handle is one of the best compositions of the last phase of Celtic art in Britain.

A brief word must now be said about an art tradition lying to the south-east of the Celtic world whose contribution to the latter may be more important than heretofore recognized. It is simplest to refer to this as Thracian art, and its major pieces come from points along or near the Lower Danube, and from Moldavia south to Bulgaria. The silver vase from Hagighiol, Dobrudja (*Ill. 228*) shows this style to have been a clumsy version of Persian and other

228 Outside the world of Celtic art, to the south-east, lay a different sphere of art in the area of the Lower Danube, Moldavia and Bulgaria, referred to as Thracian art. This was much influenced by Persian art as may be clearly seen in this silver vase from Hagighiol. The curious animals and the vessel's waisted shape are distinctive borrowings from Persian art and it can be seen to represent an intermediate stage when its linear bounding dog and devouring beast motifs are compared to some of the Celtic flagons, cf. Ills. 190, 191

229 A magnificent piece of gold repoussé work is represented by the helmet from Poiana-Coțofenești in Rumania. The eyes and eyebrows are particularly strongly marked and the animals around its lower outer side have coats worked in a Persian tradition. Their eyes and hoofs are also related to the style of the Rodenbach rams, cf. Ill. 184

oriental influences such as might be picked up by barbarians in contact with the Greek cities of the Black Sea. This vase and the silver helmet and other things found with it may date to the late fifth century BC. Apart from supplying some ideas and techniques to Celtic artists in the Early Style, Thracian art has features in common with bronze decorated buckets known from around the head of the Adriatic, the so-called Situla Art ascribed to the Veneti and related peoples. The situla ornament is more valuable for its iconography than for its claims to any kind of beauty. The waisted shape of the Hagighiol vase is a distinctly Persian borrowing, and the devouring beast on the base, and the bounding-dog linear motif, will not be missed in the light of the Celtic beaked flagons. A gold helmet from Poiana-Coţofeneşti, near Ploieşti, Rumania (*Ill. 229*) is a magnificent piece of repoussé work, and introduces not only the motif of strongly marked eyes and eyebrow, but also animals with worked coats in the Persian tradition, and eyes and hoofs relevant to those of the Rodenbach rams (*Ill. 184*). This helmet can probably be placed in the fourth century BC, but speaks for considerable antecedent experience in this kind of work. By the second century BC when great trading strongholds, *oppida*, were coming into existence, and forming an important new aspect of Celtic life, such eastern ornamental traditions gained a stronger foothold. This is the probable background of the whole matter of figured metal cauldrons, and the old oriental bestiary was even made use of for silver coins minted in or near Bratislava as late as the mid-first century BC. From such a centre as Bratislava, or indeed farther south-east, as Rumanian scholars think, must have come the great silver vessel found in a peat bog at Gundestrup, Himmerland, Denmark (*Ill. 230*). This extraordinary confection combines eastern silverworking techniques and iconography with Celtic subjects known from archaeology such as crested helmets, trumpets, torcs, and shields. The construction with inner and outer plates, and the high relief masks with eye apertures for inlay, show its relationship to Rynkeby (*Ill. 223*), and a date *c.* 100 BC seems probable.

Reference has already been made to a Celtic adaptation of Graeco-Etruscan sculpture in Provence, an area included in the great Celtic

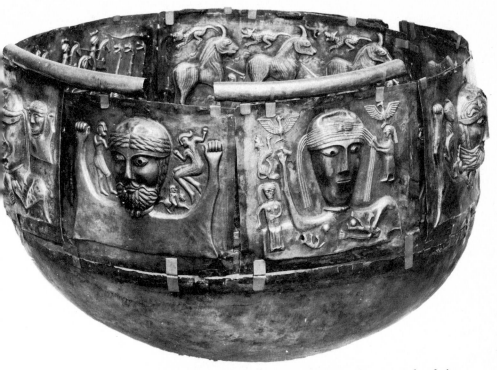

230 The great cauldron from Gundestrup, Denmark, is an outstanding example of silver work from the Celtic world, and was probably made somewhere along the Middle Danube. It is composed of silver inner and outer plates, and a base-plate, all ornamented in repoussé with Celtic and Oriental themes

expansion of the fourth and third centuries BC. The sculpture is principally known from two important sanctuary strongholds at Entremont and Roquepertuse, both of which were destroyed by the Romans in 124 BC, thus providing a firm *terminus ante quem* for the sculpture. It is probable that a consequence of this destruction was the dispersal of stone workers widely throughout the yet free Celtic world to the north so that Provençal stylistic features can be recognized in more barbaric sculpture far afield and later in date. From within the years of prosperity of these oppida, the rectangular stone upright from Entremont, Bouches-du-Rhône (*Ill. 231*) introduces a severe Celtic style little touched by Mediterranean influences

229

231 From the Celtic sanctuary at Entremont which was destroyed by the Romans in 124 BC, comes this stone pillar ornamented with engraved heads. They are engraved in groups of three and each group is arranged differently

232, 233 Two stone heads, the 'Janus' head from Roquepertuse (*left*) and the head from Salzburg (*right*) have features in common in their staring eyes and curiously twisted mouths

except perhaps in its monumental possibilities. The heads are reminiscent of the old pear-shapes with splayed noses, but now have squared chins, and they are grouped in various arrangements of three; that fundamental and auspicious number in Celtic as in other Indo-European mythologies. Best known is a Janus sculpture from Roquepertuse, in the same departement (*Ill. 232*). One face only is shown here and that in full to illustrate the treatment of the eyes, and sinister twisted mouth, for these set a style copied with diminishing success far and wide. Into this context surely comes the head until recently built into the castle walls at Salzburg, and studied by K. Willvonseder (*Ill. 233*). In this the eyes are more open, but quite similar as to the treatment of the edges, and the nose comes down from the brows. The mouth has slipped badly. The rounded chin,

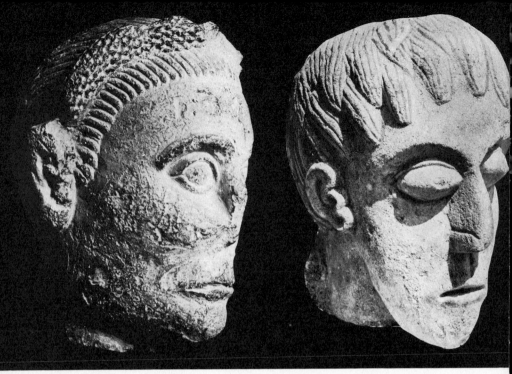

234, 235 Possibly an idealized portrait, the stone head from Entremont (*left*) contrasts strongly with the Late Celtic iconography of the head from Gloucester (*right*) which probably represents some supernatural being

and deeply worked hair, may be compared with a much more finished head from Entremont (*Ill. 234*), one of several pleasing sculptures that may be idealized portraits. The tenacity of Celtic iconography in stone is demonstrated by the head found in Gloucester (*Glevum*), and dated to the first century BC (*Ill. 235*). The treatment of the hair is found in Gallo-Roman sculpture, but the protruding eyes, nose, mouth, and ears all convey Celtic messages of older representations of supernatural personages. This is not a human portrait as has been alleged. The date of the three-faced head from Corlech, Co. Cavan, Ireland (*Ill. 236*) is not easy to approximate. It is an impressive handling of a granite boulder, not easy to work, and it may be viewed as a version in the round of the triad motif seen flat at Entremont.

Although not within the main stream of Celtic production, *Ill.* *237*, a bronze head reputedly preserved in a remote Pyrenean

236, 237 Impressive handling of a difficult stone, a granite boulder, is seen in the three-faced head from Corlech. *Ill. 237 (right)* is a bronze head from the Pyrenees which has similarities to the stone heads from Provence

church, and now in the museum at Tarbes, is of some interest. Is it a cauldron maker's version of the stone heads of Provence? It seems unlikely to have been connected with the figured vessels of east-central Celtic workmanship. Other sheet bronze and silver pieces in Gaul, brought together by Lantier, are more likely to owe their origin to craftsmen coming from across the Rhine during the increasingly troubled times of the early first century BC.

The nature of Celtic art in Britain has been touched at a few points, but something must now be said about the principal styles that developed from the mid-third century BC, foreshadowed at about that time by the decoration of the Brentford horn-cap (*Ill. 198*). Stuart Piggott has written of the partial parallelism to continental styles, but how the insular art developed an individual genius of its own. In content the motifs chiefly employed have been described by J. M. DeNavarro as both linear and plastic, the one often adorning

233

the other, a barbarian weakness, and how the designs tend to move in a circular rhythm. There is a great feeling for swelling surfaces, and this is well seen in details from the bronze ceremonial horse-cap found at Torrs, Kirkcudbrightshire, in south-western Scotland (*Ills. 239, 240*). The design is repoussé executed, and is a bold adaptation of the floral tradition involving asymmetrical palmette derivatives that yet contain a suggestion of bird heads. The beauty of the whole piece is marred by an antiquarian error in reconstruction, and so is avoided here. Best example of a flowing circular design is the round shield boss from the Thames at Wandsworth (*Ill. 238*). The pattern is composed in light relief with very smooth flowing lines in leaves and tendrils, two of which terminate in 'buds' that are also birds heads with little curled leaves for beaks. Sir Cyril Fox has pointed out that the left-hand side of the composition is a reversal of the right-hand half. Linear decoration covers the central projection, and fills in the field of two leaves behind each bird-head terminal. It will be noticed that these leaves have not swelling convex surfaces, generally so sought after, but look almost concave or dished with only the outlines in relief.

238 From the Thames at Wandsworth a round shield boss represents one of the best examples of insular La Tène art. Basically a pattern of leaves and tendrils, the craftsman has made two of the 'buds' into birds' heads

239, 240 Two details from the bronze ceremonial head-piece of a chariot pony from Torrs, Kirkcudbrightshire, well illustrate the Insular La Tène style ornament. The terminal head motif (*below*) should be compared with the Wandsworth boss (*opposite*)

In studies of Celtic art the relation of one piece to another seems often to be deduced on too prosaic a consideration of style, little credit being given to the difference in powers of possibly contemporary artists. This is due mainly to the scarcity of the surviving pieces, and also because evidence of this kind has been pressed into service to assist in constructing schemes for the general cultural chronology of the times. The shield from the river Witham in Lincolnshire (*Ill. 241*) must come next on all grounds. The bronze sheet would originally have been backed with leather, less probably wood. In its first use the face was free of decoration except for a stylized boar-figure whose outline can now only be discerned by discolouration of the bronze, and by a number of small rivet holes. The boar, itself cut out in bronze or some other thin substance, had then been removed, and the existing scheme of ornament with boss, and midrib with circular terminals, mounted instead. Although the Witham shield must be regarded as a masterpiece for parade or for votive ends, the design is based on practical usage. The central boss, or umbo, is placed above mid-point as befits the best position for the handle behind. The lower terminal is larger than the upper evidently to account for difference in perspective when the shield was held tilted forward. The stylized horse masks on the midrib next to either terminal should not be missed, and the moulding of the central boss can best be appreciated in the detailed photograph (*Ill. 242*). A half leaf projecting above and below towards the rib is executed in the relief border manner, and the whole effect was heightened by addition of red glass studs of which three survive.

The shield from the Thames at Battersea (*Ill. 246*) represents the culmination of shield art in this school so far as it is known. Modern analysis reveals that the bronze had been gilded. The shield is slightly waisted, and there is no midrib, but the pattern is perfectly symmetrical about the median line. Inspection of the coloured illustration will provide a better analysis than brief words on this page. Red glass was again used, but now more lavishly, and the intricacy of the bronze mounting for these insets is of a very high order. Recent estimations of the date of the Battersea shield place it about the turn of the second and first centuries B C rather than later.

241, 242 The bronze shield from the river Witham in Lincolnshire had two phases of decoration. Originally a plain sheet of bronze backed by leather, its only decoration was a stylized boar figure. This may be seen faintly in the overall view (*right*) on either side of the boss. Subsequently the boar was removed, leaving only a faint outline and rivet holes. The present ornament of midrib with circular terminals and a moulded central boss, seen in the detail photograph (*below*), was added and the whole effect heightened by the addition of red glass studs

237

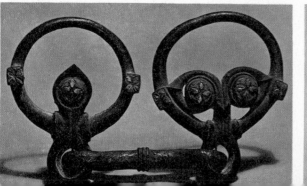

243–5 The Desborough mirror (*left*) represents the highest development of mirror art in its overall conception of curvilinear blank spaces full of movement and its ornate handle. *Ills. 244, 245 (opposite below)* illustrate examples of enamelling such as continued in Britain outside the sphere of Roman dominion after the Claudian invasion in AD 43. The snaffle bit comes from Rise in Yorkshire and the bracelets are from Castle Newe, Aberdeenshire

246 The finest example of shield art is represented by a shield from the Thames at Battersea dated to about the turn of the second and first centuries BC. Originally the bronze was gilded and red glass was set into the intricate bronze mountings

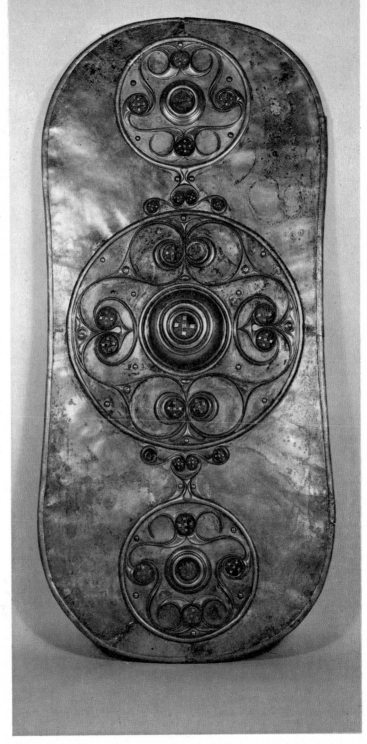

There was another school of Celtic artists decorating bronzes in a purely linear style. *Ill. 247* shows part of a shield mount from a recent discovery at Tal-y-Llyn, Merioneth. The principal motif is a triskele in reserve set against a roundel which is hatched in various ways. First, the toothed line effect is produced by the rocked-tracer technique, and secondly, both plain and basketry hatching have been used. This is an early and tentative example of a treatment that was brought into full play in the decoration of mirrors. A complete bronze shield boss with short projecting ribs was amongst the great quantity of material found at Llyn Cerrig Bach on the island of Anglesey (*Ill. 248*). This is certainly allied to the foregoing, but the choice of four roundels containing more elaborate triskeles, and all grouped on a single slightly keeled boss, produces a most coherent and finished effect.

247 A purely linear style of decoration, produced by the rocked-tracer technique and hatching, appears on a fragment of a bronze shield mount recently found at Tal-y-Llyn, Merioneth. This is a style of decoration that was to reach fruition in the decoration of mirrors *cf. Ills. 243, 249*

248　Amongst a large hoard of metalwork found at Llyn Cerrig Bach, Anglesey, was a complete shield boss with short projecting legs. It is certainly allied stylistically to the boss in *Ill. 247* and represents a further stage where four roundels with more elaborate triskeles are grouped into a satisfactory pattern

The most original contribution to Celtic art produced in southern Britain in the late first century B C, and continuing to the time of the Claudian invasion (A D 43) is comprised in a series of bronze mirrors with elaborately chased linear compositions on the back. Polished metal mirrors were not unknown to Celtic rank and beauty in the late fifth century B C, acquired from Etruscan trade, and some long handled Scythian mirrors may have made their way west at a later period. The British mirrors were inspired by Roman which had come into Gaul in the process of active trade along with military occupation. It is a tribute to the tradition of Celtic art that such a complete transformation should have been effected, and standing early in the series is the 'Mayer' mirror, most beautiful of all, probably dredged from the Thames, and now in the museum at Liverpool (*Ill. 249*). In this a clean engraved line takes control both in marking the outline of the mirror, and in sweeping over the surface connecting each of the three roundels with their complex triskele patterns; each asymmetrical and different. There is a compact, finely executed, basketry hatching, but it has been used selectively, not as a general background. The handle is perfect in its proportions and simplicity. The mirror from Desborough, Northamptonshire (*Ill. 243*) represents the highest development of the mirror art. The pattern is a noble conception of curvilinear blank spaces full of life, and off-set by narrow angular fields of close, rocked tracer, matt hatching. The handle shows elaboration, but only such as befits the magnificence of the whole piece.

A skill learnt from Roman technology, but in advance of military occupation, was that of making bronze vessels by spinning on a lathe, and several of these, made in the Belgic region of southeastern Britain, have been recognized. One of the finest had in fact been carried over to Ireland, and was found in the Shannon at Keshcarrigan, Co. Leitrim (*Ill. 250*). The photograph shows the detail of the handle in the form of a duck's head, and the upturned beak, and moulded accentuation of the eyes, carries on the essentials of Celtic plastic representation to the last moment. The eyes of this bird evidently held glass or enamel studs.

243

249 The 'Mayer' mirror, beautiful in its compact and restrained decoration, was probably found in the Thames

In the north of Britain, both before and after the Claudian invasion, enamelling continued in the free territory, and has many points of great technical interest. Examples here shown are the bronze bridle bit, with blue and red enamel settings, from Rise, near Hull, Yorkshire (*Ill. 244*), and the pair of bronze armlets from Castle Newe, Aberdeenshire (*Ill. 245*) with red and yellow enamel medallions. These bracelets, in a massive style characteristic of the final phase of true Celtic art in northern Britain, date to about AD 100. Glass has been in mind since mention of the cemetery at Hallstatt. The princess at Rheinheim had glass beads, and they became increasingly popular during Middle and Late La Tène times when bracelets were also made in this substance. A rich woman's grave of La Tène C, at Dühren, Baden (*Ill. 251*), was well supplied with

250 Made by spinning on a lathe, this fine bronze cup with its duck-head handle was found in the river Shannon at Keshcarrigan in Ireland whence it had come from south-eastern Britain

251 Glass beads and bracelets became increasingly popular in the Middle and Late La Tène period. The fine collection shown here was found in a rich woman's grave at Dühren, Baden, Middle La Tène period. The colours include clear blue, golden yellow and green

armlets in clear blue and golden yellow glass, and with beads in these colours and green. The little dog from a La Tène D grave in the cemetery at Wallertheim, Rheinpfalz (*Ill. 252*), shows the expertise of Celtic glass-work. The dog is in blue glass, the body and head being made in one with legs, tail, and ears, stuck on. The body is hollow and was presumably plugged so that the dog could be suspended or attached in some way. Thin white glass threads wrap the body, and yellow ones bind the ears, tail, and legs. H. Schermer who has described this find, draws attention to the harmonious arrangement of these three most frequent colours in La Tène glass noticing too that the muzzle has been left unwrapped in translucent blue.

252 A miniature blue glass dog, less than an inch in length, from Wallertheim, shows the expertise of Celtic glass-work. The decoration consists of thin white glass threads around the body and yellow around the ears, tail and legs; the muzzle is a translucent blue

The blacksmith's craft has been an inferred essential for the prosperity of the Hallstatt and La Tène Cultures throughout these pages, but sword blades and spear heads, and more utilitarian things, have had to remain unrepresented. Of its substance, iron is a poor survivor from the past, and such complete objects from the period under discussion as are still in existence come mainly from finds where the natural conditions were particularly favourable. Large pieces of ironwork, intentionally objects of barbarian refinement, are not known before the first century BC, and then one distinctive household adjunct comes into view. This is the 'fire-dog' which in a Celtic context would be more appropriately described as a 'fire-ox'. These are the direct ancestors of the modern versions except that until about the fourteenth century AD one dog only was used, being placed across the front of the hearth. In the tombs, two fire-dogs have been found in a number of cases. This, with other evidence, leads to the deduction that two fires, and therefore two personages, were thought appropriate for the Otherworld feast, and Stuart Piggott has graphically described the concept of '. . . an unending banquet, pledging the eternal health of a boon companion before fires that blazed for ever behind the blackened fire-dogs.' Here is one of a pair from Barton, Cambridgeshire (*Ill. 254*). It shows complete mastery of material and purpose with perception of the ox in nature as well as the requirements of formal stylism. The hammer faceting of the animal's face is still splendidly preserved (*Ill. 253*). A related piece is from a find in a peat bog at Kappel near the Federsee in southern Württemberg (*Ill. 256*). The iron surface has suffered, but differences will be noted in the shape of the bar employed, and the method of fixing it to the rest of the fire-dog. Some variation is to be expected in the ox head and horns, but the ball terminals are constant. Also from the find at Kappel are a pair of iron eagle heads of which the best preserved (*Ill. 255*) rises from a shaft with small round foot. The hole through the head behind the ears may have held horns, and such a mixture might not have been inappropriate in Celtic fantasy. This is undoubtedly an impressive piece of ironwork. If it was a double-ended fire-dog it must be wondered how it could be made to stand firmly on such

253, 254 One of a pair of typically Celtic iron fire-dogs from Barton, Cambridge. The hammer faceting of the ox face is still very well preserved, as shown in the detail (*opposite*)

small feet. Or could it have been from a four-footed contrivance such as the large iron stand from Welwyn, Hertfordshire (*Ill. 257*)? Here also are small feet. The skilled change in section of the iron bar in each of the four uprights is admirable as are the upward looking, open mouthed, heads of bellowing bulls. J.W. Brailsford has suggested that this stand was for holding wine amphorae imported from Roman Gaul, and found in the tomb at Welwyn as elsewhere. He has also pointed out the usefulness of the crossbar of the fire-dogs for resting the neck of an amphora so that it could be tilted gently when pouring the wine. Had not Fate overcome them, would the Britons have evolved a new art style in such a genial atmosphere? That in Ireland, convivial with home produced potations, a Celtic heritage was left vital for the art of the Middle Ages is well known.

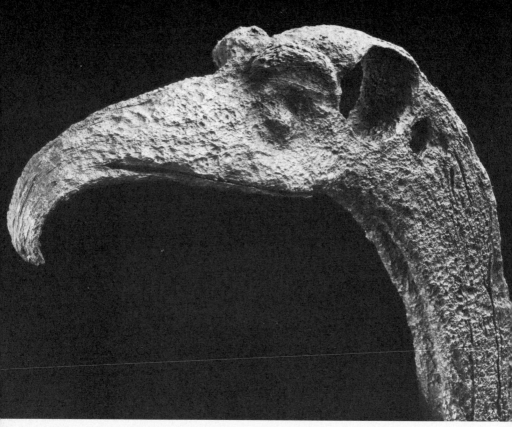

255, 256 Two examples of ironwork from the finds in the bog at Kappel, Württemberg, are the eagle's head (*above*) and the ox head (*opposite*). Both are from iron fire-dogs or similar objects

It was said earlier in this chapter that coinage largely replaced other forms of Celtic art throughout the continental territories from the end of the third century BC. One of the material factors in a barbarian people issuing, from tribe to tribe, its own coinage is that Mediterranean merchants demanded exchange in this form; metal guaranteed as to its quality by the ruler, and thus the need for distinctive marks. The Celts became accustomed to Greek coinage not only through trade, but as expeditionaries and mercenaries in Italy, the Balkans, and the islands of the Mediterranean. Only tribes with constant foreign trade found coinage necessary; simple forms of barter held sway in northern Britain and Ireland until long after the disappearance of the Romans.

258, 259 Celtic artists took the design of the gold stater of Philip II of Macedon and copied it widely in their own individual style. Here a coin of the Parisii of Gaul is shown alongside its prototype, the charioteer reverse of the stater

Amongst the Celts, the concept of coinage would have been bound up with the imagery they saw on the Greek coins with which they were first paid, or had looted. Doubtless they would have read into the imagery the same kind of magical values implicit in their own work. Both went together so that to copy Greek prototypes was something different than making replicas of other peoples ornaments, an unthinkable activity. The copies proved, however, never to be exact for the skill had to be picked up at the same time, and when Celtic coiners had become adept, that open minded and active spirit had evolved its own ideas of what that imagery should be. A simple origin for Celtic coinage used to be propounded deriving from the gold stater of Philip II of Macedon (*Ills. 258, 261*), and devolving to ever more disintegrated patterns. It is now known that the stater of Alexander III was more important in the east, but that there was an early coinage in silver amongst the Celts in Transylvania. In Gaul, Massiliote currency played an initial role, and some very fine silver pieces were struck by tribes under this influence. Original Greek

253

257 An iron stand with ox-head terminals from Welwyn, Hertfordshire

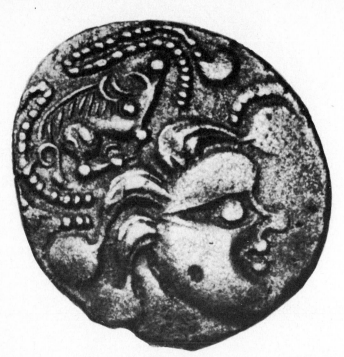

260, 261 The obverse type of a head of Apollo on the gold stater of Philip II of Macedon has been here transformed, by a Celtic artist, into an ecstatic face with a boar symbol behind it, on the obverse of a silver stater of the Baiocasses of Gaul near Bayeux

inscriptions were sometimes copied unintelligibly as part of the decoration, but true inscriptions with recognizable Celtic names come late in the series resulting from Roman example.

The two most constant elements in Celtic coinage are a head on the obverse, following Greek practice, and a horse on the reverse following Greek chariot scenes, but with the horse gaining at the expense of everything else (*Ill. 259*). Both heads and horses display a rotundity and fleshiness not found in traditional Celtic art, and this move towards naturalism has already been observed in the horses of the Aylesford bucket (*Ill. 225*), and before that in the ox-head protomes of continental pieces. This therefore is all part of the contribution of east-central Celtic craftsmen which was strongly felt in the Belgic areas of Britain. Some Plastic Style motifs are to be found. The swollen-leaf with curly tail makes up the hair and moustache of a

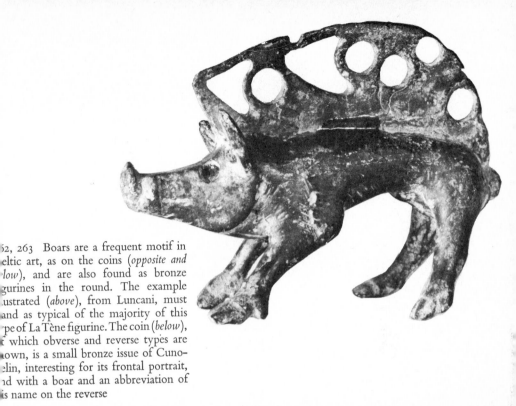

262, 263 Boars are a frequent motif in Celtic art, as on the coins (*opposite and below*), and are also found as bronze figurines in the round. The example illustrated (*above*), from Luncani, must stand as typical of the majority of this type of La Tène figurine. The coin (*below*), of which obverse and reverse types are shown, is a small bronze issue of Cunobelin, interesting for its frontal portrait, and with a boar and an abbreviation of his name on the reverse

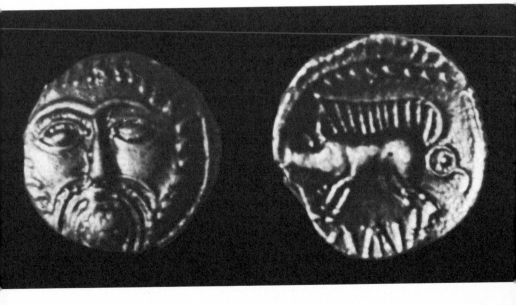

head on a coin of the Carnutes, a people between the Seine and the Loire, but this is not usual. In north-western Gaul some of the most inspired and exuberant designs were struck in silver using an iconography that often seems to provide illustrations for the Celtic mythology that was preserved in Ireland. A silver coin of the Baiocasses, a tribe around Bayeux, showing an ecstatic face with three locks of hair, and a boar symbol above between a pair of dotted horns, grasps the essence of Celtic imagination in their love for furious superhumans interdependent with auspicious symbolism (*Ill. 260*). Finally, a link with history is furnished in the name of Cunobelin, and one of his bronze issues (*Ill. 263*), charged on the reverse with a boar and an abbreviation of his name, shows on the obverse a full face, a mask in the same style as those well known from metalwork in contemporary graves of his own Belgic people. Cunobelin's coin is thus a firm link between the arts of the anonymous past and ourselves.

APPENDIX

257

List of Sites

The numbers shown refer to the illustrations in the text. Where several objects have been found at the same site, only the first illustration number is given on the map, the others follow in brackets in this list.

259

261

Abbreviations

In the List of Illustrations after each name and subject, a measurement is given of length (*l.*), height (*ht.*), or width (*w.*). If the subject is in a museum this is indicated appropriately by: M (Museum), LM (Landesmuseum), NM (National Museum). In some cases a reference for further reading is given, and this is either to a book or monograph in the Bibliography, or to a periodical listed below.

AA · · · · · · · *Acta Archaeologica*, Copenhagen
AAH · · · · · · *Acta Archaeologica Academiae Scientiarum Hungaricae*, Budapest
AJ · · · · · · · *The Antiquaries Journal*, London
Ant · · · · · · · *Antiquity*, Cambridge
Arch · · · · · · · *Archaeologia*, London
Germania · · · *Germania*, Anzeiger der Römisch-Germanischen Kommission. Frankfurt/Main
Inv. Arch. · · · *Inventaria Archaeologica*, Union internationale des sciences pré-et protohistoriques
JRSAI · · · · · *Journal of the Royal Society of Antiquaries of Ireland*, Dublin
PPS · · · · · · · *Proceedings of the Prehistoric Society*, Cambridge
PSAS · · · · · · *Proceedings of the Society of Antiquaries of Scotland*, Edinburgh
SA · · · · · · · *Sovetskaia Arkheologiia*, Moscow-Leningrad

Bibliography

The following works are all well illustrated, and contain further bibliographies. In a few cases where the title is not self-explanatory a note is added.

ABRAMOVA, Z. *Paleoliticheskoe Iskosstvo na Teritorii SSR*, (for figurines)

ALMAGRO, M. *Ars Hispaniae*, I (*Arte Prehistórico*) Madrid, 1947

ALTHIN, C-A. *Studien zu den Felszeichnungen von Skåne*, Lund, 1945

ANNABLE, F.K. and SIMPSON, D.D.A. *Guide Catalogue of the Neolithic and Bronze Age Collections in the Devizes Museum*, Devizes, 1964

BADER, O.N. *Istoriko-Arkeologicheska Sbornik*, Moscow, 1962, and *SA*, 1963, 125–34 (for Krapova cave) *Ill. London News*, 7 Nov. 1964, Archaeol. Sec. no. 2205 (for Sungir grave)

BALLESTER TORMO, I. Idolos oculados valencianos, *Archivo de Prehistória Levantina*, II (1945), 1–7

BENOIT, F. *L'art primitif méditerranéen de la vallée du Rhône*, Paris, 1945

BERCIU, D. *Contributii la problemele neoliticului in Rominía . . .* , Bucharest, 1961

BRAILSFORD, J.W. *Later Prehistoric Antiquities of the British Isles*, British Museum, 1953

BREUIL, H., and WINDELS, F. *Four Hundred Centuries of Cave Art*, Montignac, 1952

BROHOLM, H.C., LARSEN, W.P. and SKJERNE, G. *The Lurs of the Bronze Age*, Copenhagen, 1949

BRØNDSTED, J. *Danmarks Oldtid*, I–III, Copenhagen, 1957–60

CARDOZO, M. *Das origens e técnica do trabalho do ouro*, Guimarães, 1957

CLARK, G. *World Prehistory*, Cambridge, 1961 (for discussion of the Upper Palaeolithic)

CLARK, J.G.D. *The Mesolithic Settlement of Northern Europe*, Cambridge, 1936

CONDURACHI, E. *Monuments archéologiques de Roumanie*, Bucharest, 1960

DE LAET, S.J. *The Low Countries*, London, 1958

DEMARGNE, P. *Aegean Art*, London, 1964

DE NAVARRO, J.M. The Celts in Britain and their Art, In M.D. Knowles, ed., *The Heritage of Early Britain*, London, 1952

DUMITRESCU, VL. *Necropola de incineraţie . . . de la Cîrna*, Bucharest, 1961

FILIP, J. *Celtic Civilization and its Heritage*, Prague, 1962

FISCHER, F. *Der spätlatènezeitliche Depot-Fund von Kappel*, Stuttgart, 1959

FORMAN, W. and B. and POULÍK, J. *Prehistoric Art*, London, n.d.

FOX, A. *South West England*, London, 1964

FOX, SIR CYRIL *Pattern and Purpose: A Survey of Celtic Art in Britain*, Cardiff, 1958

GIEDION, S. *The Eternal Present, I: The Beginnings of Art*, London, 1962

GIMBUTAS, M. *The Prehistory of Eastern Europe*, I, Harvard, 1956

GRAZIOSI, P. *Palaeolithic Art*, London, 1960

GOESSLER, P. *Der Silberring von Trichtingen*, Berlin-Stuttgart, 1929

GUIDO, M. *Sardinia*, London, 1963

HACHMANN, R. *Die frühe Bronzezeit im westlichen Ostseegebiet . . .* , Hamburg, 1957 (for line drawings of Tufălau hoard etc.)

JACOBSTHAL, P. Imagery in Early Celtic Art, *Proc. British Acad.*, XXVII (1941), 310–20
– *Early Celtic Art*, Oxford, 1944

JANKUHN, H. *Denkmäler der Vorzeit zwischen Nord- und Ostsee*, Schleswig, 1957

JOPE, E. M. The Beginnings of the La Tène ornamental style in the British Isles, In Frere, S.S., ed., *Problems of the Iron Age in Southern Britain*, London, 1961

KASTELIC, J. *Situla Art*, London, 1966

KIMMIG, W. and HELL, H. *Vorzeit an Rhein und Donau*, Lindau-Konstanz, 1958

KLINDT-JENSEN, O. *Bronzekedelen fra Brå*, Aarhus, 1953
– *Denmark before the Vikings*, London, 1957
– *Gundestrupkedelen*, Copenhagen, 1961

KRÄMER, W. *Das keltische Gräberfeld von Nebringen*, Stuttgart, 1964

KROMER, K. *Hallstatt: Prähistorische Kunst*, Vienna, 1963

LAMING, A. *Lascaux, Paintings and Engravings*, London, 1959

LAMING-EMPERAIRE, A. *La signification de l'art rupestre paléolithique*, Paris, 1962

LANTIER, R. Masques celtiques en métal, *Monuments Piot*, 37 (1940), 104–19

LENGYEL, L. *L'art gaulois par les médailles*, Paris, 1954

LEROI-GOURHAN, A. *Préhistoire de l'art occidental*, Paris, 1965

MACK, R. P. *The Coinage of Ancient Britain*, London, 1953; 2nd ed. 1964

MARIËN, M-E. *La période de La Tène en Belgique: Le groupe de la Haine*, Bruxelles, 1961

MATHIASSEN, T. (ed.) *Danske Oldsager*, I: Aeldre Stenalder, by T. Mathiassen; II: Yngre Stenalder, by P. V. Glob; III and IV: Bronzealder, by H. C. Broholm. Copenhagen, 1948–57

MOREAU, J. *Die Welt der Kelten*, Stuttgart, 1958

MOZSOLICS, A. *Der Goldfund von Velem Szentvid*, Basel, 1950

NEUSTUPNÝ, J. and E. *Czechoslovakia before the Slavs*, London, 1961

NOVOTNÝ, B. *Počiatky výtvarného prejavu na Slovensku*, Bratislava, 1958 (English summary. Neolithic figurines etc.)

Ó RÍORDÁIN, S. P. and DANIEL, GLYN. *New Grange and the Bend of the Boyne*, London, 1964

PÉQUART, M. and S-J. and LE ROUZIC, Z. *Corpus des signes gravés des monuments mégalithiques du Morbihan*, Paris, 1927

PIGGOTT, S. (ed.) *The Dawn of Civilization*, London, 1961
– *Ancient Europe*, Edinburgh, 1965

PIGGOTT, S. and DANIEL, G. E. *A Picture Book of Early British Art*, Cambridge, 1951

PIJOAN, J. *Summa Artis*, VI, (El Arte prehistórico europeo), Madrid, 1953

POBÉ, M. and ROUBIER, J. *Kelten-Römer*, Olten-Freiburg im Breisgau, 1958

POWELL, T. G. E. *The Celts*, London, 1958

POWELL, T. G. E. and DANIEL, G. E. *Barclodiad y Gawres*, Liverpool, 1956 (for megalithic art)

SIEVEKING, A. and G. *The Caves of France and Northern Spain: A Guide*, London, 1962

STENBERGER, M. *Sweden*, London, 1963

TAYLOUR, LORD WILLIAM *The Myceneans*, London, 1964

THOMAS, E. (ed.) *Archäologische Funde in Ungarn*, Budapest, 1956

VARAGNAC, A. and FABRE, G. *L'art gaulois*, Paris, 1956

WINDELS, F. *The Lascaux Cave Paintings*, London, 1949

List of Illustrations

The author and publishers are grateful to the many official bodies, institutions and individuals mentioned below for their assistance in supplying original illustration material. In particular the author wishes to thank Professor D. Berciu, Professor D. P. Dimitrov, Professor J. D. Evans, Dr A. T. Lucas, Mrs E. M. Megaw, J. V. S. Megaw, Professor M. J. O'Kelly, Professor M. Petrescu-Dîmboviţa, Dr A. Rieth, Mrs B. Rosselló, Dr J. Thimme and Dr E. B. Thomas for the many kindnesses and assistance they have accorded him in his compilation of the material for this book.

265

21 Le Portel, Ariège. Confronted bison in black. L. of each: 63 cm. approx. Photo B. Pell.

22 Laugerie Basse, Dordogne. Engraving on pebble of a standing bison. L. 10 cm. M. de l'Homme, Paris. From a cast in the Institute of Archaeology, London. Photo Peter Clayton.

23 La Grèze, Dordogne. Engraved bison with problematic horns. L. 60 cm. Photo Archives.

24 Lascaux, Dordogne. Bison in black, with red patch on back of that facing left. L. overall: 2.40 m. Photo Archives.

25 La Madeleine, Dordogne. Antler slip carving of bison licking its back. L. 10.2 cm. NM. St Germain-en-Laye. Photo Archives.

26 Lorthet, Hautes-Pyrénées. Reindeer and salmon engraved on reindeer antler. From cast of original cylindrical piece. L. 14 cm. NM. St Germain-en-Laye. Photo Archives.

27 Niaux, Ariège. Individual bison in black outline with spears. L. of each animal: 1 m. approx. Photo Archives.

28 Altamira, Santander. Standing bison in red with black outline. L. 1.95 m. Photo B. Pell.

29 Altamira, Santander. Collapsed bison in red with black outline. L. 1.85 m. Photo B. Pell.

30 Marsoulas, Haute-Garonne. Bison painted in red dots with black horns and patches on face and shoulder. Photo B. Pell.

31 Castillo, Santander. Bison with forepart in black paint, and hindquarters formed by natural shape of rock. L. 80 cm. Photo B. Pell.

32 Font de Gaume, Dordogne. Horse in thick black outline on stalactitic background. L. 1.15 m. Photo B. Pell.

33 Le Portel, Ariège. Horse, possibly in-foal mare, in thick black outline with features of mane and coat. L. 45 cm. Photo B. Pell.

34 Altamira, Santander. Abstract designs in red. Photo B. Pell.

35 Castillo, Santander. Abstract designs in red. W. 58 cm. Photo B. Pell.

36 La Mouthe, Dordogne. Abstract design in black and red. Ht. 80 cm. Photo B. Pell.

37 Hornos de la Peña, Santander. Engraved horse with pricked ears. Ht. 70 cm. Photo B. Pell.

38 Lascaux, Dordogne. The 'Chinese horse'. L. 1.47 m. From a copy by Douglas Mazonowicz, Editions Alecto.

39 Lascaux, Dordogne. Great frieze of aurochs, horse and deer in polychrome. Aurochs L. 4 m. Photo Archives.

40 Trou de Chaleux, Namur. Engraving on sandstone block of aurochs. L. 80 cm. Inst. Roy. Sc. Nat., Bruxelles.

41 Chimeneas, Santander. Deer in black outline. L. 81 cm. Photo B. Pell.

42 Font de Gaume, Dordogne. Reindeer in black outline, once red-brown body. Traces of collapsed reindeer in red to right. Overall L. 2.5 m. Photo B. Pell.

43 Pech Merle, Lot. Aurochs in red outline. L. 30 cm. Photo B. Pell.

44 Altamira, Santander. Deer in red-brown with thin black outline. L. 2.25 m. Photo B. Pell.

45 Covalanas, Santander. Deer, or ox uncertain, in red dotted technique, with part of back and hindquarters formed by natural shape of rock. L. 1.38 m. Photo B. Pell.

46 Cougnac, Lot. Ibex outlined in red with utilization of rock surface. L. 30 cm. Photo B. Pell.

47 La Grotte du Poisson, Gorge d'Enfer, Dordogne. Engraved salmon or trout. L. 1 m. Photo B. Pell.

48 Les Combarelles, Dordogne. Engraved lion on rock surface. L. 68 cm. Photo Archives.

49 Les Combarelles, Dordogne. Engraved bear on rock surface. L. 45 cm. Photo Archives.

50 Le Placard, Charente. Fox head carved on baton of reindeer antler. L. 10 cm. NM. St Germain-en-Laye. Photo Archives.

51 Mas d'Azil, Ariège. Carved reindeer antler spear-thrower with young ibex and bird terminal, and with leaves on shaft. L. 29.6 cm. Coll. Péquart, St Brieuc. Photo Archives.

52 Isturitz, Basses Pyrénées. Feline carved in reindeer antler with perforations, and arrows. L. 9.5 cm. NM. St Germain-en-Laye. Photo Archives.

53 Lascaux, Dordogne. Black outline painting of wounded bison, 'man', and bird. Photo Archives.

54 Levanzo, Sicily. Engraving of young deer with turned head. Ht. 20 cm. Photo B. Graziosi.

55 Levanzo, Sicily. Seated figure with fanlike head, in red paint. Ht. 30 cm. Cf. Giedion, 1962, figs. 325–7. Photo F. Teegen.

56 Monte Pellegrino, Sicily. Engraved human figures. Ht. of panel: 1 m. approx. Photo Sopr. Antichita, Palermo.

57 Remigia, Gasulla, Castellon. Hunter and leaping ibex in dark brown. L. 86.5 cm. From a copy by Douglas Mazonowicz, Editions Alecto.

58 Santolea, Teruel. Archer between two figures in dark brown. Ht. 84 cm. From a copy by Douglas Mazonowicz, Editions Alecto.

59 Los Caballos, Valltorta, Castellon. Bowmen and deer in dark brown. Ht. 91.5 cm. From a copy by Douglas Mazonowicz, Editions Alecto.

60 Alunda, Uppland. Polished stone elkhead. L. 21 cm. M. Stockholm. Photo courtesy of Roy. Acad. of Letters, History and Antiquities.

61 Hvittis, Finland. Elk-head in soapstone. L. 14.7 cm. NM. Helsinki.

62 Lake Onega. Elk carved on natural rock. Photo Giraudon.

63 Small carvings in amber of the Maglemose Culture from Denmark. NM. Copenhagen.

64 Gorbunovo, central Urals. Ladle with duck-head handle carved in wood. Photo courtesy of the Archaeological Institute of the U.S.S.R., Moscow.

65 Gorbunovo, central Urals. Forepart of elk carved in wood. Photo courtesy of the Archaeological Institute of the U.S.S.R., Moscow.

66 St Andreae, Karelia. Perforated stone axe with bear-head terminal. NM. Helsinki.

67 Samus, Tomsk, Siberia. Stone carving of a sitting bear. Ht. 15 cm. Photo courtesy of Professors Okladnikov and Gryasnov.

68 Delbo, Hälsingland. Slate dagger with elk-head pommel. L. 14.5 cm. M. Stockholm. Photo courtesy of Roy. Acad. of Letters, History and Antiquities, Stockholm.

69 Karanovo, Bulgaria. Footed pottery vessel with white on red paint. Ht. 24 cm. NM. Sofia. Photo courtesy of Professor V. Mikov.

70 Jungfernhöhle, Upper Franconia. Selection of neolithic pottery. Hts. up to 15 cm. Staatssammlung, Munich. Photo courtesy of Dr Otto Kunkel.

71 Borsod, Hungary. Pottery vessel decorated in Bükk style. Ht. 9 cm. NM. Budapest. Photo courtesy of Dr E. B. Thomas.

72 Aggtelek, Hungary. Spiral decorated base of pottery vessel in Bükk style. D. 12.5 cm. NM. Budapest. Photo courtesy of Dr E. B. Thomas.

73 Domica, Slovakia. Pottery vessel of Bükk neolithic style with thick white encrustation. Ht. 12 cm. M. Bratislava.

74 Truşeşti, Moldavia. Painted amphora of Cucuteni A style. NM. Bucharest. Photo courtesy of Professor M. Petrescu-Dîmboviţa.

75 Truşeşti, Moldavia. Pedestal bowl painted with spirals. NM. Bucharest. Photo courtesy of Professor M. Petrescu-Dîmboviţa.

76 Traian, Moldavia. Painted pottery vessel with anthropomorphic figure. Ht. 40 cm. approx. NM. Bucharest. Photo courtesy of Professor M. Petrescu-Dîmboviţa.

77 Truşeşti, Moldavia. Three painted pottery vessels of Cucuteni A style. NM. Bucharest. Photo courtesy of Professor M. Petruscu-Dîmboviţa.

78 Truşeşti, Moldavia. Painted amphora of Cucuteni A style. NM. Bucharest. Photo courtesy of Professor M. Petrescu-Dîmboviţa.

79 Zengövárkony, Baranya, Hungary. Pottery dish in red paint with white encrustation. Ht. 12 cm. NM. Budapest. Photo courtesy of Dr E. B. Thomas.

80 Hembury, Devon. Neolithic vessel in fine red ware with trumpet lugs. Ht. 12 cm. M. Exeter. Photo W. Hoskin.

81 Hedsor, Buckinghamshire. Neolithic vessel of Mortlake style. Ht. 12.4 cm. British Museum. Photo courtesy of the Trustees of the British Museum.

82 Untergrombach, Baden. Pottery group of Michelsberg Culture. Ht. of tulip-beaker: 18 cm., D. of plate: 26 cm. M. Konstanz.

83 Tovstrup, Jutland. Pottery and stone club-head of phase C of Funnel Beaker Culture. Ht. of amphora: 29 cm. NM. Copenhagen.

84 Hagebrogård, Jutland. Handled vessel decorated in 'Grand Style'. Ht. 17 cm. Cylindrical pot from same find. Hanging vessel and scoop of unknown find-spot. NM. Copenhagen.

85 Cernavoda, Dobrudja. Pottery figurines of seated man and woman. Hamangia neolithic culture. Ht. of man: 11.5 cm. Ht. of woman: 11.4 cm. NM. Bucharest. Photo courtesy of Professor D. Berciu.

86 Keros, Cyclades. Figure of harpist carved in marble. Ht. 23 cm. NM. Athens. Photo Josephine Powell.

87 Karanovo, Bulgaria. Marble figurine from fourth phase of settlement. Ht. 10.7 cm. NM. Sofia. Photo courtesy of Professor V. Mikov.

88 Cucuteni, Moldavia. Pottery figurine of phase A. NM. Bucharest. Photo courtesy of Professor M. Petrescu-Dîmboviţa.

89 Szegvár-Tüzköves, Hungary. Seated figure in fired clay, brick-red in colour. Ht. 26.5 cm. M. Szentes. Csalog, AAH, XI (1959), 7–38. From a cast by courtesy of Professor J. D. Evans, Institute of Archaeology, London. Photo M. B. Cookson.

90 Hluboké Mašůvky, Moravia. Female figurine standing with outstretched hands. Ht. 36 cm. Coll. Vildomec.

91 Střelice, Moravia. Two pottery figurines of Lengyel Culture. Hts. 21 and 22 cm. M. Brno. Photo J. Kleibl.

92 Hacılar, south-west Anatolia. White and red painted anthropomorphic vessel with obsidian eyes. Bey Hüseyin Kocabaş collection, Ankara. Photo Josephine Powell.

93 Hódmezövasárhely-Kökénydomb, Hungary. Anthropomorphic pottery vessel of Tisza Culture. Ht. 23 cm. M. Hódmezö-vasárhely. Banner, Germania, XXXVII (1959), 14–35. From a cast by courtesy of Professor J. D. Evans, Institute of Archaeology, London. Photo M. B. Cookson.

94 Hódmezövasárhely-Kökénydomb, Hungary. Baked clay 'altar'. Longer sides: 48 cm. M. Hódmezövasárhely. Photo courtesy of Dr E. B. Thomas.

95 Střelice, Moravia. Two-headed animal in pottery with socket in back. Ht. 12.7 cm. M. Brno. Photo J. Kleibl.

96 Střelice, Moravia. Pottery vessel with stylized human figures in puncture, and plastic animals on neck, and heads at girth. Lengyel Culture. Ht. 38 cm. Coll. Vildomec. Photo J. Kleibl.

97 Střelice, Moravia. Model of house, in pottery, with ram's head finial. L. 15 cm. M. Brno. Photo J. Kleibl.

98 Grimes Graves, Norfolk. Figurine crudely carved in chalk. Ht. 12 cm. British museum. Photo courtesy of the Trustees of the British Museum.

99 Senorbi, Sardinia. Stylized female figurine in marble. Ht. 42 cm. NM. Cagliari.

100 Amorgos, Cyclades. Marble statue of female deity. Ht. 1.48 m. NM. Athens. Photo Josephine Powell.

101 Ereta del Pedregal, Valencia. Antler carved with oculi. M. Valencia. I. Ballester Tormo, 1945.

102 Almizaraque, Almeria. Ox-phalange carved with oculi. L. 17 cm. M. Almeria. Photo Mas.

103 Almeria, southern Spain. Stone cylinder-idol. Ht. 11 cm. M. Almeria.

104 Portugal. Find-spot unknown. Schist plaque of anthropomorphic derivation. L. 16.5 cm. British Museum. Photo courtesy of the Trustees of the British Museum.

105, Los Millares, Almeria. Pottery vessel
106 with oculos motif and incised pattern with deer. D. 10.5 cm. M. Ashmolean, Oxford. Photo Ashmolean Museum.

107 Folkton, Yorkshire. Solid chalk drums carved with faces and other decoration. Hts. from 14.2 to 10.4 cm. British Museum. Photo Eileen Tweedy.

108 Scotland. Carved stone balls from various finds. D. from 7.6 to 3.8 cm. NM. Antiq. Edinburgh. Photo Malcolm Murray.

109 Denmark. Oculos decorated vessels from Kyndeløse (two at back), and Svinø (front). Ht. of last: 12 cm. NM. Copenhagen.

110 New Grange, Co. Meath, Ireland. Decorated kerb stone in front of entrance to passage and chamber. L. 3.20 m. Photo courtesy of Professor M. J. O'Kelly.

111 Clear Island, Co. Cork, Ireland. Decorated stone in style of Passage Grave art. Ht. 1.3 m. M. Cork. Photo courtesy of Professor M. J. O'Kelly.

112 Clear Island, Co. Cork, Ireland. Detail of decorated stone showing punch technique of carving. Photo courtesy of Professor M. J. O'Kelly.

113 Barclodiad y Gawres, Anglesey, Wales. Detail of stone 22 in this Passage Grave showing punch technique. Photo courtesy of Professor M. J. O'Kelly.

114 Mané-er-Hroek, Morbihan, Brittany. Two axes and two rings made of jadeite from this Passage Grave. L. of larger axe: 35.3 cm. M. Carnac. Photo Jacqueline Hyde.

115 Gavrinis, Morbihan, Brittany. Detail of axes carved on stone uprights in this Passage Grave. Photo Jacqueline Hyde.

116 Table des Marchands, Morbihan, Brittany. End stone of chamber showing fringed border design enclosing rows of curved objects with long handles. Ht. of stone 3 m. approx. Photo Jos Le Doaré.

117 Badden, Lochgilphead, Argyll, Scotland. Decorated slab from a Bronze Age cist burial. L. 1.50 m. M. Glasgow. Photo J. G. Scott.

118 Göhlitzsch, Kr. Merseberg. Side slab from grave of Corded Ware Culture. Bow, quiver and axe, as well as hangings are shown. L. of slab: 2 m. LM. Halle/Saale. Photo courtesy of the Director.

119 Sweden. Stone axes of 'boat' type with collar around central perforation. From various finds. L. of largest 20 cm. approx. M. Stockholm. Photo courtesy of Roy. Acad. of Letters, History and Antiquities, Stockholm.

120 Hindsgavl, Odense, Denmark. Flint dagger. L. 29.5 cm. NM. Copenhagen.

121 Radley, Berkshire. Pair of gold earrings from Beaker burial. L. 4.8. cm. *Inv. Arch.* GB2. M. Ashmolean, Oxford. Photo Ashmolean Museum.

122 Bush Barrow, Wiltshire. Gold, bronze and other objects from the burial. The sceptre is a modern reconstruction. L. of larger gold plate: 21.7 cm.; L. of larger bronze dagger: 36.9 cm. Annable and Simpson, 1964, for details. M. Devizes. Photo Eileen Tweedy.

123 Rillaton, Cornwall. Gold cup from Bronze Age burial. Ht. 8.9 cm. A. Fox, 1964. British Museum. Photo Edwin Smith.

124 Mycenae, Shaft Grave IV. Gold cup with ribbed sides. Ht. 6.3 cm. NM. Athens. Photo Max Hirmer.

125 Fritzdorf, Bonn. Large gold cup with rivet-attached handle. Ht. 12.1 cm. R. von Uslar, *Germania*, XXXIII (1955), 319–23. LM. Bonn.

126 Wiltshire. Lathe-turned shale cup of Wessex Culture type. Ht. 8.9 cm. M. Salisbury. Photo Malcolm Murray.

127 Hove, Sussex. Amber cup from Bronze Age burial. Ht. 8.9 cm. M. Brighton. Photo courtesy of the Director, Art Gallery and Museum and the Royal Pavilion, Brighton.

128 Poltalloch, Argyll, Scotland. Crescentic necklace of jet beads (re-strung) from Bronze Age burial. D. of neck-opening: 14.5 cm. NM. Antiq. Edinburgh. Photo Malcolm Murray.

129 Killarney, Co. Kerry, Ireland. Detail of lunula showing technique of linear decoration. NM. Dublin. Photo courtesy of the Director, the National Museum.

130 Killarney, Co. Kerry, Ireland. Crescentic sheet-gold neck ornament known as a *lunula* with punch-engraved ornament on terminals and edges. D. of neck-opening: 15 cm. approx. NM. Dublin. Photo courtesy of the Director, the National Museum.

131 Melfort, Argyll, Scotland. Bronze bracelet of thin metal with repoussé ornament. Ht. 5.1 cm. *Inv. Arch.* GB25. NM. Antiq. Edinburgh. Photo Malcolm Murray.

132 Tufălau (Cófalva), Transylvania. Solid gold axe, one of five in this hoard. L. 15 cm. Naturhist. M. Vienna (only this axe). Photo courtesy of the Director.

133 Leubingen, Kr. Sömmerda, Saxony. Gold objects from chieftain's grave. L. of pins: 9.9 cm. LM Halle/Salle. Photo courtesy of the Director.

134 Tufălau (Cófalva), Transylvania. Spiral decorated gold discs from amongst other items in this hoard. D. 4.5 cm. NM. Budapest.

135 Barca, Slovakia. Gold hoard of Otomani Culture. D. of armlet 9 cm. approx. M. Kosice.

136 Trassem, Kr. Saarburg, Rheinland. Gold pin with head in five spirals. Part of a hoard. LM. Trier. Photo courtesy of the Director.

137 Bohemia. Gold armlets with spiral terminals from Libčeves and Větrušice. NM. Prague. Photo courtesy of the Director.

138 Cîrna, Oltenia, Rumania. Pottery statuette of stylized woman in elaborate dress. One of a number from a cremation cemetery. Ht. 17.8 cm. V. Dumitrescu, 1961. NM. Bucharest. Photo courtesy of Professor M. Petrescu-Dîmboviţa.

139 Moulsford, Berkshire. Gold torc made of four twisted bars with terminal caps. W. between terminals: 11.5 cm. C. F. C. Hawkes, *Ant.*, XXXV (1961), 240–2. M. Reading. Photo courtesy of the Director, Reading Museum and Art Gallery.

140 Moulsford, Berkshire. Detail of terminal cap. Side view.

141 Moulsford, Berkshire. Detail of twisted bars and binding.

142 Moulsford, Berkshire. Detail of end of terminal cap.

143 Derrinboy, Co. Offaly, Ireland. Middle Bronze Age gold hoard. L. of necklet: 37.7 cm. NM. Dublin. Photo courtesy of the Director, the National Museum.

144 Stanton, Staffordshire. Gold bar-twisted armlet. D. of coils: 10.1 cm. British Museum. Photo courtesy of the Trustees of the British Museum.

145 Mold, Flintshire, Wales. Fragments of sheet-gold shoulder ornament from Bronze Age grave. Ht. at centre line: 21.2 cm. Powell, *PPS.*, XIX (1953), 161–79. British Museum. Photo courtesy of the Trustees of the British Museum.

146 Mold, Flintshire. Detail showing milling around bosses and along ribs.

147 Mold, Flintshire. Detail showing variety of repoussé bosses.

148 Avanton, Vienne. Conical sheet-gold object with repoussé ornament. Ht. 40 cm. Louvre. Photo Archives.

149 Etzeldorf-Buch, Lkr. Nuremberg. Gold-leaf covering for a cult pillar. Ht. 95 cm. G. Raschke, *Germania*, XXXII (1954), 1–6. NM. Nürnberg. Photo courtesy of Dr G. Raschke.

150 Velem-Szentvid, Hungary. Gold diadem with repoussé ornament from a hoard. Ht. at centre: 16 cm. Mozsolics, 1950. M. Szombathely. Photo courtesy of Dr E. B. Thomas.

151 Angyalföld, Budapest. Three of a find of four gold cups. Younger Urnfield period. Ht. from left: 9.1, 4.7, 8.5 cm. NM. Budapest. Photo courtesy of Dr E. B. Thomas.

152 Dresden Dobritz. Sheet-bronze vessels from a hoard. Older Urnfield period. Ht. of largest vessel: 16.8 cm. S. Piggott, *Ant.*, XXXIII (1959), 122–3. LM. Dresden.

153 Trundholm, Holbaek, Denmark. 'Sun-carriage' with horse, all mounted on wheels. Bronze with gold leaf on one face of disc. Overall L. 57 cm. H. Drescher, *AA.*, XXXIII (1962), NM. Copenhagen.

154 Denmark. Gold vessels from Borgbjerg, Zealand, and Lavindsgaard Funen. NM. Copenhagen.

155 Gönnebeck, Holstein. Gold cup with repoussé ornament found in a grave with a bronze sword of Montelius Per. III. D. 14.4 cm. LM. Schleswig.

156 Gönnebeck, Holstein. Detail of base of gold cup.

157 Kivik, Skåne, Sweden. Carved wall-stone of grave, with chariot and other scenes. W. of panel: 70 cm. approx. Photo courtesy of the Roy. Acad. of Letters, History and Antiquities, Stockholm.

158 Kivik, Skåne. Carved wall-stone from grave, with unharnessed horses. W. 70 cm. approx. C.-A. Althin, 1945. Photo courtesy of the Roy. Acad. of Letters, History and Antiquities, Stockholm.

159 Hvirring, Aarhus, Denmark. Bronze razor decorated with engraved ship. L. 13.1 cm. NM. Copenhagen.

160 Solbjerg, Aalborg, Denmark. Bronze razor decorated with ships, and tweezers. L. of razor: 16 cm. NM. Copenhagen.

161 Røgerup, Fredriksborg, Denmark. Bronze ornaments from a hoard. The flange constructed counter-twisted 'Vendelring' is 16 cm. D. NM. Copenhagen.

162 Maltbaek, Ribe, Denmark. *Lur*, or bronze horn, one of a pair. Ht. 97.5 cm. H. C. Broholm *et al.*, 1949. NM. Copenhagen.

163 Clones, Co. Monaghan, Ireland. Gold dress-fastener. W. overall: 22 cm. NM. Dublin. Photo courtesy of the Director, the National Museum.

164 Clones, Co. Monaghan. Detail of ornament on terminal.

165 Gleninsheen. Gorget of sheet-gold with repoussé ornament. W. overall: 30.5 cm. NM. Dublin. Photo courtesy of the Director, the National Museum.

166 Scotland. Bronze shields from Auch-maleddie, Aberdeenshire, and Yetholm, Roxburghshire. Eight century BC. D. 46.4 and 57.1 cm. J. M. Coles, *PPS.*, XXVIII (1962), 156–90. NM. Antiq. Edinburgh. Photo Malcolm Murray.

167 Bremen. Bronze helmet found in the Weser at Bremen. Focke M. Bremen. Photo Hed Weisner.

168 Dunaverney, Co. Antrim, Ireland. Tubular bronze shaft with double hook. Ornamented with attached bronze swans, and crows, and pendent rings. L. 60.7 cm. British Museum. Photo courtesy of the Trustees of the British Museum.

169 Svijany, Bohemia. Bronze swan-headed terminals with sockets. Sileso-Platěnice Culture of Late Bronze Age. Ht. of smaller swan: 9 cm. NM. Prague. Photo courtesy of the Director.

170 Hallstatt, Upper Austria. Water birds on leg of bronze stand from Grave 507. L. of birds about 3 cm. each. M. Naturhist. Vienna. Photo courtesy of the Director.

171 Hallstatt, Upper Austria. Bronze figurine of horse of steppe type. L. 7.5 cm. M. Naturhist. Vienna. Photo courtesy of the Director.

172 Hallstatt, Upper Austria. Bronze figurine of stylized ox. Ht. 9.7 cm. K. Kromer, 1963, for this and other pieces from Hallstatt. M. Naturhist. Vienna. Photo courtesy of the Director.

173 Hallstatt, Upper Austria. Bronze cow and calf standing on edge of bronze vessel from Grave 671. L. of cow 14.4 cm. M. Naturhist. Vienna. Photo courtesy of the Director.

174 Straškov, Bohemia. Painted dish, black on polished light grey. Bylany Culture. D. 35 cm. NM. Prague.

175 Tannheim, Kr. Biberach, Württemberg. Pottery dish with deep cut decoration. D. 35 cm. LM. Stuttgart.

176 Hallstatt, Upper Austria. Gold-leaf earrings from Grave 505. D. 3.5 cm. M. Naturhist. Vienna. Photo courtesy of the Director.

177 Bad Cannstatt, Württemberg. Gold neck ornament from chieftain's waggon grave. D. 16–18 cm. LM. Stuttgart.

178 Bad Cannstatt, Württemberg. Gold cup from chieftain's waggon grave. D. 16.5 cm. LM. Stuttgart.

179 Altstetten, Zürich. Gold bowl with symbols against repoussé boss field. D. 25 cm. LM. Zürich.

180 Cintra, Portugal. Gold collar in 'Celtiberian style'. W. overall: 17 cm. British Museum. Photo courtesy of the Trustees of the British Museum.

181 Auvers, Seine-et-Oise. Gold pressed on bronze disc with coral stud. Probably a lid. Early Style of La Tène art. D. 10 cm. Jacobsthal, 1944, no. 19. Cabinet des Médailles, Paris.

182 Eigenbilzen, Limbourg, Belgium. Gold openwork strip. Early Style of La Tène art. L. 22 cm. Jacobsthal, 1944, no. 24; Inv. Arch., B6. M. Roy., Brussels.

183 Hölzelsau, Niederinntal, Austria. Bronze openwork belt-clasp. L. 16.2 cm. Jacobsthal, 1944, no. 360. Private coll. Photo courtesy of Dr C. Albiker, Karlsruhe.

184 Rodenbach, Rheinpfalz. Central detail of gold bracelet. Jacobsthal, 1944, no. 59. Hist. M. der Pfalz, Speyer. Photo courtesy of Dr C. Albiker, Karlsruhe.

185 Panenský-Týnec, Bohemia. Bronze mask-brooch with bird, and sheep's head. Early La Tène. L. 8.1 cm. NM. Prague. Photo J. V. S. Megaw.

186 Parsberg, Oberpfalz. Detail of face on mask-brooch. Jacobsthal, 1944, no. 316. NM. Nürnberg. Photo J. V. S. Megaw.

187 Basse-Yutz, Lorraine. Detail of lower handle terminal of one of the flagons showing mask with coral inlay. British Museum. Photo J. V. S. Megaw.

188 Rheinheim, Saarland. Gold ornaments from princess's grave. M. Saarbrücken. Photo Kirschmann.

189 Rheinheim, Saarland. Detail of torc terminal. J. Keller, Das Keltische Fürstengrab von Reinheim, I. 1965. Photo Kirschmann.

190 Basse-Yutz, Lorraine. Pair of beaked flagons of Early La Tène work. Bronze with coral inlay. Ht. 37.6 and 38.7 cm. to tip of spouts. Jacobsthal, 1944, no. 381. British Museum. Photo Eileen Tweedy.

191 Hallein-Dürrenberg. Detail of upper portion of flagon showing devouring monsters.

192 Hallein-Dürrenberg. Beaked flagon of bronze from chariot grave. Ht. 46.5 cm. Jacobsthal, 1944, no. 382. M. Salzburg.

193 Waldalgesheim, Kr. Kreuznach, Rheinland-Pfalz. Bronze flagon with cylindrical spout. Fourth century BC. Restored. Ht. 37.2 cm. Jacobsthal, 1944, no. 387. LM. Bonn.

194 Waldalgesheim. Detail of lower handle terminal. Bearded face. Photo J. V. S. Megaw.

195 Waldalgesheim. Bronze plaque of repoussé half-figure with leaf-crown, and raised hand. One of a pair. Ht. 7.5 cm. Jacobsthal, 1944, no. 156 (d.). LM. Bonn. Photo J. V. S. Megaw.

196 Waldalgesheim. Gold ornaments found in grave with the foregoing. D. of torc: 19.3 cm. Jacobsthal, 1944, nos. 43, 54, 55. LM. Bonn.

197 Waldalgesheim. Enlarged detail of centre portion of one of the gold bracelets. Photo J. V. S. Megaw.

198 Brentford, Middlesex. Bronze 'horn-cap' from the Thames. Probably a chariot yoke terminal. Pattern in low relief originally inset with red enamel. D. 7.3 cm. Fox, 1958, 3. M. London. Photo courtesy of the Trustees of the London Museum.

199 Marne, France. Fine pottery, some with paint, from cemeteries of fourth and third centuries BC. Ht. of tallest in group: 34 cm. British Museum. Photo Eileen Tweedy.

200 Waldenbuch, Kr. Böblingen, Württemberg. Lower portion of sandstone block sculptured with hand, and La Tène style ornament. Ht. 1.25 m. Jacobsthal, 1944, no. 15. LM. Stuttgart.

201 Pfalzfeld, Kr. St Goar, in the Hunsrück, Rheinland. Tapering sandstone pillar with rounded base. Sculptured on all four faces, each with human head and stylized foliage. Ht. 1.48 m. Jacobsthal, 1944, no. 11. LM. Bonn.

202 Holzgerlingen, Kr. Böblingen, Württemberg. Sandstone block with 'Janus' sculpture. The horns have been restored. Ht. 2.30 m. Jacobsthal, 1944, no. 13. LM. Stuttgart. Photo J. V. S. Megaw.

203, Heidelberg. Front and back views of
204 sandstone head with trefoil on forehead and leaf-crown. Ht. 30 cm. Jacobsthal, 1944, no. 14. LM. Karlsruhe. Photos J. V. S. Megaw.

205 Turoe, Co. Galway, Ireland. Stone block sculptured with elaborate La Tène style composition. Ht. 1.20 m. J. Raftery, JRSAI, LXXIV (1944), 23–52. Photo courtesy of E. M. Megaw.

206 Noves, Bouches-du-Rhône. Detail of one of a pair of sculptured heads beneath the forepaws of a stone monster. 'Celto-Ligurian' work. Ht. of head: 30 cm. M. Calvet, Avignon. Photo César.

207 Fenouillet, Haute-Garonne. Gold torc, one of five in a hoard. Variant of Plastic Style La Tène art. D. 12.5 cm. Jacobsthal, 1944, no. 67. M. St Raymond, Toulouse. Photo Dieuzade-Zodiaque.

208 Clonmacnoise, Co. Offaly, Ireland. Gold torc made of tubular sheet metal decorated with fat spiral scrolls. D. 13 cm. (inner). Jacobsthal, 1944, no. 49. NM. Dublin. Photo courtesy of the Director, the National Museum.

209 Nebringen, Kr. Böblingen, Württemberg. Bronze neck-ring with red enamel insets. From Grave 14. D. 15.2 cm. W. Krämer, 1964. LM. Stuttgart.

210 Broighter, Co. Derry, Ireland. Tubular gold collar with repoussé ornament. Ext. D. 19 cm. For comment and comparanda: R. R. Clarke, PPS, XX (1954), 42ff. NM. Dublin. Photo courtesy of the Director, the National Museum.

211 Needwood Forest, Staffordshire. Gold multi-strand torc with loop terminals. D. 19.1 cm. R. R. Clarke, supra, p. 64f. British Museum. Photo courtesy of the Trustees of the British Museum.

212 Courtisols, Marne. Bronze torc with Plastic Style ornament in faces and scrolls. D. 13 cm. Jacobsthal, 1944, no. 208. British Museum. Photo courtesy of the Trustees of the British Museum.

213 La Charme, Troyes, Aube. Bronze armlet with heavily moulded ornament, including human masks. D. 5.7 cm. M. Troyes. Photo Belzeaux-Zodiaque.

214 Barbuise, Aube. Bronze neck-ring with three projections of three balls each. D. 12.7 cm. M. Troyes. Photo Belzeaux-Zodiaque.

215 Mezek, Bulgaria. Bronze linch-pin for chariot wheel. One of a pair. L. 12.5 cm. Jacobsthal, 1944, no. 164. NM. Sofia. Photo courtesy of Professor D. P. Dimitrov.

216 Mezek, Bulgaria. Bronze terret with animal face on claw. D. 7.1 cm. NM. Sofia. Photo courtesy of Professor D. P. Dimitrov.

217 Mezek, Bulgaria. Plastic Style face on claw of large bronze terret from chariot fittings. W. 7.5 cm. NM. Sofia. Photo courtesy of Professor D. P. Dimitrov.

218 Leval-Trahegnies, Hainault, Belgium. Pair of chariot wheel linch-pins of iron with bronze coating. Decorated with Plastic Style masks. W. of heads: 4.9 and 5 cm. M. Brussels. M.-E. Mariën, 1961. Photo courtesy of M. E. Mariën.

219 Brno-Maloměřice, Moravia. Detail of bronze openwork in Plastic Style, one of a number of pieces found together. Ht. of face: 6 cm. approx. O. Klindt-Jensen, 1953. M. Brno.

220 Trichtingen, Württemberg. Silver torc with ox head terminals, and iron core. D. 25 cm. P. Goessler, 1929. LM. Stuttgart.

221 Brå, Horsens, Jutland. Ring handle and attachments of bronze cauldron. D. of ring: 20 cm. O. Klindt-Jensen, 1953. M. Aarhus.

222 Brå, Horsens. Owl-mask on upper part of handle attachment of the bronze cauldron. W. of owl face: 4.8 cm. approx. M. Aarhus.

223 Rynkeby, Funen, Denmark. Portion of side of bronze cauldron with human face, and ox heads. Ht. 20 cm. approx. NM. Copenhagen.

224 Aylesford, Kent. Stave-built bucket with bronze mounts. Belgic of first century BC. Ht. 25.4 cm. British Museum. Photos courtesy of the Trustees of the British Museum.

225 Aylesford, Kent. Detail of decorated hoop with horses.

226 Aylesford, Kent. Detail of handle attachment with human head.

227 Trawsfynydd, Merioneth, Wales. Stave-built tankard covered in sheet bronze, with openwork handle. Ht. 14.3 cm. J. Corcoran, PPS, XVIII (1952), 85–102. M. Liverpool. Photo courtesy of the Director, City of Liverpool Museums.

228 Hagighiol, Dobrudja. Silver vase with repoussé animals. Daco-Thracian. Probably late fifth century BC. Ht. 18 cm. approx. NM. Bucharest. Photo courtesy of Professor D. Berciu.

229 Poiana-Coțofenești, Rumania. Gold helmet, Daco-Thracian. Probably fourth century BC. Ht. 24 cm., D. 17.3 cm. NM. Bucharest. Photo courtesy of Professor D. Berciu.

230 Gundestrup, Himmerland, Denmark. Cauldron made of silver inner and outer plates and base-plate. Repoussé ornament with Celtic and Oriental themes. D. 69 cm. O. Klindt-Jensen, 1961. NM. Copenhagen.

231 Entremont, Bouches-du-Rhône. Stone pillar with engraved heads in groups of three arranged differently. Ht. 1.60 m. M. Borély, Marseilles. Photo courtesy of the Director, Musée Borély.

232 Roquepertuse, Bouches-du-Rhône. Full face of stone 'Janus' head from the Celto-Ligurian sanctuary. Ht. 20 cm. M. Borély, Marseilles. Photo courtesy of the Director, Musée Borély.

233 Salzburg, Austria. Stone head from the Hohenfestung. Ht. 16.8 cm. K. Willvonseder, Eine Kopfplastik Keltischer Art der Festung Hohensalzburg. *Jahrber*, 1959, 37–48. Salzburger Museum Carolino-Augusteum. The head is in the Burg Museum, Hohensalzburg. Photo courtesy of the Director, the Salzburger Museum.

234 Entremont, Bouches-du-Rhône. Sculptured male head. Ht. 28 cm. M. Borély, Marseilles. Photo Jean Roubier.

235 Gloucester, England. Sculptured male head with accentuated eyes. Ht. 24 cm. M. Gloucester. Photo courtesy of the Director, Gloucester City and Folk Museums.

236 Corlech, Co. Cavan, Ireland. Stone head with three faces. Ht. 32 cm. NM. Dublin. Photo courtesy of the Director, the National Museum.

237 Pyrenees region. Sheet-bronze head. Ht. 17.2 cm. M. Tarbes. Photo Dieuzade Zodiaque.

238 Wandsworth, London. Circular bronze shield boss from the Thames. D. 33 cm. British Museum. Photo courtesy of the Trustees of the British Museum.

239, Torrs, Kirkcudbrightshire, Scotland.
240 Detail of Insular La Tène style ornament on bronze head-piece for a chariot pony. R. J. C. Atkinson and S. Piggott, *Arch.*, XCVI (1955), 197–235. NM. Antiq. Edinburgh. Photos Malcolm Murray.

241 Witham (river), Lincolnshire. Bronze shield from this river near Lincoln. The bossed mid-rib was imposed on an earlier boar design. Ht. 1.12 m. British Museum. Photos courtesy of the Trustees of the British Museum.

242 Witham. Detail of central boss of the bronze shield showing relief ornament in Insular La Tène style.

243 Desborough, Northamptonshire. Bronze mirror with elaborate engraved pattern. L. 35 cm. British Museum. Photo courtesy of the Trustees of the British Museum.

244 Rise, Yorkshire. Bronze three-link snaffle bit with blue and red enamel insets. L. 27.9 cm. British Museum. Photo courtesy of the Trustees of the British Museum.

245 Castle Newe, Aberdeenshire, Scotland. A pair of massive bronze armlets with medallion insets of red and yellow enamel. D. 14.4 cm. British Museum. Photo courtesy of the Trustees of the British Museum.

246 Battersea, London. Bronze shield from the Thames, with red glass insets. Ht. 80 cm. British Museum. Photo courtesy of the Trustees of the British Museum.

247 Tal-y-Llyn, Merioneth, Wales. Sheet-bronze fragment of a shield mount with reserve triskele against a hatched background. NM. Wales, Cardiff. Photo courtesy of the Director and Messrs Idris Ltd.

248 Llyn Cerrig Bach, Anglesey, Wales. Bronze shield boss and midrib with engraved decoration. Ht. 36.6 cm. C. Fox, 1958, 42–44. NM. Wales, Cardiff. Photo courtesy of the Director.

249 'Mayer' mirror. Said to have been found in the Thames at London. L. 22.5 cm. M. Liverpool. Photo courtesy of the Director, City of Liverpool Museums.

250 Keshcarrigan, Co. Leitrim, Ireland. Bronze cup. First century AD. NM. Dublin. Reproduced with the consent of the Govt. of N. Ireland's Archaeological Survey. Photo A. E. P. Collins.

251 Dühren, Kr. Sinsheim, Baden. Glass armlets and beads from Middle La Tène woman's grave. D. of arm-ring: 8.7 cm. LM. Karlsruhe. Photo courtesy of Dr J. Thimme.

252 Wallertheim, Kr. Alzey, Rheinpfalz. Miniature glass dog from Late La Tène cemetery. L. 2.1 cm. *Germania*, XXIX (1951), 256. Atlertumsmuseum, Mainz. Photo courtesy of the Director.

253 Barton, Cambridgeshire. Detail of ox-head terminal of the fire-dog.

275

254 Barton, Cambridgeshire. Iron fire-dog with ox-head terminals from a Belgic grave. Ht. 71 cm. S. Piggott, *Ant.*, XXII (1948), 21–28. M. Arch. and Ethn. Cambridge. Photos courtesy of the Museum of Archaeology and Ethnology.

255 Kappel-Dürnau, Württemberg. Iron eagle-head from fire-dog or similar object. L. of head: 18 cm. F. Fischer, 1959. Federsee M. Photo courtesy of Dr A. Rieth.

256 Kappel-Dürnau, Württemberg. Iron ox head from fire-dog or similar object. Late La Tène. Ht. 43.1 cm. F. Fischer, 1959. Federsee Museum, Buchau am Federsee. Photo courtesy of Dr A. Rieth.

257 Welwyn, Hertfordshire. Iron stand with ox-head terminals. (Reconstructed.) From a Belgic grave. Total ht. 1.56 m. J. W. Brailsford, *AJ.*, XXXVIII (1958). British Museum. Photo courtesy of the Trustees of the British Museum.

258 Gold stater of Philip II of Macedon, 359–336 B C. Reverse, charioteer. D. 2 cm. British Museum.

259 Gold stater of the Parisii (Gaul). Reverse, horse and disjointed charioteer. D. 2.5 cm. British Museum. Photo Peter Clayton.

260 Silver stater of the Baiocasses (Gaul). Obverse, ecstatic face with a boar symbol behind head. D. 2.2 cm. Lengyel, 1954.

261 Gold stater of Philip II of Macedon, 359–336 B C. Obverse of *Ill. 258*, head of Apollo. D. 2 cm. British Museum.

262 Luncani. Bronze boar. La Tène. Cluj Museum.

263 Bronze coin of Cunobelin. Obverse, front facing head of Cunobelin. Reverse, boar and legend. D. 1.7 cm. British Museum.

Index

Numbers in italics refer to those of illustrations, not pages